William Vaughan is Pevsner Professor of the History of Art at Birkbeck College, University of London. After studying at the Ruskin School of Art in Oxford and the Courtauld Institute, London, he became an Assistant Keeper at the Tate Gallery, London. In 1972 he was appointed as lecturer at University College, London, until he took up the professorship at Birkbeck. He is the author of numerous articles and books on eighteenth- and nineteenth-century painting, including *Romanticism and Art* (2nd edition, 1994); and *British Painting: The Golden Age from Hogarth to Turner* (1999). In 1998 he was chosen to deliver the Paul Mellon Lectures at the National Gallery, London, on the subject of British painting. Professor Vaughan is married with two children.

D0365955

Thames & Hudson world of art

This famous series provides the widest available range of illustrated books on art in all its aspects.

If you would like to receive a complete list of titles in print please write to:

THAMES & HUDSON
181A High Holborn
London WC1V 7QX

In the United States please write to:

THAMES & HUDSON INC.
500 Fifth Avenue
New York, New York 10110

Printed in Singapore

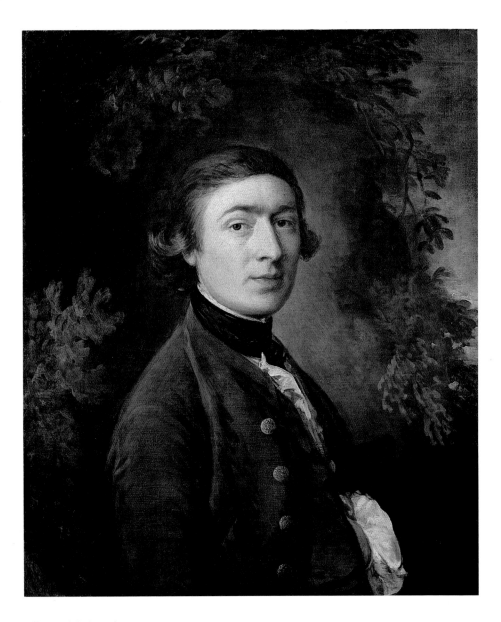

1. **Thomas Gainsborough,**
Self-Portrait, c. 1758–59.
This confident self-portrait was
painted at the time when the artist
was beginning to establish himself
as a fashionable portrait painter.

William Vaughan

Gainsborough

172 illustrations, 68 in colour

Thames & Hudson world of art

For Pek

Acknowledgments

This book has grown from classes I have taught at Birkbeck
College, and my first debt is to my students for the stimulating
debates I have had with them about Gainsborough over the years.
I am particularly grateful as well to John Hayes and Brian Allen,
both of whom kindly read through the text and made innumerable
helpful suggestions. I would also like to thank my wife, Anthea
Peppin, for improvements to my manuscript and for many
perceptive observations on the pictures discussed in it.

First published in the United Kingdom in 2002 by
Thames & Hudson Ltd, 181A High Holborn, London WC1V 7QX

www.thamesandhudson.com

British Library Cataloguing-in-Publication Data
A catalogue record for this book is available from the British Library

ISBN 0-500-20358-X

Designed by Derek Birdsall
Typeset by Omnific

Printed and bound in Singapore by C. S. Graphics

Contents

Introduction: Effect and Substance

Mary, Countess Howe, is stepping forth through a stormy landscape. The wife of a celebrated naval officer – later to become Admiral of the Fleet and a national hero through numerous victories – she could be described here as being in full sail. Undaunted by the weather, she is displaying all her finery. Her rose pink dress – the simple, but fashionable, *robe à l'anglaise* – is partly veiled with a gauzy shawl and apron and embellished with flounces of lacy sleeve. Their shimmering tones are picked up in the pearls in her necklace and earrings. Then there is a surprise. Her head is crowned with a sharp-edged light straw sun hat that cuts across the canvas, holding our attention at the point where it can dwell on her handsome face, with its serene and confident gaze. With her right hand she slightly lifts her skirts, enough to protect them from the mud on the ground and reveal an elegant pair of black, buckled shoes. It is a romantic picture, full of expectancy. You feel there must be a story. But there is no story. This is just Thomas Gainsborough doing a routine commissioned portrait, and giving it more performance than any client had a right to expect. It was painted in the early 1760s at Bath, when the artist was in his mid thirties and at the height of his powers – very much the confident figure he shows us in a self-portrait painted a year or so earlier.

Such resplendent pictures as this have secured Gainsborough lasting fame. There are not many historical British artists who can claim an international standing. Gainsborough is one of that select company – along with J. M. W. Turner (1775–1851), John Constable (1776–1837) and William Hogarth (1697–1764). Of these, he is probably the most immediately appealing. He presents few difficulties at first glance. His paintwork is so delicious it can be consumed almost like confectionery. The eighteenth century was an age when visual pleasure was much in evidence in the arts. It was the dominating feature of the Rococo style – that exquisite celebration of the sensuous and the momentary

2. **Thomas Gainsborough,** *Mary, Countess Howe,* c. 1763–64. A classic image of aristocratic elegance. The sitter was wife to a celebrated naval officer. Already victorious, Earl Howe was later to become Admiral of the Fleet.

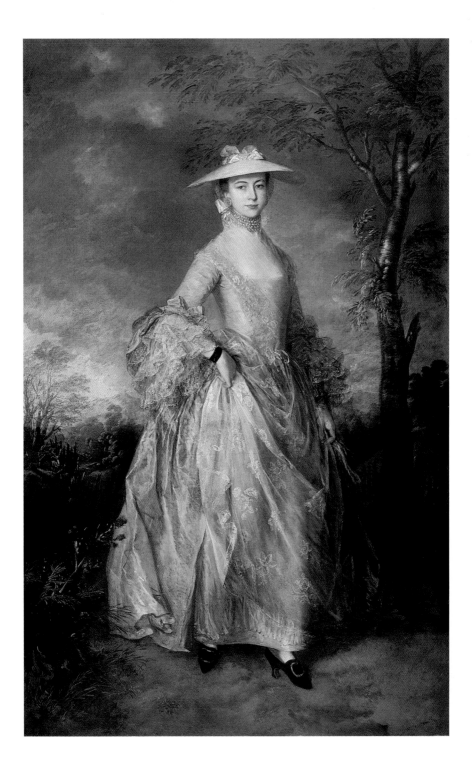

that emerged in France at the end of the reign of Louis XIV (r. 1643–1715) and that was soon to conquer all of Europe. Like most artists of his and the preceding generation (such as the great Venetian painter Giovanni Battista Tiepolo, 1692–1770), Gainsborough was profoundly affected by the Rococo. He felt a particular debt to the earliest and most innovative painter of the movement, Antoine Watteau (1684–1721). Following in the footsteps of this master of wistful scenes of gallantry and make-believe, he developed an art with a poignancy and sensibility of its own.

It is often thought that such art, while appealing, is somewhat superficial. It is the painting of effect rather than of substance. Yet this is not altogether true. As Svetlana Alpers and Michael Baxandall have recently established in their study of Tiepolo (1994), these works can be the products of profound pictorial intelligence. The sense of transience and the momentary so frequently evoked is a telling expression of the mentality of the age in which the artists lived. It had its profound as well as its pleasurable side. Gainsborough was far more than a simple pleasure seeker or giver. While throwing himself into the enjoyment of life 'up to the hilt' (as he was fond of saying), he had a clear knowledge of current scientific and cultural developments and

3. **Antoine Watteau**, *Pilgrimage to the Isle of Cythera*, 1717. Gainsborough greatly admired the wistful elegance of Watteau, the French painter of the early eighteenth century who had a formative role in the development of the Rococo style. This picture shows couples departing to a fabled island of delight.

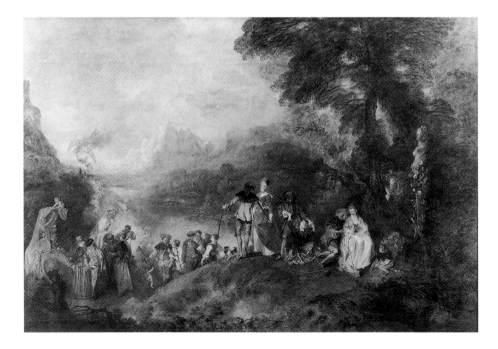

thought seriously about his art. He was also deeply religious and sensitive to the problems and miseries of his times. He frequently responded to these with consideration and compassion. Such qualities make themselves felt, I would argue, in the best of his pictures as well.

Like most artists in Britain at the time, Gainsborough was thoroughly commercial. He painted principally for money, in order to live. This is why he made so many portraits. They were the most lucrative form of art at the time, the only sort of picture many people ever bought. This was not simply a matter of vanity. Portraiture was a very serious business in the individualistic and entrepreneurial world of eighteenth-century Britain. It proclaimed status, marked out power relations. These were crucial matters in a society that was experiencing unprecedented social mobility, but for which hierarchy was still of critical importance. Portraiture also had its intellectual side. It was seen as a serious site for the penetrating observation of character, for revealing what the poet Alexander Pope called the 'ruling passion' in a person. Gainsborough was legendary for the acuity of his likenesses and held to be a uniquely perceptive recorder of personality.

Gainsborough was a businessman who also claimed to be an unworldly creative individual, a 'genius' no less. This paradoxical position was one that he shared with many other artists and entrepreneurs of his age; for example, John Wood, the property speculator who made a fortune from building in Bath, while aspiring to restore the city as the mystical centre he believed it to have been in the days of the Ancient Britons. Such contrasts – interpreted by Marxist historians as a sign of the innately contradictory position of early capitalism – are one of the energizing forces of the age. In Gainsborough's case, spiritual yearning was focused on rural scenery. This was the 'nature' to be set against the society explored and exploited in his portrait practice. It was his first love, his refuge and escape. In his early years he painted it with unprecedented directness and freshness. Later on he developed a more deliberately poetic treatment. Less lucrative than portraiture, it represented a purer aesthetic ambition for him. Nowadays his landscape painting tends to be less popular than his portraits, though it is greatly revered by connoisseurs and intensively analysed by academics. It was, however, a side of his art that deeply impressed his contemporaries as a sign of his profound creative genius. It also became a powerful inspiration to the later generation, including Constable and Turner, who developed landscape in Britain into

4

a major genre. Constable, a particularly strong admirer, read the moods of Gainsborough's landscapes in terms of the artist's compassionate personality. Viewing one of these, a picture at Petworth House, he wrote: 'The stillness of noon, the depths of twilight, and the dews and pearls of the morning, are all to be found on the canvases of this most benevolent and kind-hearted man. On looking at them, we find tears in our eyes, and know not what brings them.'

It was for similar reasons that he was respected for his 'fancy pictures' – figurative scenes of country children and rustic lovers that we now see as sentimental or even uneasily prurient, but which were widely admired as his most original creations, full of

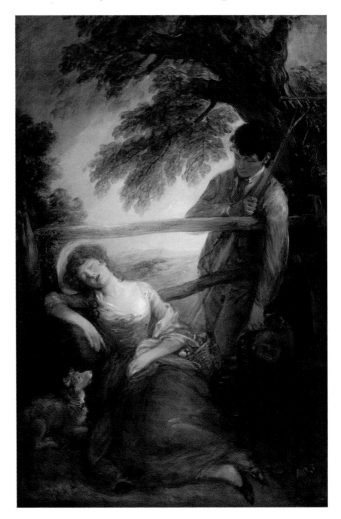

4. **Thomas Gainsborough**, *Mr and Mrs Andrews* (detail), *c.* 1750. Landscape painting was Gainsborough's first love. In this background to one of his early portraits (see plate 44) he depicts a view near his native Sudbury with unprecedented freshness.

5. **Thomas Gainsborough**, *Haymaker and Sleeping Girl*, late 1780s. A 'fancy piece' from the artist's later years. In contrast to the directness of his early views, he now depicts nature in a broader and more nostalgic manner.

natural feeling. Yet if we find it hard to share the admiration for these – despite acknowledging the supreme technical skill evident in many of them – we can find it easier to appreciate the other aspect of Gainsborough's work that seemed to contemporaries to mark out his genius. This was his drawings. Gainsborough was a natural draughtsman of great verve and facility. Whether he is making a direct study of some natural form – such as a tree or a cat relaxing – or mapping out a spirited imaginative composition, he amazes and delights us with the brilliance of his line and the aptness of his markings. He, himself, saw this as the most personal and intimate side of his art. It was a sign of this that he would never sell his drawings, and only gave them to friends as tokens of affection. He was also insistent that it was the individualism of his handling – whether in painting or drawing – that made his 'genius' most evident.

172

7

Such attitudes emphasize how much Gainsborough was a figure of his age. Whatever his innate talent (and it must have been considerable), it was his environment that stimulated him to develop his art as he did. From this point of view, he was lucky to have come to maturity at a time when promotion of artistic practice in Britain was experiencing an upturn, after centuries of neglect. When he came to study in London, from his native Suffolk town of Sudbury, in 1740, at the age of thirteen, he entered a community rich with possibilities. Only a few years earlier Hogarth had become the first British artist to gain an international reputation with his satirical moral progresses. He proved conclusively that the assumption that his countrymen had no talent in this area was false. Hogarth was part of a lively group of practitioners who taught at the St Martin's Lane Academy, where Gainsborough studied. Gainsborough remained an integral part of the British art scene as it developed, and his own work moved forward with it. He benefited from the great increase in the interest in the arts among those gaining financially from the prodigious development of Britain as a commercial and trading nation during this period. For a time it seemed as though Britain's rise to eminence as a political and economic power would lead to comparable cultural supremacy.

Gainsborough was perhaps less lucky in the latter part of his career in being caught up in the high-minded debates about art that surrounded the founding of the Royal Academy of Arts in London in 1768. The free-booting world of Hogarth gave way before the politer one of Sir Joshua Reynolds (1723–92), the Academy's first president. Through the new institution,

6. **Thomas Gainsborough,**
Study of Willows, early to mid-1730s.
Gainsborough was a dextrous draughtsman.

7. **Thomas Gainsborough**,
Study for Diana and Actaeon, *c.* 1784.
Compositional sketch for one of the
artist's late unfinished works
(see plate 165).

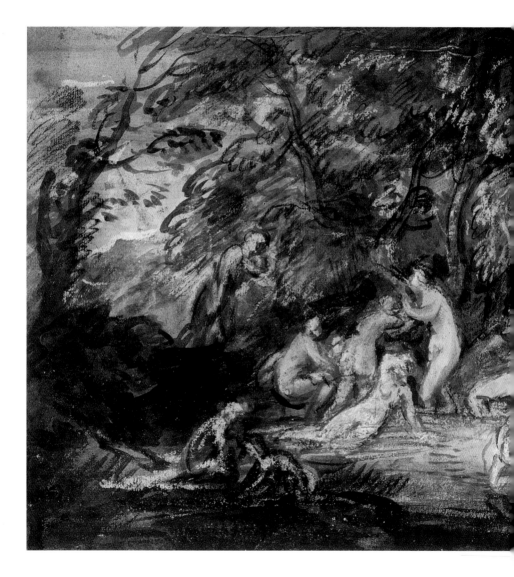

a form of public control was introduced without appropriate state support being offered to make such a system work properly. Here, a familiar British pattern can be seen – that of the governmental quango, in which control is handed to a few well-connected individuals who operate amateurishly and often ineptly, frequently threatening a thriving indigenous and independent practice. Something of an outsider, Gainsborough acted shrewdly in this complex and challenging position; but the outcome was not always to the advantage of his art.

We are lucky to have Gainsborough's work still with us. It is both a delight in itself and a crucial record of the sensibilities that prevailed in British culture in the latter part of the eighteenth century, a key period in the history of the country when it was rising to become a leading European power and beginning to be admired throughout Europe for what was (perhaps misguidedly) thought to be its liberal and progressive culture. Gainsborough – despite his personal conservative tendencies – was part of this stream of innovation. However, he was someone who was borne along by it, rather than being an initiator. A modest man, he did not trust his own powers until they began to be evident to those around him. His rise to prominence was slow and during this rise he moved through several of the multifarious layers of the art practice of the period. This adds an interest for us. For we can find in him the jobbing provincial painter as well as the society portraitist he became after his move from his native Suffolk to Bath in 1759. At all stages of his career, furthermore, he produced works of outstanding and unusual quality – pictures that were as different from each other as the circumstances in which he operated. He was as changeable as a chameleon, but unlike a chameleon, his changes tended to make him more rather than less visible. The history of that visibility will form the subject of this book.

Chapter 1: Origins

8. **Thomas Gainsborough,**
Portrait of Mrs Philip Dupont,
c. 1777–79. Sarah, one of the
artist's milliner sisters, lived
most of her life in Sudbury.
Her son Gainsborough Dupont
became Gainsborough's only
studio assistant.

9. **Thomas Gainsborough,**
Miss Susanna Gardiner,
c. 1755–59. A charming portrait
of one of Gainsborough's nieces.
The simple half-length, viewed
through an oval opening, was a
typical form of modest portraiture
at the time.

Gainsborough is sometimes spoken of as a country lad, but this is not quite the case. He was born in the small but prosperous market town of Sudbury in Suffolk. Like many others in that community, his family dealt in cloth. No one could look less like a country lad than the dapper youth in the picture now believed by many to be a precocious early self-portrait, painted in the late 1730s when he was about twelve. The painter of this work shows himself neatly coiffeured in a smart suit with a waistcoat modishly unbuttoned in the centre. He is holding brush and palette in true professional manner, already bent on an urban career.

It is true that Gainsborough, who early on had a love of landscape, could reach the country within minutes from his family home. But much the same could have been said of most town dwellers in the eighteenth century, when urban settlements were so much smaller than they are now. An equally important formative experience probably came from his early contact with fabrics and costumes. His father was a wool handler and two of his older sisters, Mary and Sarah, became milliners, one already practising while he was still a child. Gainsborough paints the costumes of his sitters (particularly the women) attentively and with evident sensuous pleasure. Many grand portraitists of the day – notably his rival Reynolds – regarded drapery painting as a superficial matter and would frequently hire others to do this part of their portraits. Not so Gainsborough. Shimmering silks and rich brocades, diaphanous muslin, deep folding woollen cloths were invariably treated solely by him or (in later years) with the help of one trusted assistant. He also maintained a close connection with such materials throughout his career. When he was at Bath, his sister Mary Gibbon ran a milliner's business from the building where he also had his studio. It has often been speculated that many of the fine fabrics in the portraits of that period were from her shop.

Gainsborough came from a large family. Born in the spring of 1727 (he was baptized on 14 May), he was the youngest of ten children. His mother, Mary Burrough, was from a local family.

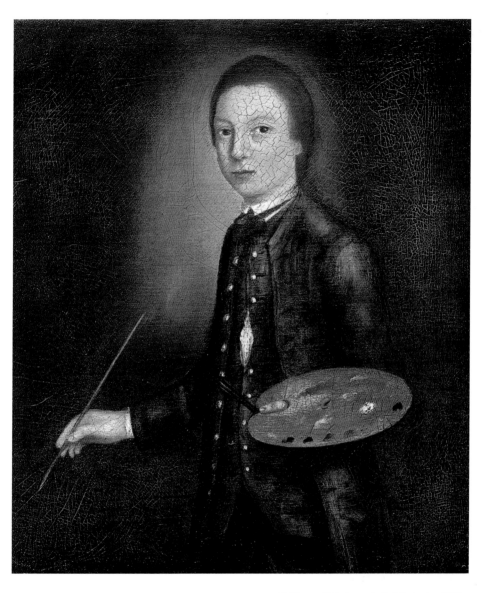

10. **Thomas Gainsborough**, *Self-Portrait*, *c.* 1739.
This picture is now widely accepted as a precocious
self-portrait by the artist when he was about twelve
years old.

Her brother was a clergyman and the teacher at Sudbury Grammar School, which Gainsborough attended. Like so many people from a trading background, the family had a strong dissenting element in it. Many members of his family moved into Methodism as this movement emerged. He, himself, was a regular chapel-goer, and respecter of the Sabbath. 'I generally view my works of a Sunday,' he once remarked, adding, 'tho: I never touch.'

It might seem strange that a society portrait painter should belong to a sect that severely disapproved of luxury and high living. However, it must be remembered that Gainsborough never saw himself first and foremost as a portraitist. His taste for landscape fitted better with his religious persuasion. For Methodism was a religion of emotion and 'natural' sentiment, the elements that dominate his later art. His faith probably helped him resolve some of the contradictions of his situation. It was, after all, common enough for those who served the high born and wealthy to use Methodism as a means of maintaining independence of thought and dignity while in a humble position. Gainsborough's own milliner sister, Mary, whom he turned to often as a confidante, was also the wife of a Methodist minister. It was the religion of endurance, not of revolt.

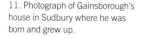

11. Photograph of Gainsborough's house in Sudbury where he was born and grew up.

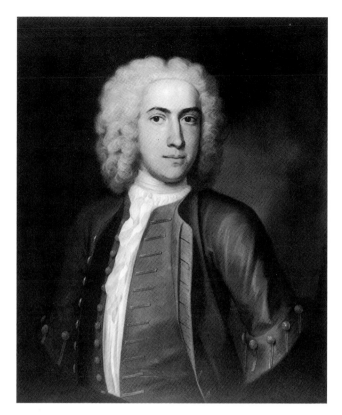

12. John Theodor Heins, *Portrait of John Gainsborough*, 1731. The artist's successful businessman cousin who helped the family when it fell on hard times. The painter was a German artist practising in Norwich.

Gainsborough was brought up in a substantial house which is now a museum dedicated to his work. The scale of this building is somewhat deceptive, for times were not easy. His father, John, was a troubled man whose business failed in the 1730s. In 1733 he became the local postmaster. This collapse of his father's fortunes might, in a way, have been behind the decision to send Gainsborough to London in 1740 to train as an engraver – there was no family business for him to go into. The family was only able to continue living in their house because of the generosity of a more prosperous nephew. This John Gainsborough, as befitted his status, had his portrait – and others of his family – painted by the Norwich-based German artist John Theodor Heins (1697–1756) in around 1731. It was probably one of the earliest pictures Gainsborough would have known and may have been an encouragement to him in his choice of career. Its sober, rather stilted style has some affinity with that of the self-portrait the precocious young artist did a few years later.

13

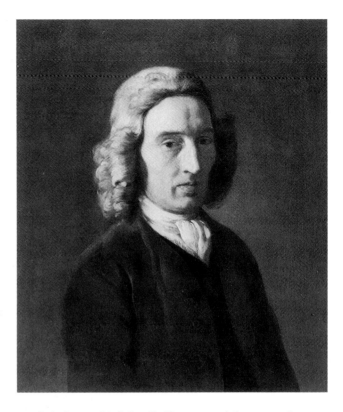

13. **Thomas Gainsborough,** *Portrait of John Gainsborough,* c. 1746–48. Gainsborough's father, whose business failed in the early 1730s, was a troubled and saturnine man. This portrait was painted near the end of his life.

Gainsborough's father died in 1748, and there are only a couple of early portraits of him by the artist. These show a saturnine man, who seemed drawn in on himself. He was widely regarded as a dark horse and reputedly kept a firearm about him. We shall probably never know if this is more than a romantic fiction, but it is certainly true that there was a strange strain running through this branch of the Gainsborough family.

The most striking case of this eccentricity was Gainsborough's eldest brother, also John (1711–85). Known as 'scheming Jack', he was constantly making inventions of little practical use, such as a self-rocking cradle and a cuckoo clock that sang all day. Typically, he advertised his business with an eccentrically shaped shop sign. He was also a 'longitude maniac' – one of many in the eighteenth century who devoted their time to trying to find a reliable way of calculating longitudinal positions. This was a matter of prime importance for the safe navigation of ships, and the government offered a prize of £20,000 for a solution. Eventually, after much acrimony, the prize was won by the clockmaker John Harrison. But prior to

14. **Thomas Gainsborough,** *Portrait of John Gainsborough ('Scheming Jack'), c.* 1770–74. Gainsborough's eccentric elder brother, known as 'scheming Jack', was forever involved in hare-brained ventures. Amongst his many bizarre inventions was a self-rocking cradle.

15. Scheming Jack's shop sign, 1761. Typically, 'scheming Jack' chose an unconventional shape for his sign.

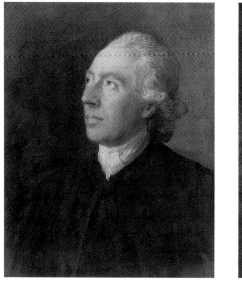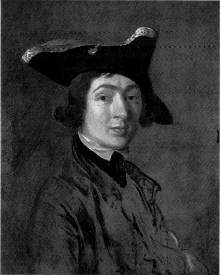

this the country was infested with often unhinged adventurers devising all manner of schemes. Gainsborough's friend and first biographer Philip Thicknesse paints a sad picture of 'scheming Jack' at the end of his life, living in straightened circumstances with his wife and family, still desperately trying to build his inventions and touching all who came to visit for some money to buy more brass for his latest contraption.

Gainsborough himself was touched by eccentricity, and was much given to quirky utterances. 'I am so childish that I could make a Kite, catch Gold Finches, or build little ships', he wrote to a friend near the end of his life. He doubtless saw this strangeness as part of his cachet as a 'genius'. Yet he also had a price to pay, for his own daughters developed a similar eccentricity in adult life, one to the point of derangement. In his later years their predicament caused him much grief.

If Gainsborough's father and 'scheming Jack' were somewhat embarrassing figures, the artist could look with more calmness on other members of his family. He was closest to his brother Humphrey (1718–76) who became a Methodist minister. As well as being a man of uplifting sentiments – as the artist's upward looking image of his brother suggests – Humphrey was an ingenious man in a far more productive way than 'scheming Jack'. In an age of rapid agricultural advance, he devised a drill plough and a tide mill, both of which were awarded premiums by the Society of Arts and Manufactures. Equally topical were

the modifications that he made to improve the performance of the steam engine; modifications that were adopted (some say usurped) by its inventor, James Watt. Gainsborough – like his brother, a man of practical intelligence rather than bookish learning – applauded his brother's endeavours and did what he could to gain recognition for them.

He turned to his devout sisters for support throughout his life. Indeed, he remained remarkably close to his family even when settled as a fashionable painter in London. It is typical of this closeness that the one studio assistant he ever had was his nephew Gainsborough Dupont, son of one of his milliner sisters and a Sudbury man himself.

Gainsborough's own character was paradoxical. The quizzical expression on one of his frankest self-portraits (tellingly unfinished) suggests a struggle within him between the respectability he so admired in his brother Humphrey and his devout sisters, and the manic tendency that so bedevilled poor 'scheming Jack', and seems to have troubled his father and his daughters, too. It also suggests that strange mixture of daring and diffidence that runs through his career. He certainly had a positive personality, was charming and a witty talker. But he seems also to have been modest and often unconfident. He could be guided by obsessions – such as his passion for musical instruments of all kinds that his friend the musician William Jackson satirized. He also had a penchant for the ladies, was 'deeply schooled in petticoats' as he put it – in a telling linking of dress and the erotic. Such enthusiasms perhaps explain his ability to make daring professional moves at times – as when he took the decision to move from his secure practice in Bath to chance his reputation in London. He seems, in fact, to have encouraged himself in intuitive and impulsive behaviour, despite the dangers. Perhaps he felt that this was the only way his genius could be allowed to flourish. This may also explain why he was so devout. Religion encompasses vice as well as virtue. It condemns wickedness, but sanctions forgiveness. At heart he was a good old-fashioned sinner, acknowledging his weaknesses and hoping always to be saved, along with all the rest of us miserable mortals. Sinning gave his art its spark.

Chapter 2: Learning the Business

In 1740, at the age of thirteen, Gainsborough was sent to London by his father to receive a training. According to some early records, he was first 'under the care' of a silversmith. However, it appears to have been the engraver Hubert François Gravelot (1699–1773) who gave him his principal instruction. This may not have been a formal apprenticeship. By the 1740s guild control of artistic practice in London was weak, and it was no longer necessary to be a master of craft to engage in business. Engraving was a more lowly profession than painting, but it was also a more secure one. Perhaps John Gainsborough's financial difficulties played a part in making the less prestigious but safer choice. Modest family circumstances certainly caused a number of other eighteenth-century artists to begin their careers as engravers – Hogarth and William Blake (1757–1827) being two of the most notable examples.

Gainsborough mastered printmaking, and practised it from time to time throughout his life. He also learned much else with Gravelot, who as well as being an engraver was a painter and designer, and a leading figure in the promotion of contemporary French taste in London at the time. Arriving in 1732, he had previously been a pupil of the leading Rococo painter François Boucher (1703–70). A brilliant draughtsman, he made his mark from the start. The engraver George Vertue (1684–1756) prophesied that he would 'furnish this Nation with many things … of a much better taste.'

Despite its foreign origins, the Rococo was in many ways the principal stimulus for the development of a modern indigenous art in Britain. Light, fresh and witty, it seemed to cock a snook at the grandiose Baroque that had preceded it. In its native France it had been the means of subverting the pomposity of the court of Louis XIV. It became associated with luxury and decadence, although it also had a sober side. The age of Boucher was also the age of Jean-Baptiste-Siméon Chardin (1699–1779), of modest moralities, deft but unpretentious still lives – simple but intelligent painting of things as they are. In Britain it was adapted by Hogarth and others to form the basis of a new art of modern life.

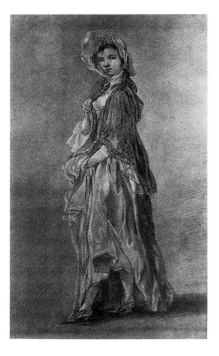

18. **Thomas Gainsborough,** *Study of Young Girl Walking,* late 1740s. A drawing from Gainsborough's first years in London, which shows the influence of his master Gravelot.

19. **Hubert François Gravelot,** *A Young Lady Seated in a Chair, Turned to the Left, c.* 1744. A pupil of the leading French Rococo painter François Boucher, Gravelot came to England in 1732. His brilliant draughtsmanship secured him instant success, particularly in book illustration. He instructed Gainsborough in the early 1740s, returning to his native country in 1746.

Like Gravelot, Gainsborough had a natural gift for drawing. He seems to have picked up from his master the flowing manner that became the basis of his art. Comparison of chalk studies of women made by both of them around this time shows a similar use of lively, broken lines, a comparable sensibility in the handling of light and shade. It also shows differences. Even at this early stage, Gainsborough seems to pay more attention to fabrics, to the turns of ribbons and the contrast in texture between a girl's shawl and her dress beneath. Gravelot is more concerned with the overall disposition of the figure. Properly trained at the French Academy in Paris, he was a master of form. Gainsborough is still uncertain about bodies. The stance is awkward, the head does not fit. Gravelot's lady has a well-drawn hand making a confident gesture. Gainsborough's girl bunches one hand up and hides the other in her skirts – to avoid, one suspects, a difficulty. The basis of this uncertainty was probably lack of experience in drawing the figure. Gainsborough did, it is true, attend the academy in St Martin's Lane, where Gravelot was an instructor. However, this hardly offered the rigorous training available to students in France. The academy was held in the evening, after normal hours of work. It was a free, self-help association without any formal tuition.

Gravelot inv.
The Words by Mr. Lockman.

G. Bickham jun. sc.
The Musick by Mr. Gladwin.

The Invitation to Mira,

REQUESTING

Her Company to Vaux Hall Garden.

To the Right Hon.ble the Lady FRANCES SEYMOUR, these four Plates are humbly Inscrib'd.

Affettuoso.

Come, Mira, Idol of ye Swains (So green ye Sprays, the Sky so fine) To Bow'rs where

heav'n-born Flora reigns, & Handel warbles Airs divine, & Handel war........bles Airs divine.

Come, ev'ry sprightlier Joy to taste,
That rural Art & Nature boast:
Fly thither with ye Lightning's haste,
And be ye universal Toast.

A Scene so beauteous can't be shown,
Tho' thou shouldst ev'ry Realm survey;
As all, where'er thou com'st must own:
Thy Graces claim the highest Sway.

For the Flute.

According to Act of Parliat. 1st June 1738.

20. **George Bickham**, *The Invitation to Mira*, from *The Musical Entertainer*, 1737–38. A publication of one of the songs sung at Vauxhall Gardens in London, a leading place of entertainment at the time. The engraving shows the celebrated statue of Handel that had been created for the gardens by the sculptor Louis-François Roubiliac.

Yet the St Martin's Lane Academy was important for bringing Gainsborough into contact with a brilliant group of British and foreign artists. Run by Hogarth – who had acquired it from his father-in-law James Thornhill – it promoted a lively modern style. One of the main projects undertaken by members of the academy was the decoration of the celebrated pleasure grounds, Vauxhall Gardens. In the 1730s and early 1740s the proprietor, Jonathan Tyers, was employing artists to transform this venue from a somewhat disreputable place for questionable encounters into a site for polite entertainment, where performances of works by leading composers such as Handel and Arne could be enjoyed. The sculptor Louis-François Roubiliac (1705–62) provided a celebrated sculpture of Handel as the modern Apollo – shown on many of the programmes of performances, while Hogarth and others provided decorative panels of historical and pastoral scenes to adorn the supper boxes. Gainsborough was particularly close to one member of this group, Francis Hayman (1708–76), who specialized in genre and historical scenes, and is reputed to have assisted him in completing one of the supper-box decorations for the scheme *Children Building Houses with Cards* (*c.* 1743). While an imaginary scene, this picture shows a 'conversation'; the kind of informal grouping of people in social surroundings that had become popular in portraiture. Gainsborough was to produce many of these in his early years.

21. **Francis Hayman**, *Children Building Houses with Cards*, c. 1743. Hayman was employed to paint several decorative panels for supper-boxes at Vauxhall Gardens, London. Gainsborough is reputed to have assisted Hayman in completing this one. He also provided landscape backgrounds for some of Hayman's portraits.

Gainsborough's first clearly datable picture is a portrait of a dog in a landscape. *Bumper, a most sagacious cur* (as the inscription on the back of the canvas puts it) was painted in 1745, when his training was drawing to a close. The format of the picture is a conventional one, but it shows that rare feeling for landscape mood that distinguished the artist's work from the start. It also suggests, from the attentive and individualized expression on the dog's face, his gift for capturing likenesses for which he was also famed. Gainsborough had a strong sympathy for animals and painted many remarkable dog portraits in his career. The portrait of Bumper also shows how fully Gainsborough had absorbed the British painting technique of the times. This is unlike Gravelot's method, in which the paint is built up meticulously in several layers as was common on the continent. Like Hogarth and Hayman, Gainsborough painted 'wet on wet', working his colours together, mostly in a single layer. It was a more rapid and spontaneous method, born perhaps of the economic need to produce pictures quickly, but leading to its own

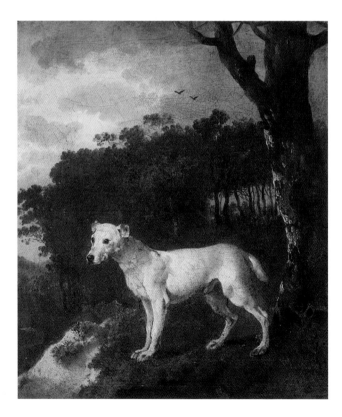

22. **Thomas Gainsborough**, *Bumper*, 1745. Gainsborough's earliest surviving dated painting. He had a particular fondness for dogs and always painted them with an attention to character.

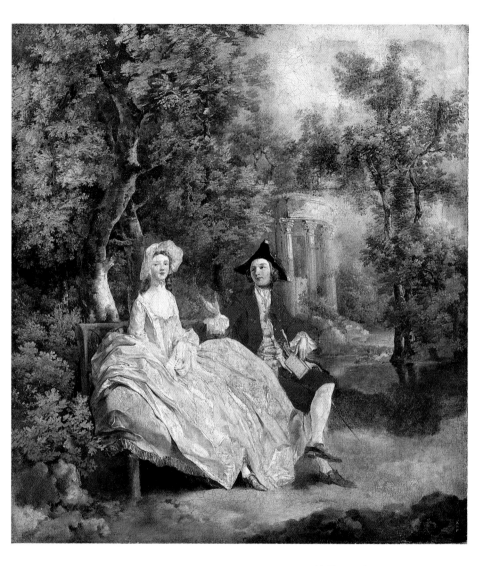

23. **Thomas Gainsborough**,
Conversation in a Park, c. 1746–47.
It is sometimes supposed that this is a
portrait of Gainsborough and his wife
at the time of their marriage in 1746.
However, the features are not particularly
close. The mood of the work is unusually
gallant for Gainsborough, possibly
suggesting an element of satire.

kind of virtuosity and brilliance of effect. Even at this early stage in his career Gainsborough was practising the method in his own way. He mixed his colours with more ground glass and other transparent substances than was normal. This resulted in his surfaces having a particular kind of luminosity.

By 1744 Gainsborough had his own studio. Two years later he was conducting business from his lodgings at 67 Hatton Gardens. This was somewhat to the east of the normal artistic community. It would have been a particularly unusual choice for a portrait painter, since location was all-important for attracting clients. Maybe this is a sign that he was hoping to succeed largely in landscape. He was certainly prized for such work by his fellow painters. There are records of Hayman employing him to provide landscape backgrounds for his own portraits. The unusual choice of location may also have been related to the other major event in his life in 1746, his marriage to Margaret Burr in July. There seems to have been some haste about the marriage, perhaps because Margaret was already pregnant. It took place at Dr Keith's Mayfair Chapel, a place notorious for clandestine marriages. There might have been other reasons, however, for the secrecy. Margaret, a 'pretty Scots girl', according to Gainsborough's friend Thicknesse, was the illegitimate child of a high-born person. This appears to have been Henry, 3rd Duke of Beaufort, who settled £200 a year on her for life. Such a sum – equivalent to approximately £20,000 today – must have made a huge difference to a young impecunious artist starting on a risky career. One is tempted to accuse Gainsborough of gold digging, yet there does seem to have been a genuine affection between the two.

It may be that a conversation group of this period, showing a young woman in a pink dress being courted by a gesticulating man in a red suit, represents the artist and his new wife. The figure of the man is drawn with unusual confidence – so much so that some have suggested he might have had help with it from a more established master. It is not his happiest work. The mood of gallantry seems so forced as to be almost satirical.

Some time early in 1749, Gainsborough returned to Sudbury. This seems a retrospective step and would suggest that he had failed at that point to build up a viable clientele in London. One early account records his frustration at being unable to sell the landscapes he was then painting. There may have been personal reasons behind the move as well. The Gainsboroughs' first child, Margaret, had died in infancy and been buried at

St Andrews, Holborn on 1 March 1748. Mrs Gainsborough may have wished to have subsequent children born and brought up in the healthier environment of Suffolk. As she was financially the stronger partner at that time, she may well have had the upper hand in such decisions. In any case, Mary, their first surviving child, was born in Sudbury in February 1750.

Gainsborough had opted for a provincial career. However, there is one sign that he still wished to be remembered in the metropolis. In May 1748 he had painted a view of *The Charterhouse* for the recently established Foundling Hospital. The hospital was a fashionable place for ambitious artists to donate works

25

24. **William Hogarth**, *Captain Thomas Coram*, 1740. Like most young artists in London in the 1740s, Gainsborough was deeply impressed by Hogarth's work. In this portrait of the old sea captain who set up the Foundling Hospital in London, the artist has given a new and earthy vigour to the tradition of grand portraiture. Gainsborough used Hogarth as a model for infusing liveliness and modernity into his own work, while avoiding the sense of the burlesque to be found in the work of the great satirist.

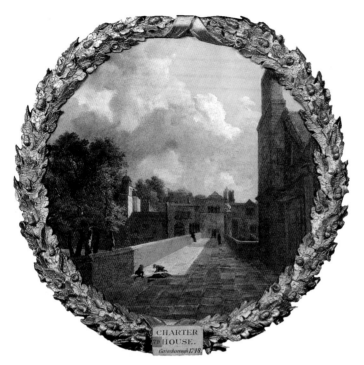

25. **Thomas Gainsborough,**
The Charterhouse, 1748.
Gainsborough was invited
to contribute this view of a
charitable institution to the
Foundling Hospital in London;
a signal honour for a young
artist. This suggests that he
was particularly valued for his
painting of landscape and
scenery at the time.

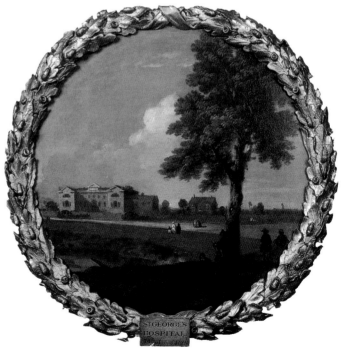

26. **Richard Wilson,**
St George's Hospital, c. 1746–50.
Wilson was the rising star of
landscape painting at this time.
His contribution to the Foundling
Hospital, London, is composed
in the classical manner, while
Gainsborough's work (see
plate 25) concentrates more
on the atmospheric effects to
be found in Dutch art.

during the 1740s and 1750s. Hogarth had set the pace with his magnificent portrait of the founder, Captain Coram, and had been followed by other leading portrait and history painters, such as Allan Ramsay (1713–84), Thomas Hudson (1701–79) and Hayman. The hospital was visited regularly by people in society and the collection of pictures formed a public gallery of modern British art for them to inspect. Gainsborough's contribution was part of a series of views of charitable institutions in London. Modest roundels, they were interspersed in the hospital's Governors' Court Room between the grander historical scenes. It has been suggested that this choice of topographical views may have been made to demonstrate that British painters were able to master this genre. The celebrated Venetian view painter Antonio Canaletto (1697–1768) was active in London at that time, and local artists keenly felt the competition. If this is the case it must have been a signal honour that the twenty-one-year-old Gainsborough should have been selected to join a group of well-established artists, mostly a generation older. The resultant work is a delightful example of his powers, but he seems to have been keener to show his prowess in perspective and the handling of light and shade than to give an informative view of the building he is depicting. For the latter is cast in deep shadow from a sun shining behind the large silhouetted tower on the right side of the picture. Unlike the other roundels in the series, Gainsborough's picture is painted on a red ground, which gives a particular richness to the tones. It contrasts with the lighter, calmly ordered view of *St George's Hospital* contributed by the other young rising landscape talent of the day, Richard Wilson (1714–82). Wilson was later to become the leading figure in the introduction of classical landscape painting into Britain, and Gainsborough was held to be the first to encapsulate the beauties of local scenery. In these two roundels their future rivalry, perhaps not intimated by them at the time, can already be perceived.

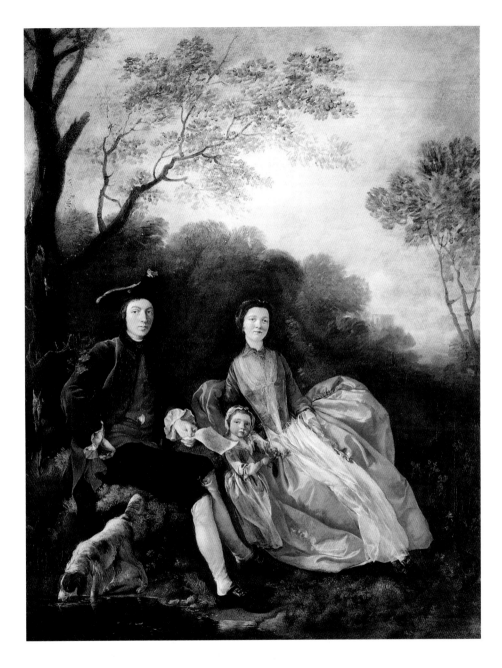

27. **Thomas Gainsborough**, *Portrait of the Artist with Wife and Daughter, c.* 1748.
A 'conversation' of Gainsborough and his wife in the early years of their marriage.
It is possible that the image of the child is a posthumous portrait of their first born,
who died in 1748. This would account for the sitters' sombre expressions and the
subdued mood of the subtly painted landscape.

Chapter 3: The Suffolk Practice

When Gainsborough returned to Suffolk early in 1749, he was a young man of twenty-two who had completed an apprenticeship in London and had had a modest practice there. He was going back to his native town, like so many others who trained in London, to set up a local business, drawing on family friends and old acquaintances as a basis for his clientele. Eleven years later, when he left to settle in Bath, he was a rising star with his sights set on fame and fortune. The years between had seen a turn around in the artist's practice and thinking. Gradually, it would seem, he became aware of his powers and began to seek outlets for them beyond the confines of his native county.

Until 1752 he stayed in Sudbury. These were times of family changes, both sad and happy. He came with the recent memory of a child lost. One of the last works painted before he left London appears to have been the conversation group of him and his wife with their dead infant daughter wedged between them, in the folds of Mrs Gainsborough's billowing sack dress. Nothing could be further in mood from the gallantry of the earlier *Conversation in a Park* (*c.* 1746–47) than this sombre work. 23 While the deceased child eyes us quizzically, the father stares out sadly and the mother gazes abstractedly into the distance. Behind, the landscape is chilly and autumnal. In October 1748 Gainsborough's father died. He rarely spoke of his father, though he was on his mind sufficiently to make a drawing of him from memory three years after his death. Even more surprisingly, he rarely mentioned his mother and does not seem to have painted her portrait, although she survived until 1755. Perhaps the fact that he was the youngest of ten children meant that he was rather distant from his parents and related more to his brothers and sisters. On the happier side, his wife gave birth to two daughters, Mary in 1750 and Margaret in 1752. Gainsborough was to paint them many times in the following fifteen years while they were growing up, when they were still full of promise and showed no signs of the affliction that was to mar their adult years.

With a growing family to support, Gainsborough worked hard to establish his reputation both as a landscapist and portraitist. It would seem that he may well have celebrated his return by producing the work now known as *Cornard Wood*. While painted in what Gainsborough later called his 'schoolboy stile', it is a *tour de force* on a sizeable scale and would have had a particular impact in Sudbury where the scene of the local woodland would have been well known. He may have felt encouraged to depict this view by the success of his recent painting of *Charterhouse* for the Foundling Hospital in London. Although the artist was later to disdain topography, he was not averse to commissions for such work at this time.

In portraiture, Gainsborough worked on a small scale, doubtless because this was all his current clients would pay for. His standard work was simple heads and half-lengths like the remarkably frank, though sympathetic, portrait of the aged mother of a friend, Mrs John Kirby. But he also painted a number of small conversations, in which he could turn his knowledge of

38

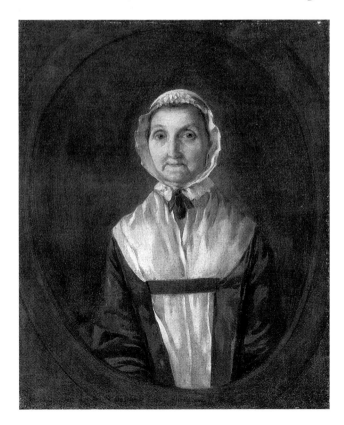

28. **Thomas Gainsborough,**
Mrs John Kirby, c. 1748.
The mother of Gainsborough's close friend Joshua Kirby.
This is a good example of the straightforward yet sympathetic half-length portrait that formed such a large part of the artist's practice in his early years.

London fashions to advantage. Although going out of fashion in the metropolis, the conversation portrait still seemed stylish in the provinces. It was at this time that he painted the remarkable conversation of *Mr and Mrs Andrews*. Like *Cornard Wood*, 44 this picture conveys a unique sensibility in which local and cosmopolitan perceptions are intriguingly combined. They are the masterpieces of his Sudbury practice.

Towards the end of 1752 Gainsborough moved to Ipswich, where he rented a fine house in the centre of town. He was to remain there for seven years, until he removed to Bath. Quite why he moved at that point is not known. It may well be that the birth of a second child earlier in the year had convinced him of the economic need to expand his practice. There are signs that he was experiencing some financial difficulties at this time, though these continued after his move. Ipswich was a larger and more substantial town than Sudbury. It had a port which did a thriving and growing trade in Suffolk agricultural produce with London and elsewhere. It had a local garrison at Landguard Fort, and the officers mingled with local gentry to form a stylish social scene. It was while in Ipswich that Gainsborough first began to receive commissions from the aristocracy. He was undoubtedly helped in this by his friendship with a key figure in this world, the town clerk Samuel Kilderbee, who he painted as a jaunty gentleman, 30 commandingly set against a moody landscape and admired, in traditional manner, by a respectful dog. Such a friendship might seem opportunistic, but it was genuine for all that. Years later in the 1780s, when Gainsborough would have had no professional use for an Ipswich functionary, they remained close enough to make a trip to the Lake District together. Despite this, there were limits to his practice. He was never able to charge more than 8 guineas for a head and 15 gns for a half-length at this time. This compares with the 12 and 24 gns, respectively, being charged in London by leading portraitists of the time such as Reynolds and Hudson. By the late 1750s he was also receiving one or two commissions for full-lengths, notably that of his friend William Wollaston (private collection). However, it was not until he got to Bath that this grander side of his portrait practice really took off, and his prices rose accordingly.

It is at this time that talk of Gainsborough's passion for music first occurs. Doubtless acquired in childhood, this interest now became an important part of his social world. He befriended the local composer Joseph Gibbs and became a member of the Ipswich Music Club. There is mention of a grand conversation of

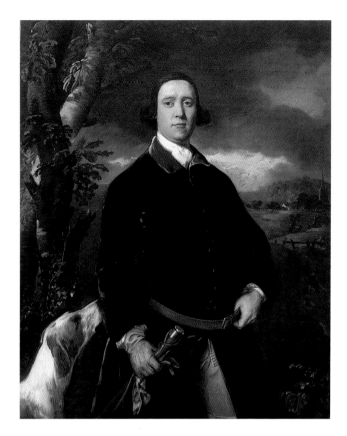

29. **Nathaniel Hone**, *Philip Thicknesse*, 1757. Thicknesse was governor of Landguard Fort just outside Ipswich. He met Gainsborough in the early 1750s and soon became an enthusiastic supporter. Brilliant but quirky, he later fell out with the artist, though he wrote the first biography of him after his death.

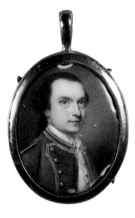

this club by Gainsborough which is now sadly lost. As was typical in eighteenth-century clubs, it would seem that the meetings were as full of drinking and high jinks as of serious music making. Constable, speaking to surviving members in the 1790s, recorded how Gainsborough used to be the butt of jokes and had his wig thrown about the room. As he observed, they did not seem to know who they had amongst them until he had left.

Undoubtedly, this musical connection was good for business. Many of his wealthy clients were amateur musicians. The most important at this time was Thicknesse, the governor of Landguard Fort. Thicknesse, who wrote the first biography of the artist, was a brilliant but quirky man. He was a powerful supporter of the artist and may well have been the leading influence behind his move to Bath. He was as much attracted by the playful side of Gainsborough's character as by his art. It is typical that his account of how he came to know the artist's work was through a trick. While walking with the editor of a local

30. (opposite) **Thomas Gainsborough**, *Samuel Kilderbee*, *c. 1757*. The Town Clerk at Ipswich, Kilderbee was one of the local notables who helped promote Gainsborough's career. They remained good friends for life.

31. (right) **Thomas Gainsborough**, *Tom Peartree*, *c. 1752*. This painting of a local was cunningly set up by Gainsborough on a garden wall where it deceived many into thinking it was a real person leaning over.

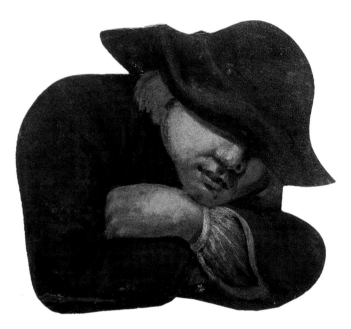

paper in a field belonging to the latter, Thicknesse was struck by a 'melancholy faced countryman' leaning over a garden wall, who seemed to be observing him. Suddenly he realized the figure was a painting, a cunning piece of *trompe-l'oeil*, set up to startle visitors. The perpetrator of this joke, he learned, was one Thomas Gainsborough.

We hear so often of stories of artists achieving fame through the display of such skills that we tend to dismiss them as mythical. In this case, however, 'Tom Peartree' (as the figure became known locally) really does exist. We can see how cleverly Gainsborough has chosen a pose that would be natural for a figure slouching motionless over a wall, how he has contrived to hide the eyes, which might have given away the fact this was a painting more easily, beneath the brim of a hat. Furthermore, the insolent immobility of this yokel would be likely to startle people of social standing who passed it. No one likes being stared at; and being stared at by those thought of as inferiors is particularly irritating. How typical of Gainsborough, too, that his subversiveness here should be of the harmless, humorous kind.

Despite the effect of Tom Peartree, Thicknesse was most impressed by Gainsborough's landscapes when he visited the artist's studio. He commissioned a view of Landguard Fort, and continued to promote this side of his friend's work. Thicknesse claimed later to have been the discoverer of Gainsborough. However, we should recall that Gainsborough was at that time making other important and influential contacts which were to stand him in good stead in the future. On the artistic side, a highly important figure was Joshua Kirby (1716–74). A house and coach painter, he was pious and earnest in character. He was a stalwart figure of the kind that the mercurial Gainsborough found particularly attractive. In this case, the bond was so close that Gainsborough requested, at the end of his life, to be buried near him. Although based in Ipswich, Kirby already had important London contacts. When he published a book on perspective in 1754 he persuaded Hogarth to produce a plate for it. This playfully undermines the illusion on which perspective is based by showing such effects as a man on a distant hill lighting a candle for a woman leaning out of a window in the foreground. Such game playing must have amused the author of *Tom Peartree*, who did himself contribute an illustration to Kirby's book. Later, when he moved to London, Kirby became a tutor to the future George III and may well have helped Gainsborough gain royal patronage.

32. T. Major, after Gainsborough, *Landguard Fort,* 1754. This engraving of Landguard Fort is taken from the painting of the view that Thicknesse commissioned from Gainsborough. At this time in his life Gainsborough was not averse to painting topographical views, but later he refused such commissions.

Kirby would have kept Gainsborough in touch with the London art world. Through him he would have learned how the portrait business was being mastered there by Reynolds, a man returned from Italy full of learning and able to provide the wealthy with grandiose portraits replete with classical allusion, such as the celebrated *Commodore Augustus Keppel* (1753), which outstripped his own capabilities. If anything could have convinced him that London was not the place to go it must have been this. On the other hand, there were signs that Ipswich was beginning to run dry as a place for portrait commissions. Already in 1758, probably at the insistence of Thicknesse, he was in Bath for the season. Doubtless it was the success of this venture that caused him to take the plunge in the autumn of 1759 and move with his family and settle in the fashionable resort.

82

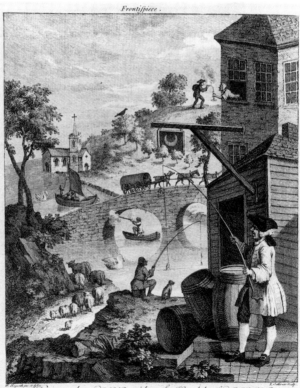

Frontispiece.

33. Thomas Gainsborough, *Joshua Kirby, c.* 1757–58. Kirby was a local painter with London contacts who befriended Gainsborough. He published a book on perspective which included a satirical plate by Hogarth. Later he became a tutor to the future George III. Gainsborough was, at his own request, buried next to Kirby at Kew.

34. William Hogarth, *False Perspective,* frontispiece to Joshua Kirby's *Dr Brook Taylor's Method of Perspective made easy,* 1754. It may seem strange that Kirby should have commissioned Hogarth to contribute this engraving to his book on perspective for in it the rules of perspective are systematically broken.

Whoever makes a DESIGN *without the Knowledge of* PERSPECTIVE *will be liable to such Absurdities as are shewn in this Frontispiece.*

Chapter 4: Places and Pastorals

From the start, Gainsborough thought of himself primarily as a landscape painter. Despite a growing portrait business, he remained highly active in his preferred field. He painted at least two hundred landscapes, more than sixty of which come from the time before he moved to Bath. At the time when he began, landscape painting in Britain was largely dominated by foreign artists, or artists of foreign origin. They were usually Netherlandish – such as John Griffier the Younger (fl. 1738–73), whose family came from Amsterdam, and Peter Tillemans (1684–1734), who was born in Antwerp. Gainsborough was one of a small group of pioneers who established landscape as a British practice.

It is often difficult to tell exactly when particular works by Gainsborough were painted. Only one, the early *Landscape with Peasant Resting* of 1747 is actually dated. However, it is clear enough that the manner in which he worked altered dramatically, moving from detailed, Dutch-inspired scenes in his earliest years to broad and emotively charged evocations of indeterminate terrains. There was greater continuity of subject matter. The scenes can, by and large, be described as belonging to that genre of painting known as 'pastoral'. The term itself comes from a kind of poetry familiar in the West since classical antiquity, in which shepherds and shepherdesses are depicted living lives of simple rural bliss. Pastoral poems were highly popular in the eighteenth century, produced by such writers as Alexander Pope and James Thomson, and were used to contrast an ideal natural life with the artifice of the city. In the early years of the century it was recognized that such evocations had little to do with the description of contemporary rural life. As Pope put it in his *Discourse on Pastoral Poetry* (1709): 'Pastoral is an image of what they call the Golden Age. So that we are not to describe our shepherds as shepherds at this day really are, but as they may be conceived then to have been; when the best of men followed the employement.'

As urbanization grew, however, there was a shift of mood. City dwellers who felt themselves increasingly distant from

rural life began to transfer their dream of the Golden Age into the present day. Mindful of the changes taking place in the countryside that were being brought about by the agrarian revolution – the introduction of new farming methods and the landscaping of great estates – they saw the ideal country life as existing, but being under threat, and sought to preserve and praise it in art and literature. This was the period in which Oliver Goldsmith leapt to fame, with his celebration of simple rural virtues in *The Vicar of Wakefield* (1766) and his bemoaning of their loss in *The Deserted Village* (1770). Gainsborough's own art moves between these polarities. While the subjects of his landscapes remain similar, their mood shifts from one of simple pleasure to that of wistful longing.

Gainsborough's *Landscape with Peasant Resting* comes from the time when he had recently finished his training and was trying to make a living in London. It shows a peasant boy reclining at the side of the road, watched by his dog. Further along the road, neatly bridging the gap between foreground and background, a group of cattle are strolling. In a moment they will be out of sight, further down the road. It is hard to tell if this lad is in fact responsible for the cows disappearing out of his sight, but if he is, he certainly is not showing much concern.

The rolling landscape, clumps of trees and strong lighting effects all show the influence of seventeenth-century Dutch landscape painting. As John Hayes has made clear, Gainsborough modelled his art at this time closely on such work, which was beginning to be collected in London in the 1740s. The artist

35. **Thomas Gainsborough**, *Landscape with Peasant Resting Beside a Winding Track*, 1747. Gainsborough's only dated landscape, it shows the pastoral scenes that he favoured and the strong influence of Dutch seventeenth-century landscape, particularly in the trees and the sky.

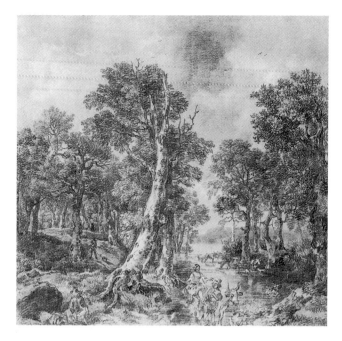

36. **Thomas Gainsborough after Ruisdael**, *La Forêt (The Forest)*, late 1740s. Jacob Ruisdael was the Dutch painter Gainsborough admired most.

often found employment restoring Dutch pictures and even adding figures to them which gave him a close knowledge of their techniques. At the time these painters were valued for their naturalism, which was contrasted to the more idealized landscape paintings of artists working in Italy. Gainsborough emulated this quality, yet he sought to lighten it to convey a sense of the idyllic mood of the pastoral.

One drawing from the period is a copy of a composition by Jacob Ruisdael (1628/9–82). Gainsborough seems to have admired this artist in particular, perhaps because of his mastery of moody atmospherics. Another favourite was Jan Wijnants (fl. 1643–84) whose treatment of plants he emulated. The most important work Gainsborough painted in this 'Ruisdael' mode is his large view of *Cornard Wood*. It was already admired in his lifetime, when it came to be known as *Gainsborough's Forest*. There remains an uncertainty about when it was painted. When the work emerged on the art market in 1788 the artist wrote to the *Morning Herald* explaining its origins. He said the picture 'was actually painted at SUDBURY, in the year 1748: it was begun *before I left school*; – and was the means of my Father's sending me to London.' The problem here is that Gainsborough went to London not in 1748, but in 1740. He was only thirteen then,

37. Jacob Ruisdael,
A Pool Surrounded by Trees, and Two Sportsmen Coursing a Hare,
c. 1665. Ruisdael's moody views of woodland scenes particularly
attracted Gainsborough. The type of land represented is close to
that found in Gainsborough's native Suffolk. Ruisdael's colouring,
however, tends to be darker than Gainsborough's.

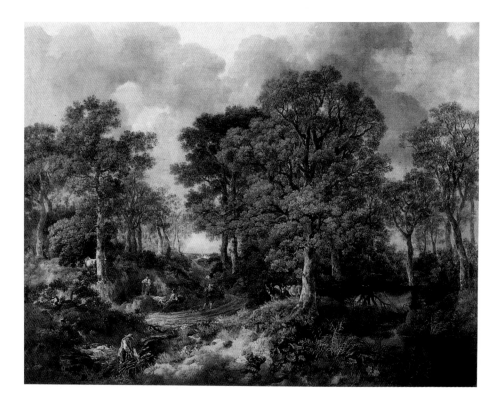

38. **Thomas Gainsborough,**
Cornard Wood, near Sudbury, Suffolk, 1748.
The masterpiece of Gainsborough's early years shows a wood just
outside the artist's home town. While the design and handling of sky
and trees show a clear debt to Ruisdael, the scene is nevertheless
closely observed and peopled with local characters. Gainsborough
retained an affection for this work, though he later described its
detailed treatment as being in his 'schoolboy' style.

and it is hard to believe that this magnificent picture could really be the work of an inexperienced lad. Attempts to explain away this paradox remain unconvincing. There probably never will be a way of accounting for what might simply be the slip of a pen, or the confused memory of an ageing man in pain and within months of death. However, it is certainly an early work closely connected with Sudbury. It shows the view from a hill above Great Cornard, a village two miles from the town, looking through the woods towards the church of St Mary's, Great Henny, which can be seen in the gap between the trees. The picture has always appealed for the curious, yet touching, way in which it simultaneously imitates Ruisdael but shows a local scene in a manner that is so detailed as to be almost naive. The great critic Roger Fry – who was not given to praising British art freely – said that it was 'in effect a transposition of a Dutch landscape into an English mood, and with a freshness and delicacy of feeling which is entirely personal to Gainsborough.'

That 'delicacy of feeling' can be seen in the way every feature has been dwelt on lovingly, as though he wished to capture each leaf and twig on every tree. It can be seen in the subtly handled illumination, the dappled fall of light and dark from a cloudy sky so typical of Suffolk which Gainsborough would have known from childhood and which Constable was to celebrate later. It can also be seen in the whole orchestration of the work. The picture falls into two parts, like two movements in a piece of music. The 'major' part shows the path through the wood, where passing travellers are caught in glimpses of sunlight. The 'minor' part is the silent shaded pool to the right, where an untamed nature reigns. This sensitive balancing of modes, of the human and the natural, might well have been influenced by the intense musicality that was to play such a part in the artist's career a few years later.

As appealing as the evocation of local scenery is the rural life represented here. For once, the figures seem to be ones that might really have been found along a road through the woods in the 1740s rather than the stereotypes of the pastoral. They are earthy characters, like the rustics in Henry Fielding's contemporaneous novel, *Tom Jones*. In the foreground there is a woodcutter (a favourite recurrent character in the artist's repertoire) bent on his work. A little further off, a labourer rests on his shovel, watched by a pretty milkmaid. A traveller has just passed them. He is not some romantic wanderer taking in the scene, but a man on business with a bundle hastening on, looking

neither to right nor left. Beyond, some black-coated functionary is making his way more sedately on a horse. It is tempting to find a political message in all this, to see it as a celebration of the world of the common people before the enclosures of the later eighteenth century dispossessed them and agricultural 'improvements' enslaved them in a capitalist economy. This is, in effect, what it is, but surely without any conscious polemic attached. More than in any other picture, Gainsborough comes close here to suggesting rural life as it is and not glamorizing or sentimentalizing it. We are far away from the rhetoric of his later scenes.

The only real surprise is the slightly naive effect of insistent detail. It is far more precise than the dated pastoral of a year earlier. However, the reason for this is probably because it is, in fact, of an actual place and full of exact observations. It seems that in this period Gainsborough was taking topography, the painting of places, seriously. At much the same time he was completing his view of Charterhouse for the Foundling Hospital. Perhaps this was a necessity. Portraits of places, like portraits of people, tended to be easier to sell than imaginative compositions, and were far more likely to be commissioned as well.

Gainsborough later expressed disdain for topography. Whatever his view of it at this time, it did lead to some remarkable works. Apart from *Charterhouse* and *Cornard Wood*, there were a number of commissions for specific views when he was in Ipswich. Each one was different and would not be necessarily be associated with Gainsborough if we did not have documentary evidence. The first is *Holywells Park, Ipswich* which shows the striking range of man-made ponds constructed to supply Cobbold's brewery with pure water from the natural springs of Holywells. He has done his best to make a conventional idyllic scene from this remarkable early industrial site. The ponds are flanked by trees, as in a classical design, but this only emphasizes their man-made unnaturalness. With his eye for the individual and unusual, Gainsborough has built on this by the way he shows them reflecting the cool light of the sky before darkened woods in the middle ground. Even more directly topographical 40 is Gainsborough's view of a local church, that of Hadleigh. This was painted for the vicar, The Reverend Dr Thomas Tanner, son-in-law of the Archbishop of Canterbury, who had become rector of Hadleigh in 1743 and had recently undertaken a programme of improvement, here celebrated. It seems likely that Gainsborough received this commission through his friend

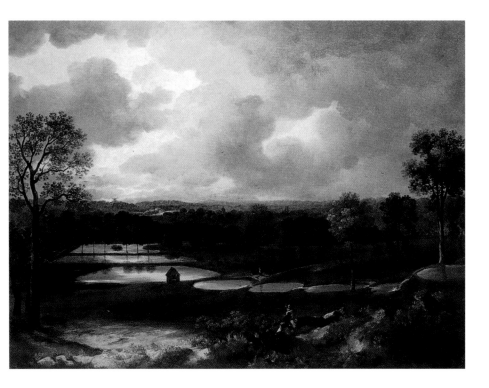

39. **Thomas Gainsborough**, *Holywells Park, Ipswich*, 1748–50.
This view was painted for Cobbold, the Ipswich brewer.
It shows a remarkable arrangement of ponds designed to
provide the brewery with pure water from a natural spring.

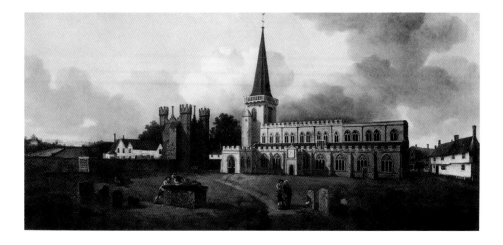

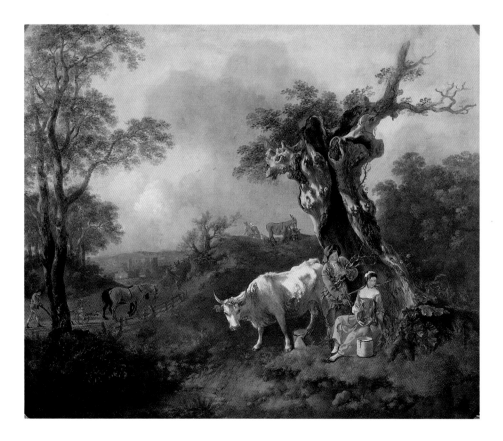

Kirby, whose firm had been employed in the renovations, producing an altarpiece. Kirby was a close associate of Hogarth, and it may be for this reason that Gainsborough has included a tribute to the London master of modern life. The boys who are gaming somewhat scandalously on the table tomb in the foreground are taken from those similarly employed in a plate in Hogarth's series *The Idle and Industrious Apprentice* (1747).

Gainsborough was still prepared to produce topographies when he first met Thicknesse, producing both a view of *Landguard Fort* and a drawing of the officer's country retreat. Yet Thicknesse was amongst those who were encouraging him to raise his sights at this time and become more involved in imaginative compositions. Although landscape commissions remained slow, he did begin to receive some prestigious ones by the mid-1750s. A notable one was for two square-shaped scenes (intended as overmantels) for the Duke of Bedford in 1755. He received 21 gns for one of these, which shows a milkmaid with a woodcutter, a price that compares well with what he was then being paid for portraits. Like other scenes with rural figures at this time, this shows a particularly localized form of pastoral, in which shepherds and shepherdesses have been replaced by more robust workers. He has lost none of his Dutch-inspired realism in his painting of these figures, or the pollarded tree (based on Wijnants) that shields them and the cow behind. On the other hand, this couple are now engaged in some kind of transaction. There is a 'story' here, unlike the labourer and milkmaid who simply relax near each other in companionable silence in *Cornard Wood*. There is also a ploughman at work in the middle ground. It may be that Gainsborough is including here some element of criticism in the dull shaded area where the ploughman works, implying an area of toil to be distinguished from the freer, brighter world of the milkmaid and woodcutter. It is as though he is discovering a discrepancy opening up between his admiration of the beauties of a free nature and the growing realities of oppression in the actual countryside. It was the former that he was to concentrate on later in his career, growing ever more grander and poetic in his evocation of a disappearing world.

40. **Thomas Gainsborough,**
St Mary's Church, Hadleigh,
c. 1748–50. Gainsborough probably received the commission for this view via Joshua Kirby, who was refurbishing the church. The boys playing on the tomb in the foreground are copied from an engraving in Hogarth's series *The Idle and Industrious Apprentice.*

41. **Thomas Gainsborough,**
Landscape with a Woodcutter and Milkmaid, 1755. An example of the more ambitious form of pastoral painting that the artist was developing in the mid-1750s. It combines decorative Rococo effects with characterful features borrowed from Dutch art. In this case, the principal model was Jan Wijnants who specialized in large-leafed plants and gnarled trees.

Chapter 5: Conversations

'Perfectly like, but stiffly painted, and worse coloured.' This is how Thicknesse described the portraits that he found when he first visited Gainsborough's Ipswich studio in the early 1750s. Apart from standard heads and half-lengths – the bread and butter of the portrait business – these would have been the small conversation groups that formed the most ambitious part of the artist's practice at the time. Looking at these now, we would probably want to differ with Thicknesse about the colouring which, if not sensational, is often exquisite in effect. But we would certainly agree with the charge of stiffness. These little groups – as can be seen in his masterpiece of the period, *Mr and Mrs Andrews*, have a doll-like quality about them. They some- 44 times seem to be marionettes rather than people.

Thicknesse was – by his own account – one of those who persuaded Gainsborough to move towards a more ambitious, large-scale form of portrait, the kind that made it possible to establish a modish practice in Bath at the end of the decade. He is perhaps understandably dismissive of the stilted conversation portraits that were falling out of fashion. From our perspective, however, these are some of the most perceptive and appealing of all his works. Their apparent naiveties often throw up striking insights. Gainsborough had become familiar with the practice of painting conversations while an apprentice. The fashion for small group portraits of families and friends in social gatherings had emerged in London some twenty years before. Introduced by artists such as Philippe Mercier (?1689–1760) and Joseph Van Aken (*c.* 1699–1749) who had a continental training, con- versations adapted the conventions of the French Rococo style to a practical form of portraiture. A little later it was taken up by Hogarth with great, if temporary, success, and was also prac- tised by Hayman, an artist particularly close to Gainsborough at this time. Although falling out of favour in London in the late 1740s, conversations continued to find favour in provincial society. By painting such works in Suffolk in the early 1750s, Gainsborough would seem to be following a path similar to that

42. Francis Hayman,
The Jacob Family, c. 1745.
Hayman was a leading painter of
the small informal group portraits
or 'conversations' that were
popular in the second quarter
of the eighteenth century.

43. Thomas Gainsborough,
*John and Ann Gravenor, with
their Daughters, c.* 1752–54.
Gainsborough's early conversation
portrait groups show a debt to
Francis Hayman and reveal his
uncertainty with figures at the
time and the vivid sense of local
scenery which gives such work
an appealing freshness.

of other regional specialists such as Arthur Devis (1711–87), who had a practice in his native Lancashire, or of Mercier, who was by then living in York.

The stiff gestures of the figures in these little works are not just the product of naivety. They are intended to show the polite modes of deportment and address that marked off those in society from the lower orders. While ostensibly displaying people in carefree social gatherings – taking tea, conversing in a club or simply strolling in a park – they were precisely staged statements of the sitters' status and ambitions. Perhaps the fine self-portrait of Gainsborough with his wife and dead child show him developing this genre. The sense of sorrow in this moving work is intensified by the chilliness of the beautifully painted landscape. Yet while he was able to use his sense of atmospherics to telling effect in these group portraits, he was less confident in his handling of the groups themselves. More than three people seems always to have been a problem. Certainly the four members of the Gravenor Family (*c.* 1747) presented difficulties, even though he had examples from his mentor Hayman to draw on. The gentleman and ladies in Hayman's *The Jacob Family* (*c.* 1745) sit and stroll plausibly enough in their elegant park landscape.

27

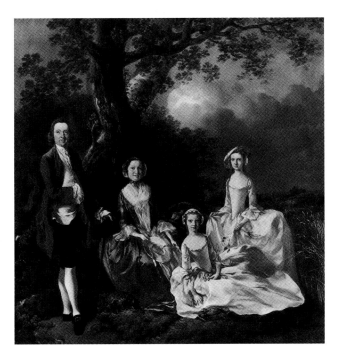

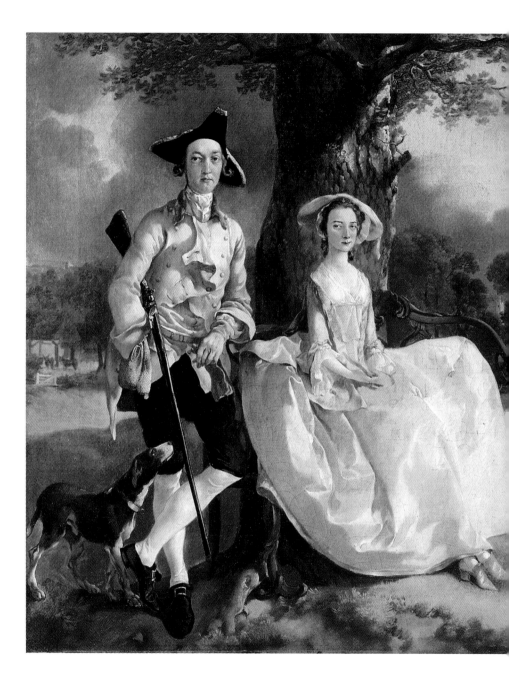

44. **Thomas Gainsborough**, *Mr and Mrs Andrews*, c. 1750.
The finest of all Gainsborough's early conversations, it shows the *hauteur* of members of the landed gentry combined with a wonderfully vivid depiction of local scenery. The tree against which the couple are placed can still be found at the end of the garden of their house, The Auberies.

The Gravenors, on the other hand, stand and squat uneasily on the edge of an ordinary field. They are townfolk out in the country for the day, and they look a little lost. Three of them lurch uncomfortably to the left, as though they had been at the cider too much at lunchtime. Yet despite such awkwardnesses, there is an engaging frankness in their all too believable faces. The painting of their costumes, as of the moody weather behind them, is exquisite.

It is perhaps the greatest proof of Gainsborough's innate ability as a painter that he was able to profit from inexperience at this stage in his career to produce unusual works of brilliance and insight. In the best of these, naivety and knowing combine in unexpected harmony. Nowhere is this more the case than in his masterpiece of the period, the portrait of *Mr and Mrs Andrews*. 44 Conversations showing couples in front of luxuriant countryside were commonplace at the time. But no one else had ever attempted one in which couple and landscape are given equal importance. The canvas is landscape shaped and the figures are kept firmly to one side to allow us a good view. Nothing balances them on the other side except some harvested sheaves of corn, stacked in the bottom right-hand corner. Like the slightly earlier *Cornard Wood*, the landscape is specific. It shows The Auberies, the couple's estate on the edge of Sudbury. It is a place that the artist would have known from earliest childhood. While probably painted in the studio, the scenery has the freshness and directness of a picture done in the open air. He knew those trees, that hill; the kind of light that falls on a bright but cloudy summer's day. He also knew the couple, recently married in St Andrews Church, Sudbury, on 10 November 1748. It is a truly local picture, but for all of that, it is not a friendly one. The couple have disconcertingly smug expressions on their faces. These have been used by the Marxist critic John Berger to suggest the artist was exposing the arrogance of the land-owning classes of the period. Historians have countered with evidence of Gainsborough's personal knowledge of the couple, suggesting that the artist could not possibly have intended to be censorious of them under such intimate circumstances. However, they are forgetting one thing. Gainsborough certainly knew both Robert Andrews and Frances Carter (as she then was) from childhood, but not as an equal. They were from established families; he was from one on the lower edge of respectability. He had gone to Sudbury Grammar School like Robert Andrews, but he had not gone on to Oxford University like Andrews. He had become

a humble apprentice in London. When his father had suffered the humiliation of bankruptcy, Frances Carter's father had been one of those who had bailed him out. In her eyes, Thomas Gainsborough was the son of a charity case. The artist knew those looks this couple were giving him and recorded them with characteristic exactness. He also witnessed something else. She is seated on an almost caricaturally Rococo bench, as though in a modish park. He has been out shooting and poses almost indifferently beside her. Theirs was an arranged marriage, forged by their parents to secure the integrity of an estate both parties had a share in. If the Andrews had little love for Gainsborough, they probably did not have much for each other either.

Gainsborough would have known this scene from childhood, but not quite as it appears here. The woods and church beyond would have been much the same as always. But the foreground shows the activities of Andrews as a new, 'improving' farmer. Where there was once common land, there are now fields fenced in with Andrews' own flock secured inside. The field beside them has been ploughed in the modern manner – you can see the ridges of regular furrows. Everything is modern and ordered, and private property. It is a very different world that is portrayed here from the open road along which ordinary country folk wander and do their business in *Cornard Wood*. It is the paradoxical nature of the picture that gives it its extraordinary conviction. A landscape – perhaps the best he ever did – painted with deep affection. A couple depicted with circumspection. Fashionably dressed, they inhabit it incongruously. An instinctive master of colour and effect, Gainsborough has balanced his unusual design through subtle tonal arrangement. The figures would weigh the composition too heavily to the left, if they were not lightened by blues and greys in their costumes that relate more to the light tones of the sky than the heavier ones of the ground. Thus the forms that should be the most solid in the picture are secured in their marginal position by hues that suggest a certain insubstantiality. There is a final mystery. On Mrs Andrews' lap there is a blank, unpainted space. Most commentators have assumed it was intended for the game bird that Mr Andrews had recently bagged. Others, however, have pointed out that she would hardly have been likely to welcome such a bloody offering on her immaculate blue dress. We will probably never know the truth of the matter. Whatever was left out does not seem to have bothered the couple, who acquired the work in this unfinished state from the artist.

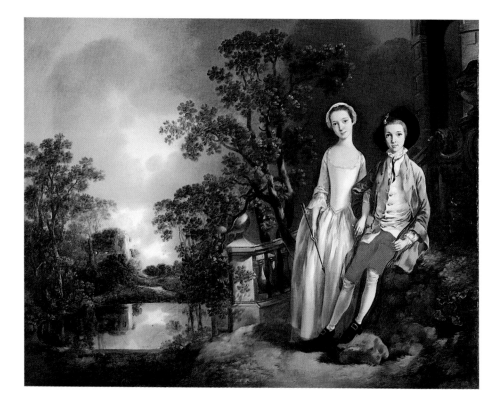

45. **Thomas Gainsborough,**
Heneage Lloyd and his Sister, Lucy, c. 1750–52.
In contrast to *Mr and Mrs Andrews* (see plate 44), this conversation
is more fanciful with a romantic parkland vista in the background.
The arrow in Miss Lloyd's hand may be a playful allusion to love,
though this seems a strange theme for a portrait of a brother and sister.

Other conversations of the period achieve an easier elegance, perhaps because they presented less problems to the artist. In *Heneage Lloyd and his Sister, Lucy* (*c.* 1750–52) he is able to show the offspring of gentry in delicious parkland. The young girl holds an arrow, as though playfully alluding to the role of cupid, as she links arms with her somewhat embarrassed brother. The world of gallant make-believe is perhaps one that Frances Andrews would have preferred to the earthy squiredom to which she had become aligned.

Conversation usually implies a group, but Gainsborough also specialized at this time in single figures engaged in activities promoted in polite society. Such is the portrait of his friend the Reverend John Chafy. The clergyman sits contentedly in the open air, sawing away at his cello as though he had not a care in the world. As a fellow amateur musician, Gainsborough knew and wrote of his dream of escaping life's troubles and retreating into nature with his instrument. But the landscape that Chafy sits in is an artificial one, a formal park with an urn. There is no real escape here.

46. **Thomas Gainsborough**, *The Rev. John Chafy*, 1750–52. An early instance of a musical portrait by Gainsborough. Like the artist, Chafy was a keen amateur musician. Unlike most 'gentlemen' of the time, he did not appear to mind being represented actually playing his instrument – the kind of pose usually reserved for professional performers. The way he is holding the cello clasped between his knees is of historical interest, since cellos were not in those days supported by a spike as they are now.

47. **Thomas Gainsborough**, *John Plampin*, *c.* 1750.
The pose of splayed legs was fashionable at the time – it was
borrowed from a portrait by the French painter Watteau.

John Plampin, a jaunty young man with prospects, is shown in the height of fashion. His legs are spread out wide in a manner already much favoured by Hayman and other members of the St Martin's Lane Academy. These artists were copying a pose they had found in an engraving after a portrait by Watteau. Doubtless they thought this peculiar arrangement to be the last word in French *chic*. In fact, Watteau's sitter was an old soldier who had to keep one leg up because of a war wound. Such a situation is humorous enough in itself, but Gainsborough has added to the comedy by positioning the branch on which Plampin rests his left hand in such a way that it looks like a third leg. The dog that sniffs at his breeches is arranged in a manner that parallels and stresses the position of Plampin's legs. It is almost as though the artist is wishing to suggest that his wealthy young sitter is 'cocking a leg' at the landscape to indicate possession. As so often with these early conversations of Gainsborough, it is hard to know what is deliberate and what is accidental in the striking peculiarities in their design. Yet it is tempting to believe that he sometimes relished an exercise in visual wit at the expense of some of the arrogant young puppies he confronted.

48. François-Bernard Lépicié, after Antoine Watteau, *Antoine de la Roque*, 1734.

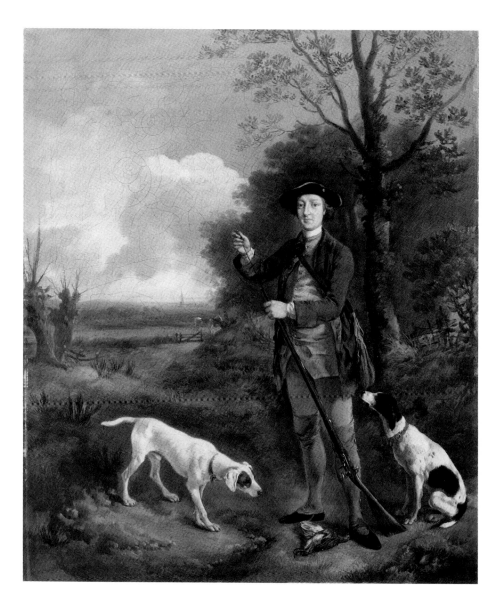

49. **Thomas Gainsborough,**
Major John Dade, of Tannington, Suffolk, *c.* 1755.
By the time Gainsborough painted this small portrait,
he was able to handle figures with greater skill.
There is a relaxed elegance in this image of a
gentleman out shooting.

Later conversations have a more relaxed appearance. The elegant portrait of Major John Dade shows a Suffolk landowner out shooting. It is an autumnal scene and the artist has blended the sitter's costume subtly with the browns of the background. Dade is cleaning his gun after a kill. The action causes his body to sway forward in a slight and elegant curve – quite unlike the mechanical arrangement of Plampin's limbs. He looks out towards us as though we had momentarily interrupted him. A further sense of action is given by the retriever that stares up expectantly at its master, having presumably just deposited the recently shot game bird at his feet. Another dog sniffs the booty suspiciously.

Such changes reflect the broader shift in Gainsborough's practice that will be discussed in the next chapter. In the mid-1750s he began to experiment with a more informal kind of large-scale portrait that appealed to a more fashion-conscious clientele than local squires such as Andrews and Dade. It was his success with such work that soon caused him to phase out the provincial conversation from his repertoire altogether.

50. **Thomas Gainsborough**, *Edward Vernon*, *c.* 1753.
An early full-scale portrait by Gainsborough of a celebrated admiral.
It is close in manner to that of Thomas Hudson, the master of
Sir Joshua Reynolds and then a leading London portraitist.

Chapter 6: Scaling Up

Gainsborough began to develop large-scale portraits in the mid-1750s. He had painted some full-size half-lengths before – such as that of Admiral Vernon, apparently modelled on the stolid example of one of the reigning masters of the London portrait business, Thomas Hudson. Such works have none of the ease that was later achieved, and that first became evident, perhaps, in the painting of his two young daughters chasing a butterfly.

To some extent this was a response to changes in fashion. Partly due to the influence of Reynolds, a new and more expressive form of grand portraiture was now becoming popular. However, conversation painting did not altogether cease – particularly in provincial areas – and Gainsborough's change of direction is also a sign of a growth in his ambitions. Egged on by such friends and patrons as Thicknesse, he was beginning to think more highly of his capabilities. It was a critical move. Without having mastered the conventions of large-scale portraiture during this period, he would never have been able to cut the figure that he did when he moved to Bath at the end of 1759.

The picture of his daughters chasing a butterfly may have been undertaken as a test of his powers to handle larger pictures. 51 It was the first of a series of depictions of his daughters in unusual and appealing poses. Like most of these, it was unfinished – a sign that he was experimenting. The children are rushing to catch a cabbage white butterfly that has settled on a thistle. They hold hands, and their two forms fan out from this clasp like the wings of a butterfly – as though to link pursuer and prey in fragility and transience. Margaret, aged about three, rushes forward eagerly. Mary – two years older and already more circumspect – holds back a little. Desire and caution are balanced in the expressions on their faces. The darkened landscape behind heightens the sense of their vulnerability – sadly prescient of the unhappy futures that did in fact lie before them.

Gainsborough has captured the moment so naturally that it might seem there was no more to the picture. It has been pointed out, however, that the theme of a child chasing a butterfly is an ancient morality, suggesting the vanity of earthly desires.

51. **Thomas Gainsborough**, *The Painter's Daughters Chasing a Butterfly*, *c.* 1756. One of Gainsborough's most appealing and memorable images, it shows his two young daughters as though at play in their garden. Unusually for the artist, the work can also be read as an allegory on hope and transience. This traditional theme would have been known to Gainsborough through its treatment by John Bunyan (see plate 53).

52. **Thomas Gainsborough**, *The Painter's Daughters with a Cat*, c. 1760.
Like most portraits of the artist's daughters, this one is unfinished, the cat
only being indicated sketchily. While these portraits were stimulated by
a genuine parental affection, it seems that the artist may also have been
using his daughters to try out experimental poses at a time when he was
seeking to enrich the repertoire of his portraiture.

53. 'Of the Boy and the Butterfly',
an illustration from one of the
best-known children's books
of the eighteenth century, written
by John Bunyan, author
of *The Pilgrim's Progress*.

The artist was no bookish person and did not normally elaborate his pictures with allegories. However, he would surely have known this theme from his own childhood. It occurs in one of the best-known children's books of the period, John Bunyan's *Temporal Things Spiritualized*. Originally published in 1686, it was constantly in print in illustrated editions throughout the eighteenth century. 'Of the Boy and the Butterfly' tells of a boy eagerly pursuing a butterfly. This is an 'emblem' for the author of, 'those whose hearts are wholly at the world's dispose.' 'All are but painted nothings and false joys', Bunyan moralizes, 'like this poor butterfly to these our boys.'

Gainsborough might have been tempted to explore allegory through his admiration for Hogarth. As an apprentice in London, Gainsborough might well have come across Hogarth's own treatment of the theme, *The MacKinnon Children* (c. 1742) in which a young girl and boy attempt to trap a butterfly resting on a sunflower. He would have known, too, Hogarth's emphasis on

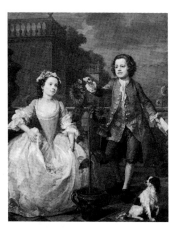

54. **William Hogarth**,
The MacKinnon Children,
c. 1742. Gainsborough may have
seen this lively portrait of children
attempting to trap a butterfly
when he was an apprentice
in London.

movement as the basis for beauty. It is even possible that the serpentine outline formed by Mary's apron, as she lifts it, is a reference to Hogarth's celebrated 'Line of Beauty', his emblem of graceful motion which had recently been expounded in the artist's *Analysis of Beauty* (1754). The paintwork also has a Hogarthian brio – perhaps because the picture was never finished. It still requires that final glazing layer that Gainsborough used to soften effects.

In one very important sense, however, the picture is not Hogarthian. It may contain an allegory, but it is also a picture of sentiment, whose mood and meaning come more from gesture and expression than from the interpretation of a narrative. There is a sympathy for the girls quite unlike the Swiftian bitterness that one finds in Hogarth's more remote allegories on children. Gainsborough has, in fact, updated Hogarth, investing his work with the new interest in children that was growing at this time. In this, he goes beyond the emblematic to a more emotive form of communication.

Surprisingly, this touching picture – one of the finest he ever painted – did not seem to mean much to Gainsborough. He left it behind when he moved to Bath. It was acquired by a friend, the Reverend Robert Hingeston, Master of Ipswich School, either as a gift or (as seems more likely) at the auction of works held in October 1759 when the artist was selling up prior to departure. The portrait may have had some personal meaning for the purchaser. Hingeston and his wife lived in the big house that backed on to the Gainsboroughs' garden and he must have seen the young girls playing there throughout the seven years they were in Ipswich. Presumably, the moral theme of the work would also have had a special resonance for a clergyman schoolmaster.

Gainsborough may have thought he had developed beyond such work as he became more adept at handling poses. Both painter and sitters have grown up a bit in the double portrait of 'Molly and the Captain' (as he frequently called them) enfolded with a pet cat. There is a knowingness in their expressions that might have become uncomfortable if the picture had been completed. As it is we can enjoy the puzzle of the emergent moggy, and also gain an idea of the way he built up his pictures at this time. It shows the rich earth red ground he used which gives a special glow to the silvery brushstrokes he laid on top of it.

The painter's professional portraits at this time are understandably more restrained. His picture of Ipswich town clerk Samuel Kilderbee shows him as a genial gentleman. Kilderbee

55. **Thomas Gainsborough**, *Portrait of William Wollaston*, 1758–59.
Wollaston was an influential gentleman (later, he was a member of
Parliament) who shared Gainsborough's love of music. The artist has
depicted him here in a relaxed informal manner, as though wrapped
in thought after playing his flute.

56. **Thomas Gainsborough**, *Lady Innes*, *c.* 1758–59.
During his Suffolk period, Gainsborough seems to have portrayed men more
than women. This portrait is more traditional and stilted than that of Wollaston
(see plate 55). However, it has the charm and fascination with costume that
were to become key features of his female portraits a few years later in Bath.

was a highly influential local figure, and the artist seems to have made a special effort to show how he could handle grandeur and substance. Doubtless this work attracted new and better commissions. The care that he took in planning such work can be seen in surviving compositional drawings that he made for some of them. He seems to have been particularly anxious to give the right kind of nonchalant pose to the *Honourable Richard Savage*, a relative of the Duke of Hamilton, who had power to recommend him in aristocratic circles.

The finest of such informal portraits is that of William Wollaston. A local landowner and fellow amateur musician, Wollaston is shown in a serpentine pose, looking up at us as though he had just stopped playing his flute. The expression is 55
good natured, if a little condescending. Wollaston also provided the opportunity for Gainsborough to essay a full-scale full-length, one of the earliest he did (*c.* 1758). The mood in that work is very different from the forceful military full-lengths with which Reynolds was currently impressing London society. Wollaston was not without authority – he was a colonel of the Suffolk militia and later became a Member of Parliament, but he preferred to be shown in these portraits as a genial country gentleman rather than as a figure wielding power.

Gainsborough worked largely for male sitters during this period when painting grand portraits. This was to be very different in Bath, where female sitters provided the opportunity for many of his most flamboyant works – notably the portrait of Ann Ford with which he made his debut. During his later years in Suffolk when he did paint women they were usually shown in a more restrained and traditional manner, as in the case of the beautifully ornate and floral portrait of Lady Innes. Perhaps 56
this was because the role of women was still more restrained in provincial Suffolk than in the fashionable centres of Bath and London.

There are signs that, even before he moved to Bath, Gainsborough was becoming restless in Suffolk. During 1758 he travelled, looking for work elsewhere and perhaps a better class of clientele. It is from this period that the first letters survive that show a sense of his artistic integrity. He defended the uniqueness of his 'touch of the pencil [brush]' when a client complained about roughness in a portrait. Gainsborough was not just any painter now. He was a 'genius' with a manner of his own. It was this that gave him the confidence to risk moving to the centre of culture and fashion in the West.

Chapter 7: The Bath Practice

During the last months of 1759 Gainsborough moved with his family to Bath. It was the most momentous decision of his career. It turned him from a provincial painter into a leader of fashion. By the time he left in 1774, he was at the top of his profession. Only Reynolds could surpass him in terms of material success as a society portrait painter, and most would concede that Gainsborough, while not matching the range of Reynolds, could equal him in most important aspects of portraiture and outclass him in some. Bath provided Gainsborough with the opportunity to reach these heights. By the time he arrived the town was already established as the most fashionable watering place in England. Renowned since antiquity for the therapeutic effects of its hot springs, it had been transformed into a centre for social gatherings and polite entertainment by Beau Nash, the master of ceremonies in the early eighteenth century. The local property speculator John Wood had sealed this reputation by remodelling the city with an impressive series of streets and buildings in the classical style. These were still being erected in Gainsborough's time.

Like London, Bath had a 'season' when it would be descended upon by high society. Once established in his practice, Gainsborough became a principal attraction in the social round. His work was well advertised – particularly after his grand portrait of the current master of ceremonies, Captain William Wade, was presented to the Octagon Card Room and installed in the new assembly rooms in 1771. Gainsborough first occupied part of a grand new house (now demolished) designed by Wood, just beside Bath Abbey. This was a central location, well placed for attracting business. He had his studio on the first floor. A couple of years later, in 1762, his sister Mary Gibbon brought her millinery business here from Colchester. Mary's move is a sign of the artist's growing success in Bath. It also may have been helpful in providing him with fashion accessories for his portraits.

As a leading place of entertainment, Bath provided opportunities for all kinds of fortune seekers. It was a notorious resort for gamblers, and for male and female adventurers seeking lucrative

matrimonial alliances. Those seeking good health were beset by doctors with miracle cures and apothecaries with patent potions. It was also a place where performers of all kinds could make their names. It was here, in the theatre in Orchard Street, that the famous tragedienne Mrs Siddons first succeeded as an actress, and Richard Brinsley Sheridan as a playwright with *The Rivals* (1775). Gainsborough's career can be said to have followed a path similar to theirs. He was, in fact, particularly close to leading figures in the performance industry in Bath, such as the actor John Henderson and the musician Thomas Linley. It is no accident that the first major picture he painted was of a young woman connected with this world. This was the amateur musician Ann Ford. This picture was intended to show a new audience what the artist could do. It does so with great panache. Ann Ford is depicted in a rich brocaded silken dress against a deep red hanging. Her musical skills are alluded to by the cittern in her lap and the viola da gamba behind her. Her left elbow rests on a spreading pile of music. Her head, lightly supported by her hand, is turned, as though she were distracted by the memory of a fetching air. This also allows her body to be displayed in an attractive contrapposto. She forms a curving S-shape, which might be yet one more tribute by the artist to Hogarth's 'Line of Beauty'. It was too much for some observers. The prim Mrs Delaney – friend of the royal family and now best known for her flower collages – commented: 'a most extra-ordinary figure, handsome and bold; but I should be very sorry to have any one I loved set forth in such a manner.'

This reaction could be taken as a sign that Hogarthian brio in portraits was now distinctly out of favour. Certainly Gainsborough soon gave up giving his pictures this kind of a swagger. In the case of Ann Ford, however, he was surely responding to the character of the sitter. Ann Ford was no ordinary young woman – the daughter of a lawyer, she had outraged her father by daring to appear on stage as a performer. Such was his fury that he actually had her arrested to prevent such a disgraceful public exhibition. She eventually returned to the theatre. A subsequent attempted arrest by her father was only prevented when one of her supporters, a regimental colonel, threatened to set his troops on the Bow Street runners that had been sent to apprehend her. It is typical of her that in this portrait she should have had herself shown in the daringly unladylike action of crossing her legs – something that only men were supposed to do.

57. **Thomas Gainsborough**, *Ann Ford (Mrs Philip Thicknesse)*, 1760. A stylish portrait of a musical amateur, it was perhaps intended as an advertisement of his skills to the Bath clientele. The sitter was a spirited woman who had gained notoriety by defying her father and performing on stage. Later she married Philip Thicknesse.

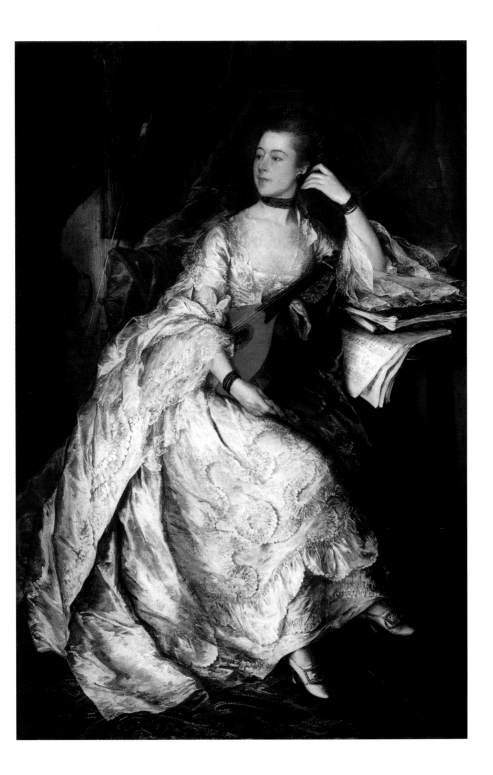

Ford's stormy career did not stop here. Soon after this portrait was painted, rumours began to circulate of a liaison between her and an aged admirer, Lord Jersey. Typically, she published a vigorous defence of herself, complete with a caricature of the man who had attempted unsuccessfully to buy her favours. He is old and gouty, staggering about with a stick: her pose is reminiscent of Gainsborough's portrait of her, complete with cittern and small round table by her side. This suggests that the portrait was well known by this time. Ford's action preserved her reputation, which was soon to be assured when she became the wife of Gainsborough's friend and supporter, Thicknesse. Gainsborough, too, secured his when he made it clear that he could combine stylishness with decorum in such portraits as *Lady Alston* (1761–62) and *Countess Howe* (*c.* 1763–64).

90, 2

Gainsborough tried as much as possible to adapt to all kinds of portraiture then current. He even moved into pastel, an area much in vogue in Bath due to work of William Hoare (1707–92), an artist already well established. Hoare managed to survive this onslaught, and his practice flourished both during Gainsborough's stay and after. Well educated, and well connected, he was able to rely on solid support from the local gentry. He also had the good sense to remain on excellent terms with Gainsborough, who soon gave up rivalling him in the production of neat, well-finished pastel heads.

58. Sketch from 'A Letter from
Miss Fxxd', 1761. A caricature
produced by Ann Ford for a pamphlet
in which she refuted rumours of a
liaison between herself and an aged,
gouty admirer, Lord Jersey.

59. **William Hoare**,
Henry, 9th Earl of Pembroke,
c. 1760–70. William Hoare was a
local artist who had a well-established
reputation for pastel portraits such
as this before Gainsborough arrived
in Bath. Although Gainsborough
occasionally produced small pastel
portraits himself (see plate 60), the
two artists remained on good terms.

60. **Thomas Gainsborough**,
Caroline Russell, late 1760s.
An example of the small, intimate
pastels that Gainsborough drew in
emulation of William Hoare during
his first decade in Bath.

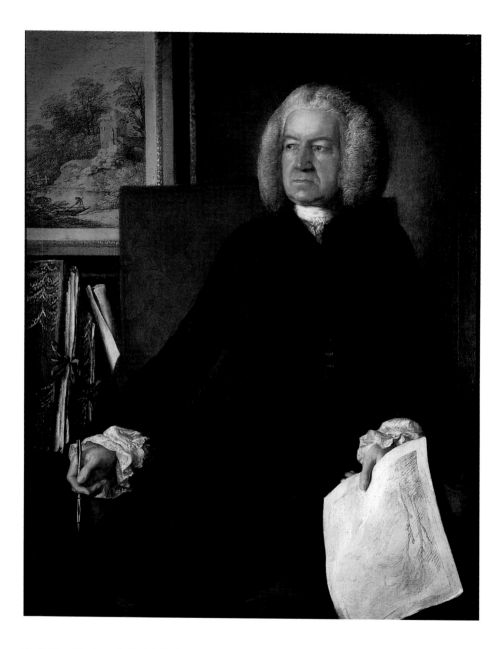

61. **Thomas Gainsborough**, *Uvedale Tomkyns Price*, 1760. Grandfather of Uvedale Price, the celebrated theorist on the picturesque, Price senior appears himself to have been an amateur of art and landscape. A Welsh squire of the old school, he is depicted by the artist with appropriate dignity and sobriety.

Gainsborough did, however, continue to handle plainer work in oils. His portrait of Uvedale Tomkyns Price – grandfather of Uvedale Price, the writer on the picturesque – shows a stern-faced man in his seventies, soberly dressed in black. There is a landscape by Gainsborough in the background, and he holds a drawing and chalk in his hands. This suggests that he was himself an amateur artist and admirer of the painter's favourite artistic activities. A Welsh country gentleman, he displays here his preference for the rural. He may well have shared the excoriating view of Bath expressed in Tobias Smollett's novel *Humphrey Clinker* (1771), where Mr Bramble complains of, 'A *compound of villainous smells*, in which the most violent stinks, and the most powerful perfumes contended for the mastery.' He goes on to list grotesque mixtures of 'mingled odours', including those of 'sour flatulencies, rank armpits, sweating feet, running sores and issues' with 'spirit of lavender, assafoetida drops, musk, hartshorn, and sal volatile.' Such, he concludes, 'is the fragrant aether we breathe in the polite assemblies of Bath—Such is the atmosphere I have exchanged for the pure, elastic, animating air of the Welsh mountains.'

There was, indeed, a darker side to Bath, a sordidness to set beside the glitter. But there was also darkness in a different sense, a deep link to Druids and an ancient Celtic past. Surprisingly, this link was promoted by Wood himself. The speculator who laid out modern Bath claimed to be restoring an ancient British spiritual centre, where King Bladud reigned over an idyllic land renowned for its beauty and the health-giving properties of its 'sacred spring' – the source for the later Roman baths. The arts and sciences, too, he claimed, flourished there, in a celebrated Druidic academy. The street plan he laid out was full of occult references to this lost ancient world. The classical vitruvian man can be found in the proportions of Queen's Square. The Royal Circus, with its ring of trabeated columns, was a revitalized Stonehenge.

It is hard to know how much of this affected Gainsborough. He certainly made no reference to such ideas. However, it may well be that Wood's celebration of the local scenery encouraged him to develop his own idyllic version of it in his landscapes – as will be seen in Chapter 12. He had his own reasons for looking to the city as a source of good health. After a serious illness in 1763, he took a house on Landsdown, one of the hills that surrounded Bath which Wood claimed was renowned for the longevity of its inhabitants. In 1766 he moved into Wood's 'Stonehenge',

62

occupying No. 17 in the Royal Circus. His sister rented a house two doors away, at No. 15, where she let out lodgings. A contemporary drawing seems to have been made from one of its windows. Whatever Wood's mystical aspirations for the place, the Royal Circus was a highly profitable, as well as fashionable, address and Gainsborough's business flourished as never before.

In their combination of commerce and spiritual aspiration, both Wood and Gainsborough can be seen as symptomatic of the age of trenchant entrepreneurial capitalism in which they lived. Wood may well have felt an affinity between Gainsborough's Arcadian landscapes and the claims he made for the region. However he would have had little sympathy for the artist's religion. He was a strong opponent of the Methodists who were gaining strength in Bath at the time. Gainsborough's brother-in-law was a Methodist minister in Bath and the artist himself was an active member of the chapel. Then – as now – Bath attracted all kinds of cults and sects. Methodism was more firmly rooted than many of these in the social structure of Bath. It was widespread amongst the hard-working traders and shopkeepers who serviced the visitors in search of good health or fortune; people indeed like Gainsborough's sister, the industrious milliner and landlady Mary Gibbon.

62. **John Robert Cozens,** *The Royal Circus, Bath,* 1773. Gainsborough moved into the Royal Circus in Bath in 1766 and was still living there when this view – apparently taken from his sister's house two doors down from his own – was painted.

63. **Thomas Gainsborough,**
Ignatius Sancho, 1768.
Ignatius Sancho, the celebrated
'African Man of Letters', was
employed by Gainsborough's
patrons, the Montagus, when
this portrait was painted.
It was supposedly completed
in an hour and forty minutes.

Although in one sense Gainsborough could be said to have risen above this situation, in another he still remained part of it. Whatever his claims to genius, he still made his living principally as a fashionable portrait painter. He never became too grand to forget this, and retained close friendships with others in the service industry. Perhaps it was this that spurred him to paint the direct and sympathetic portrait of the 'African Man of Letters', Ignatius Sancho, in 1768. Sancho was then, as he had been for many years, a servant in the household of Mary, Duchess of Montagu. This portrait was executed during a visit by the Duchess, and was apparently painted in one hour and forty minutes. As such, it gave the artist an occasion to display a virtuoso performance. But it was none the less perceptive and observant for all of that.

A FAMILY PIECE.

64. **William Dickinson, after Henry Bunbury,**
A Family Piece, 1781. A caricatural view of the
typical portraitist's studio of the day. The painter,
smiling obsequiously, is about to immortalize
an unprepossessing family in a grand design,
complete with allegorical accessories.

Chapter 8: The 'Magick' Studio

All contemporary commentators agreed that Gainsborough had a special way of painting. There was something miraculous about it. In his panegyric on the artist after his death, Reynolds talked of 'those odd scratches and marks, which, on a close examination, are so observable in Gainsborough's pictures, and which even to experienced painters appear rather the effect of accident than design.' He then goes on to describe how 'this chaos, this uncouth and shapeless appearance, by a kind of magick, at a certain distance assumes form, and all the parts seem to drop into their proper place.' 66

65

66

We can recognize this 'magick' as the familiar way in which the mind configures a set of marks to make a form. We can play this game with any picture, going up close to it, so we see just a surface of marks and colours, and then moving back until we perceive an image. Gainsborough was unusual, however, in making this process part of the way in which he expected us to look at his work. He seems to have delighted in creating surfaces of exuberant and chaotic appearance that began to shape recognizable features with uncanny accuracy as you receded.

'You please me by saying that no other fault is found in your picture than the roughness of the surface', he wrote to a client, the lawyer Robert Edgar, on 13 March 1758, 'for that part being of use in giving force to the effect at a proper distance, and what a judge of painting knows an original from a copy by; in short being the touch of the pencil, which is harder to preserve than smoothness.'

He was proud of the individuality and appearance of 'the touch of the pencil' – which not only guaranteed the 'originality' of his work, but was also critical in giving a striking appearance to the picture when viewed 'at a proper distance'. He also expected the viewer to be able to examine this 'roughness' close to. The reason he gave for removing his pictures from the Royal Academy exhibition in London in 1784 was that they were hung

so high that they could only be seen at a distance and could not be experienced both near and far as he insisted was important for the full effect to be experienced. This process was, in effect, a further development from the 'wet on wet' process that he had acquired through his training in London. Like the Impressionists a century later, he was using a single layer method of painting in which colours that looked separate near to combined at a distance optically. He did this, however, with a very different kind of brushstroke – one that was fluid and mobile. As his daughter Margaret later observed, 'His colours were very liquid, and if he did not hold the palette right, would run over.'

Gainsborough made no secret of the means by which he achieved such special effects. As a portrait painter, his studio was open to all. He seems, in fact, to have dramatized his way of achieving a likeness. It is not certain when he developed his method. The earliest account of it comes from his first years at Bath, when it was recorded by the miniaturist Ozias Humphry (1742–1810). Humphry was at that time at the beginning of his career and had come to the city, like Gainsborough, to make his fortune.

Gainsborough would begin a portrait by shutting out the light, turning his painting room into 'a kind of darkened Twilight' in which neither the sitters 'or their pictures were

65. Thomas Gainsborough, *Queen Charlotte* (detail), *c.* 1780. A close up of the paint surface of Gainsborough's portrait of Queen Charlotte which shows the 'odd scratches and marks' that appeared, according to Reynolds, to be 'rather the effect of accident than design'.

66. Thomas Gainsborough, *Queen Charlotte* (detail), *c.* 1780. A more distant view of the same portrait to show how, as Reynolds put it, 'this chaos, this uncouth and shapeless appearance, by a kind of magick, at a certain distance assumes form.'

scarcely discernible'. The reason for this was to allow the artist to perceive the general forms of his subject without distracting detail. His next unusual practice was to ensure accuracy of appearance. He placed the canvas he was working on right beside his sitter, so that the two could be seen close together and compared directly. As Humphry puts it, the picture was, 'so placed upon the Eisel (sic) as to be close to the Subject he was painting, which gave him an Opportunity (as he commonly painted standing) of comparing the Dimensions and Effect of the Copy, with the original both near and at a distance; and by this method (with incessant study and exertion) he acquired the power of giving the Masses, and general Forms of his models with the utmost exactness.' After having secured his dimensions by such means, Gainsborough would let more light in 'of necessity' for finishing the picture. 'But his correct preparations', Humphry concludes, 'were of the last importance, and enabled him to secure the proportions of his Features as well as the general contours of Objects with uncommon Truth.'

According to later accounts, Gainsborough still maintained the same distance from his sitter as from his canvas. This led to him using paint brushes attached to poles six foot (2 metres) in length – an extraordinary practice that presumably does much to explain the boldness of his 'touchings'. This dramatic process, with its darkened rooms and giant brushes, must have been all the more striking to a clientele used to being received in light and luxurious surroundings, and treated to obsequious flattery by an artist working deftly with delicate implements securely on the other side of a canvas.

Gainsborough's practice of commencing in low light may have had some unanticipated side effects. It seems to have contributed to the rich warmth of his tones, and also to have helped him capture the overall impression of a face, its 'countenance'. It gave such works as the study of his friend the actor James Quin a 'speaking' likeness – something that he was able to carry over into the more rhetorical full-scale work he later painted.

'Reynolds and other portrait painters who have understandably great merit, seem to us', wrote Thicknesse in 1770, 'to be less careful about what we call the countenance: we never saw a Portrait of Gainsborough's (if the subject was worthy of his attention) but it would enable a stranger to form the same judgement of the person from the portrait as from the life!' This was one of the many points on which Reynolds and Gainsborough differed. In line with his classical allegiances, Reynolds took

64

67. **Thomas Gainsborough,** *James Quin*, 1763. Portrait of Gainsborough's friend, a celebrated Irish actor of the day. Here, the artist uses the dark conditions in which he habitually began his portraits to achieve a depth of effect.

68. **Thomas Gainsborough,** *James Quin*, 1763. A study of Quin, showing the rich effects which could be achieved through painting by candlelight. It is likely that this study was begun as a work in its own right, rather than as a basis for the later full-scale work (see plate 67).

a more conceptual approach to portraiture. He believed that nobility of character should be expressed, if necessary, at the expense of accuracy of appearance. As he said in his fourth *Discourse* delivered in 1771, a year after Thicknesse's observations: 'If a portrait painter is desirous to raise and improve his subject, he has no other means than by approaching it to a general idea.... It is very difficult to ennoble the character of a countenance but at the expense of likeness.'

Gainsborough, on the other hand, insisted that portraiture was, first and foremost, about resemblance. 'I am vastly out in my notion of the thing if the Face does not immediately look like', he wrote in a letter to the Earl of Dartmouth in 1771. In this case, he was discussing the unsatisfactory outcome of a grand portrait of Lady Dartmouth in which the sitter had insisted on being represented in the kind of generalized costume that had been promoted by Reynolds. Commenting on 'the unluckiness of

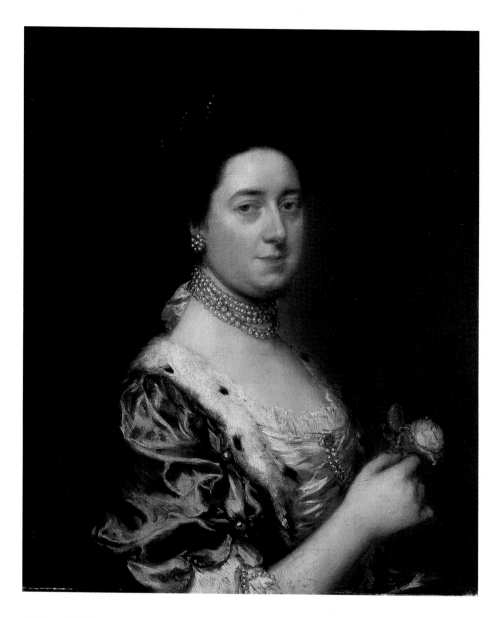

69. **Thomas Gainsborough,**
Portrait of Catherine, Countess of Dartmouth, c. 1771.
The artist painted this picture after an earlier attempt at
representing the sitter in idealized classicizing costume
had proved unsatisfactory. Gainsborough was opposed to
depicting sitters in fancy costumes since he argued that
they meant accurate likeness, which he held to be the
principal purpose of portraiture, could not be achieved.

fancied dresses taking away Likenesses, the principal beauty and intention of a portrait', Gainsborough offered to portray the lady again in his own manner, more individualized in both features and dress. The resultant work may be no more flattering, but it certainly has a more convincing 'countenance'.

It seems highly likely that Gainsborough gained his conviction about the primacy of likeness, and the value of depicting people in their normal dress to help achieve this, from his St Martin's Lane acquaintances in London. Similar ideas – derived from such anti-classical continental theorists as Gerard de Lairesse and Roger de Piles – were expressed by Hogarth in his 1753 publication, *Analysis of Beauty*. It is typical of this approach that Gainsborough should have taken care to finish not just the faces in his portraits, but also all the details of the costume. In contrast to Reynolds, who had a whole factory of assistants and students at work completing his canvases, Gainsborough only ever had one helper. This was his nephew Gainsborough Dupont, who began to work for him in 1772, and was closely trained in his methods.

Gainsborough was fascinated with low-light painting for other reasons than those already discussed. Like others of his generation – notably Joseph Wright (1734–97) – he was fascinated by the effects of candlelight, both the warm glow it gave to forms, and the way that it could cast strong shadows to emphasize unexpected parts of a figure. Later in life, he was to explore

70. **Joseph Wright**,
Three Persons Viewing the Gladiator by Candlelight, 1765. Wright achieved fame during the 1760s depicting subjects viewed by candlelight. Although very different from pictures by Gainsborough, they do show the fascination with studying by candlelight as a means of emphasizing form, and also suggest something of the mystique of picture making that Gainsborough hoped to convey in his work.

the use of illumination to give an added mystery to landscape, in light shows of his own construction. These were in emulation of similar scenes by Philippe Jacques de Loutherbourg (1740– 148 1812), but more generally they might be seen as part of a growing response amongst fine artists to that popular form of visual entertainment, the magic lantern.

Gainsborough also used his studio to perform transformations in his landscape. Here, the process might seem to be going in the opposite direction to that in his portraits, whose features he never touched without being in the presence of the sitter. For a while, he would make sketches out of doors and bring them back to his studio to form the basis of imagined compositions. He often used models of animals, fashioned by himself, to people these, such as the fine horse subsequently owned by Constable. He was also, according to Thicknesse, in the habit of bringing back rocks and foliage to construct miniature versions of the scenes he was working on. In this, he was doing just as painters had been advised to do since at least the days of Cennino Cennini in the fourteenth century. He was seeing landscape as more a subject for invention than observation.

In line with this view, he was in the habit of drawing imagined landscapes by candlelight in the evening as a form of relaxation. Many of his worked-up compositions probably originated like this. They differ strongly in appearance from those fine figure and costume studies that he made in which the brilliance and delicacy of his line is being set to record things

71. **Thomas Gainsborough,**
Old Horse, 1770s.
Like many other artists of the day, Gainsborough used models of figures to help him plan his compositions. He constructed many of these himself. This, the only surviving one, was once owned by Constable.

72. **Thomas Gainsborough**, *A Wooded Landscape with Figures and Cattle in a Stream*, *c.* 1760–65. An imaginative landscape composition – perhaps one of those that he drew for relaxation when at home with his family in the evenings.

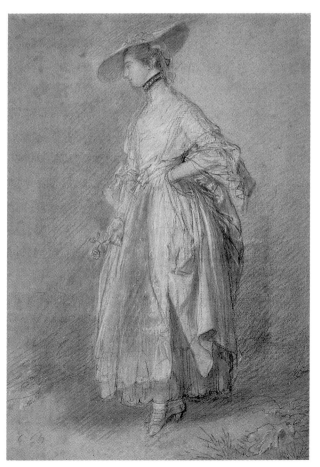

73. **Thomas Gainsborough**, *A Woman with a Rose*, *c.* 1763–65. A studio study of either a model or a lay figure. It shows the artist's fascination with the details of costume, the texture of fabrics and how they fall.

actually observed. Yet whether observed or imagined, his draw-
ings showed his virtuosity to greatest effect. 'If I were to rest his
reputation upon one point', wrote his somewhat acerbic friend
William Jackson, 'it should be on his drawings. No man ever
possessed methods so various in producing effects, and all excel-
lent – his washy, hatching style was here in its proper element.'
Jackson – who had an ungenerous and inaccurate view of his
friend's intellectual capacities – saw this as a matter of what he
termed 'facility'. 'His drawings almost rest on this quality alone
for their value; but possessing it in a eminent degree (and as no
drawing can have any merit where it is wanting) his works,
therefore, in this branch of art, approach nearer to perfection
than his paintings.'

Yet there was more to this 'facility' than Jackson supposed,
and, while most evident in drawing, it ran throughout his art. It
was the magic of the visual effect in which there was an exciting,
ever-changing interplay between pattern, design, texture,
colour and resemblance. This thoroughly modern sensibility
had its origins in the art and ideas of Hogarth. It is perhaps no
accident that the writer whom he appeared to have appreciated
most of all was Laurence Sterne. The author of *Tristram Shandy*
(1759–67) was himself a profound admirer of Hogarth and
referred several times to his serpentine 'Line of Beauty' in his
own explorations of the transient and accidental. Despite
his legendary aversion to books, Gainsborough read Sterne's
works avidly. The two met when Sterne came to Bath and struck
up a friendship. It is a tribute to this that Gainsborough named
one of the family's dogs 'Tristram'. From Sterne, Gainsborough
was able to gain encouragement to pursue an exploratory art
of psychological and pictorial complexity at a time when this
was coming increasingly under threat in the official world of
visual art.

Chapter 9: Music

Gainsborough was a keen, indeed a passionate, amateur musician. He played an astonishing variety of instruments – including the viola da gamba, the violin, the guitar, the flute and the harpsichord – and proclaimed himself happiest when doing so. 'I'm sick of Portraits and wish very much to take my Viol da Gamba and walk off to some sweet village', he wrote to his friend William Jackson some time in his late, busy years at Bath. Clearly music was a refuge for Gainsborough. But it is less clear how accomplished a musician he was, or how important it was for his career as a painter. Opinions differ on all these matters. Jackson, speaking in the severe tones of a professional, said that the artist was 'too capricious' to learn any instrument properly, 'though having a nice ear he could perform an air on the fiddle, the guitar, the harpsichord or the flute.' He seems to have been

74. **Thomas Gainsborough,** *Study of a Music Party,* early 1770s. A rapid, but highly evocative, sketch, perhaps recording one of the musical evenings that Gainsborough enjoyed at the house of the celebrated musical family, the Linleys.

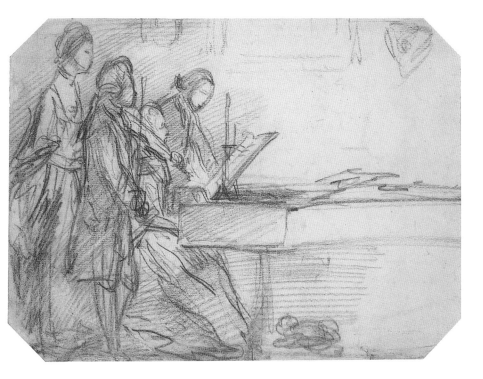

largely self-taught and more intuitive than learned in his approach. As Henry Bate-Dudley said in his obituary of the artist in the *Morning Herald* on 11 August 1788, 'He always played to the feelings.' Others, notably Thicknesse, spoke of his skills at improvisation. Had he lived now, he might well have been a jazz enthusiast.

This interest in spontaneity and performance might seem to relate to Gainsborough's pictorial interests – his rapid and instinctive way of working with all his 'odd scratches and marks'. He did, himself, often make musical analogies when talking of painting; as when he wrote to Jackson: 'One part of a picture ought to be like the first part of a Tune; that you can guess what follows, and that makes the second part of the Tune and so I've done.' It is tempting to believe that there is a certain lyrical flow in his forms that accords with the sensibilities of one who is accustomed to pursuing the course of a melody. Yet, we should be careful before making too much of his musical skills as a means of interpreting his art. The dynamics of his pictures can, after all, be accounted for in terms of Rococo influence and the Hogarthian aesthetic. Analogies between aural and visual form reach back at least to Pythagoras and were actively pursued in the eighteenth century – not least of all by the great scientist Sir Isaac Newton with his Colour Music Scale. But this was before the time when music became seen as the paradigm of pure form and was used as such by the aesthetes and abstractionists of early modernism, such as James Abbott McNeill Whistler (1834–1903), Vassily Kandinsky (1866–1944) and Paul Klee (1879–1940).

While discussion about the 'musical' element in Gainsborough's pictorial method must remain speculative, we are on safer ground when it comes to the consideration of his connections with musicians, many of whom he counted amongst his closest friends. Gainsborough's first known musical contacts were made during his time in Ipswich. If Thicknesse is to be believed, this is the first time the artist ever learned an instrument, though he soon developed a remarkable aptitude. He was, as has already been related, a member of the Ipswich Music Club and took part in their regular high jinks. Certainly the society of musicians appealed partly for this reason. His daughter Margaret told the academician Joseph Farington in 1799 that her late father's passion for music led him 'much into company with Musicians, with whom he often exceeded the bounds of temperance & His Health suffered from it, being occasionally

unable to work for a week afterwards.' These social contacts had a more professional side, however. Learning a musical instrument was regarded as a natural part of the education of a gentleman in the eighteenth century. Many of Gainsborough's patrons – such as Wollaston and Thicknesse – were keen amateur musicians. Shared interests certainly helped in obtaining commissions.

While the performance of music was a polite accomplishment, there was a fine social distinction to be maintained between the amateur and the professional. As with painting, it would have been disgraceful for a gentleman to earn money as a performer. In his book *Music and Image* (1988), Richard Leppert has pointed out that well-bred individuals are shown holding instruments, but not playing them in eighteenth-century portraits. One rare exception is Gainsborough's portrait of the Reverend John Chafy exercising his cello in the open air. The reason for this is probably that this is an early provincial portrait, relating to a former tradition of performance that had not quite died out. Wollaston, painted in a grander style a few years later, fingers his flute, but does not place it to his lips. Even Ann Ford, who had committed the disgraceful act of performing on stage, has herself holding, but not playing the instrument of her downfall. It is worth recalling, too, that when she became the

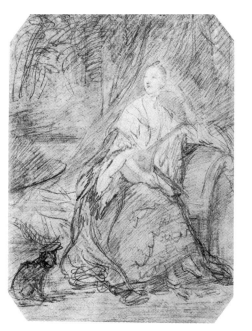

75. **Thomas Gainsborough,**
Study for Portrait of Ann Ford,
c. 1760. A compositional study
for the portrait of Ann Ford
(see plate 57).

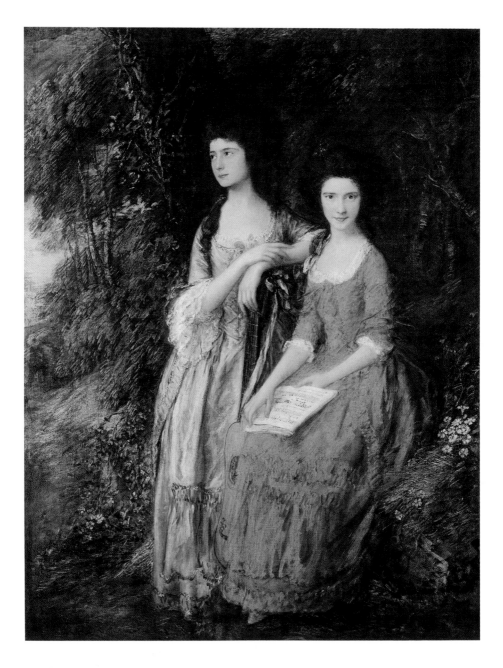

76. **Thomas Gainsborough**, *The Linley Sisters*, 1772.
A double portrait of Elizabeth and Mary Linley, both celebrated
singers, seated romantically in a glade. At the time they were
painted Elizabeth was on the point of eloping with the playwright
Richard Brinsley Sheridan.

respectable Mrs Philip Thicknesse she abandoned all attempts at a professional career in music.

Gainsborough's musical acquaintanceships greatly increased when he went to Bath. He was particularly close to the celebrated Linley family. Thomas Linley was a highly successful singing teacher and composer who was largely responsible for the Assembly Room concerts. Gainsborough's spirited drawing of a musical evening may well have been made at his family's house. In 1775, Linley had a noted success in London with the opera *The Duenna*. Most of the music was, in fact, written by his brilliant son, also called Thomas, who died tragically in an accident three years later. Linley's daughters Elizabeth and Mary were singers of the highest accomplishment who performed frequently in oratorios and were successively leading sopranos at the Three Choirs Festival. Gainsborough painted several portraits of them, including the celebrated double picture which was exhibited at the Royal Academy in 1772, when they were respectively eighteen and fourteen. They are shown more as young women than as performers. Romantically situated on a wayside bank beside wild flowers, they display the beauty and elegance for which they were famed. Mary, the younger and more ebullient of the two, fixes us with an impish gaze. Elizabeth, more modest and unassuming, stands behind her and stares abstractedly out of the picture. Perhaps she was already dreaming of the man with whom she was to elope a few months later – Richard Brinsley Sheridan. The elopement caused a rift. Thomas Linley had no time for a penniless actor. Only after the success of Sheridan's *The Rivals* in 1775 was there a reconciliation. Linley later went into partnership with Sheridan at Drury Lane, London, where *The Duenna* was staged with such success. Respectability was restored. Part of the price of this was that Elizabeth, as a married woman, gave no more public performances.

Bath was also where Gainsborough first met William Jackson. Although earning his living principally as a teacher of music (and from 1777 as cathedral organist) in his native Exeter, Jackson also had a reputation as a writer of songs. In 1780 he had a striking success with his opera *The Lord of the Manor* at Drury Lane. This success was not repeated, however, and in his last years he turned to critical writing. It is from this period that his somewhat acerbic remarks about Gainsborough's abilities come. Gainsborough's letters to him during his Bath period suggest a happier relationship. At the time Jackson was also practising –

74

with tolerable ability – as a landscape painter, and the generous encouragement Gainsborough gave contrasts strongly with the disparaging views that the composer expressed about the artist's musical amateurism.

Gainsborough also built up strong friendships with many of the foreign musicians then working in the lucrative venues of London and Bath. He was particularly close to the leading violinist of the day, the Italian Felice de' Giardini, and to the German performers and composers Johann Christian Bach and Karl Friedrich Abel. Bach, the youngest of Johann Sebastian's sons, settled in England in 1762, after having studied in Italy. A Catholic convert, he brought a southern wit and lyricism to the Germanic tradition, prefiguring in some ways the music of Mozart, who greatly admired him. In 1776 he was invited to send a portrait of himself for a gallery of famous musicians being formed in Bologna, Italy. Quite naturally, he chose Gainsborough to do the job. The resultant image is a masterful character study that shows the musician as a confident,

77. **Thomas Gainsborough,** *Johann Christian Bach, c.* 1776. The youngest son of Johann Sebastian Bach, Johann Christian established himself in London where he ran a series of highly successful concerts with his friend and fellow German Karl Friedrich Abel. This picture is a copy of a work commissioned by the academy at Bologna in Italy.

78. **Thomas Gainsborough,** *Karl Friedrich Abel,* 1777. Abel was the most celebrated viola da gamba player of his day. He is shown here, however, in his role as composer.

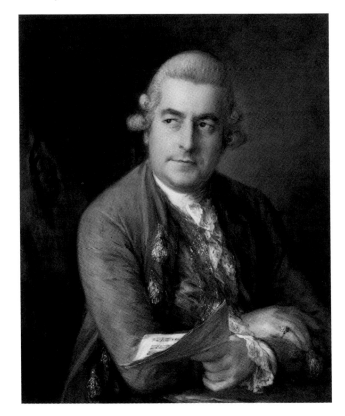

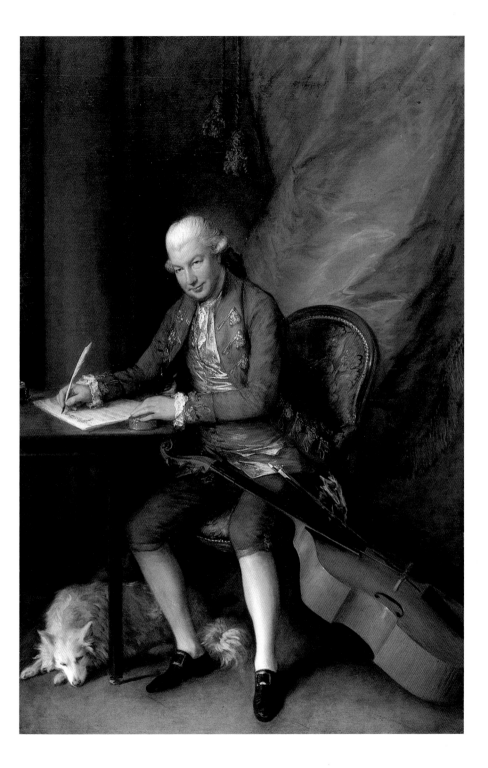

good-humoured man. Leaning forward purposefully, he thrusts a score (presumably his own) towards us, out of the picture space. Bach seems to have shared with Jackson some of the professional musician's irritation at the artist's musical efforts. Coming across him trying yet one more instrument – this time a bassoon – and puffing and making a dreadful noise, the German exclaimed, 'Pote it away man; pote it away…do you want to burst yourself like the frog in the fable?' The criticism expressed by Bach and Jackson is a sign of the growing distinction between their sphere and that of the amateur. The coming of subscription concerts increased this separation. Musical performances became more staged events, matters of virtuoso display. It was a change analogous to the growth of exhibitions in the visual arts.

Gainsborough seems to have had a warmer relationship with Abel. A close friend of Bach, the two ran a series of subscription concerts together in London, first in Soho Square and then in Hanover Square, where they had a purpose-built concert hall for which Gainsborough provided decorative illuminated panels. The great master of the viola da gamba, Abel knew he was performing and composing for an instrument rapidly going out of fashion. Perhaps it was for this reason he asked that his instrument be buried with him when he died. He was a practitioner of great sensitivity and finesse. The feeling in his work and playing appealed to Gainsborough who emulated this tolerably well in his own da gamba playing. The portrait he painted of him and exhibited at the Royal Academy in 1777 is one of his finest. The composer performer is shown leaning forward towards the table where he is writing, his viola da gamba resting on his knee, his dog lying patiently on the floor by his feet. There is an absorbed inwardness in his countenance, as though he were enwrapped in one of his own haunting melodies. The artist seems to have picked up on a stoop noticed by a satirist who recorded Abel performing. He has used this to emphasize a gentle attentiveness. Nothing could be more different from the enfolding rhythms of this work than the cocksure stance of the celebrated oboist Johann Christian Fischer, the man who made a disastrous marriage with one of Gainsborough's daughters, and about whom Gainsborough had serious personal misgivings.

In these portraits of his musical friends and acquaintances Gainsborough showed the same shrewd perception of character that he did for other work. They do not form a 'genre' or particular type. With the exception of early conversations and the Linley sisters, however, they are all placed in interiors, a setting

he tended to keep for his more intimate work. It is striking, too, how even professional musicians avoid being shown actually playing their instruments. It was in the nobler role of composer that Bach, Abel and Fischer had themselves represented.

These portraits do not resolve the question of the extent to which Gainsborough's musicality affected his work as a fine artist. They do suggest, however, the respect and affection he had for music and musicians. Perhaps his admiration of a sister art made him more aware of the truly pictorial characteristics of his own, the rhythms of design, the harmonies of colour arrangement, the tonal balances of light and shade. In this way, it may have helped him to become a purer and profounder visual artist.

79. John Nixon,
Karl Friedrich Abel, 1787.
A satirical drawing of Abel
performing in concert.

Chapter 10: The Old Masters

80. **Anthony van Dyck,**
George Villiers, 2nd Duke of Buckingham and his Brother Lord Francis Villiers, 1635. The elegant portraits of Van Dyck had a profound influence on the development of grand portraiture in Britain. Gainsborough used him increasingly as a model from the time he set up studio in Bath, paying particular attention to his poses and the brilliance with which he captured the effects of rich fabrics.

81. **Thomas Gainsborough,**
The Blue Boy, ?1770. The vogue of painting sitters in the costumes of Van Dyck portraits had grown in Britain since the 1730s. This work, now Gainsborough's most famous painting, shows a mastery of this genre that remains unsurpassed.

Gainsborough's best-known work is *The Blue Boy*. It shows a cool and elegant youth fixing us with his gaze as he stands, hat in hand and arm akimbo, before a moody landscape. It is a masterful image, and yet it is one of his most derivative pictures. Its costume, pose and painterly technique are all based on the portraits painted by the great Flemish artist Anthony Van Dyck (1599–1641) for the court of Charles I in the previous century. There was no subterfuge about this. Portraits *à la Van Dyck* had been in vogue since the 1730s. They were tribute images to the painter who was held to have brought the courtly portrait to Britain and who remained its unrivalled master. Gainsborough was claiming with this work that the master could, in fact, be rivalled. That he should feel the need to make this claim is a sign both of his growing ambitions and of the increased expectations of British art at the time. The picture was probably exhibited at the Royal Academy in 1770, two years after that august institution had been established. Its first president, Sir Joshua Reynolds, had already delivered two of his celebrated *Discourses*, in which he stressed the need for British artists to master the higher reaches of art, painting historical works in the 'great style' that had been initiated by the sculptors of Classical antiquity and renewed by the Italians during the Renaissance. True to the academic tradition, he believed there was one standard of ideal beauty, valid for all time, and that it was the duty of British artists to acquire the power to represent this by emulating the works of the Old Masters and absorbing their values and expertise.

Reynolds had set a practical example of this theory long before, when he returned to London from his studies in Italy in

82. **Joshua Reynolds,** *Commodore Augustus Keppel,* 1753. On his return from Italy in 1753, Reynolds popularized a new form of grand portrait, in which individuals were shown in poses based on classical statues. This portrait of his friend, a naval officer, appears to be based on the Apollo Belvedere.

83. **Thomas Gainsborough,** after **Van Dyck,** *Lords John and Bernard Stuart,* early to mid-1760s. Gainsborough used to travel to country houses near Bath where he could study the works of Old Masters. It was probably on such a journey that he made this study of a Van Dyck portrait.

1753. It was then that he had produced his celebrated portrait of Commodore Keppel, a work that subsequently remained on display in his studio for seventeen years. Keppel was not a historical painting, but it was the next best thing. It was a portrait ennobled by adopting the classical pose of a statue of Apollo.

In his *Discourses,* Reynolds made it clear that, while historical painting was the noblest form of art, 'lesser' types of art could be improved by adopting some of its characteristics. It was for this reason that he argued for 'breadth' in portraiture, expressing ideal character at the expense of individual features. The point was a social one as well as an aesthetic. For it was the 'intellectual dignity' of the great style, he argued, 'that ennobles the painter's art; that lays the line between him and the mere mechanick.' Gainsborough, who certainly had no wish to be thought a 'mere mechanick' had been ennobling his art in his own way ever since he had come to Bath. Previously he had sought to enhance his manner by emulating Hogarth. But *Ann Ford* is the last work that makes direct use of the British master's lively 'Line of Beauty'. By this time, Reynolds had already belittled Hogarth's theory in his essays on taste in Dr Johnson's *The Idler* (1759). Even if he did not know of *The Idler,* Gainsborough would have heard of the *débâcle* when Hogarth had attempted to paint a picture – *Sigismunda* – in the Italian style and had been dismissed as a vulgar fellow incapable of the 'intellectual dignity' necessary to achieve ideal beauty. Gainsborough remained a Hogarthian in his liveliness and spontaneity, but he looked elsewhere to give his work grandeur.

Gainsborough had not been to Italy. Nor had he had the benefit of a classical education. However, he did have access in Bath to several fine collections of Old Master paintings in country houses, such as Corsham, Stourhead and Wilton, in the region. He made copies of works, including several of portraits by Van Dyck, such as that of *Lords John and Bernard Stuart.* From such studies he absorbed the repertoire of elegant Renaissance poses that Van Dyck had himself acquired through study in Italy. He also learned how to refine his painterly manner, using longer and more graceful brushstrokes, richer tones and more vibrant colour harmonies. By and large, Gainsborough focused on Flemish masters and in doing so he was making a shrewd choice. Flemish painting had already been hugely influential in Britain, brought over by émigrés since the seventeenth century. Associated with the Catholic court in Brussels, it combined a degree of Netherlandish realism with courtly elegance.

57

The Blue Boy was painted after Gainsborough had been making such studies for nearly a decade. It shows how well he had learned his lessons. According to an old tradition, it was actually painted to counter a remark by Reynolds about the use of colour. Taking the example of the Venetians, Reynolds claimed that 'cold' colours – such as blues, greens and greys – should be kept out of the 'masses of light in a picture'. These should be 'always of a warm mellow colour, yellow, red, or a yellowish white', while the cold colours should be kept to support and set them off in the surrounding parts. If this rule was not observed, Reynolds warned, 'it will be out of the power of art, even in the hands of Rubens or Titian, to make a picture splendid and harmonious.' It is easy to see why *The Blue Boy*, with its cool central tones and warm background, might seem to be picking up the challenge of that remark. Yet the remark comes from the seventh *Discourse*, delivered six years after the picture was exhibited at the Royal Academy. If anything, Reynolds was fighting a rear-guard action here, trying still to claim that his rival had made a mistake. Prior to the exhibition of *The Blue Boy*, Reynolds had himself painted many portraits *à la Van Dyck*. Afterwards he abandoned the practice for many years. In the seventh *Discourse* he singled out the practice as 'fantastical' and a means by which 'very ordinary pictures acquired something of the air and effect of the works of Vandyck, and appeared therefore at first sight to be better pictures than they really were.'

Setting this catty remark aside, we can see – as many professors of art have stressed – that Gainsborough is breaking a convention here. All things being equal, warm colours tend to advance and cool colours recede in a picture. He has deliberately reversed the normal order here – though it is something Van Dyck did himself on occasion. What Reynolds is refusing to acknowledge is that Gainsborough has done something out of the ordinary to achieve a very particular effect. His cool central tone gives a febrile air to the picture which seems to fit the changeable moods of adolescence. Gainsborough is not painting to achieve some generalized 'ideal beauty', he is painting a particular beauty, a poignant evocation of one of the most transitional moments of life. In doing this, he has picked up on the wistful mood of Van Dyck's portraits of the collapsing world of Charles I's court, doomed to destruction a few years later in the Civil War (1642–46). But he has transposed it to a new world of yearning, the early romanticism of the later eighteenth century. It is worth remembering that the sitter, Jonathan Buttall,

84. **Peter Paul Rubens,**
The Watering Place, c. 1620.
While known principally for his
large figure compositions, the
great Flemish painter Rubens
was also a painter of ebullient
landscapes. Their combination
of local scenery and painterly
bravura appealed to
Gainsborough.

85. **Thomas Gainsborough, after
Rubens,** *The Descent from the
Cross,* early to mid-1760s.
A copy of the central panel
of Rubens' altarpiece in the
cathedral at Antwerp in Belgium.
It was probably made from an
engraving. The artist used the
design as a basis for figures in *The
Harvest Wagon* (see plate 86).

was no aristocrat. He was the son of a *parvenu*, a wealthy Soho ironmonger. Here he is aping an aristocratic fashion from a bygone age. It is possible Gainsborough was simply using him as a clothes horse here, trying out a type of work for which there was – despite Reynolds' censures – still a healthy demand. However, there is probably something more personal involved. Buttall was a close friend, who was to be a pall bearer eighteen years later at the artist's funeral.

At the same time as he was remodelling his portrait style with the help of Van Dyck, Gainsborough was moving away from the meticulous Dutch manner of his early landscapes under the influence of the more painterly Flemish and Italian paintings he was seeing. Rubens became particularly important to him. The Flemish master had painted ebullient views of the local terrain around his country estate near Antwerp. As will be seen in Chapter 12, such works provided a key to Gainsborough for his own idyllic re-interpretation of the local scenery around

86. **Thomas Gainsborough**, *The Harvest Wagon*, 1767. An idyllic harvest scene that owes much in mood to the landscapes of Rubens. It also, surprisingly, makes use of the composition of figures in Rubens' *The Descent from the Cross* for the carousing peasants in the cart.

Bath. Gainsborough also used Rubens to help him with complex figurative compositions. The Flemish artist was first and foremost a painter of historical and religious subjects. Gainsborough made a copy – probably from an engraving – of *The Descent from the Cross* (1611–14) – the central panel of Rubens' great altarpiece in Antwerp Cathedral, Belgium. There was nothing in Gainsborough's training to give him the means of designing such arrangements and he was doubtlessly striving here to enlarge his repertoire. But what is most extraordinary is the use he finds for these intertwined figures. Their general arrangement reappears in the group of peasants on and around the cart in *The Harvest Wagon*, exhibited at the Society of Artists, London, in 1767. This almost seems to be a parody of Reynolds' habit of quotation – an exercise in inappropriateness. Rubens' tragic image of the dead Christ being lowered from the cross is used not

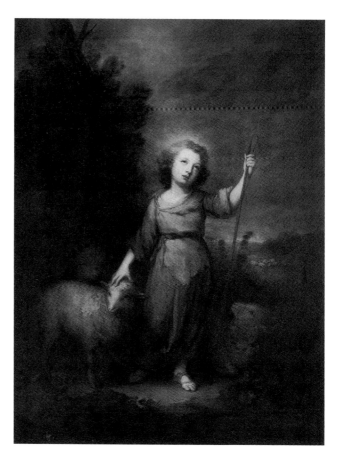

87. Thomas Gainsborough, after Bartolomé Esteban Murillo, *The Good Shepherd*, c. 1778. Later in his career Gainsborough became interested in the figurative scenes of the Spanish painter Murillo, using many of them as the basis for his own 'fancy pieces' of poor children in landscapes.

to dignify some grand moment of pathos, such as that of a dying hero, but it is adapted to shape a disparate array of carousing rustics. The Saviour's pallid corpse has become a girl resting, fetchingly *décolleté*. The mourners releasing his arm from the cross have become a pair of topers, vying for the cider barrel. Could someone as religious as Gainsborough have been knowingly committing a blasphemy here? It seems more likely that he was simply engaged in a formal experiment, in a bid to give more grandeur to his work. It cannot have been one that he found particularly satisfactory as he abandoned it in later renderings of the theme.

Gainsborough continued to study the Old Masters throughout the rest of his career, but he did so selectively. He added the painterly Spanish and Venetian schools to his repertoire, using them particularly for the 'fancy pieces' that gained him so much praise. He retained a particular affection for Watteau, and adapted the French master's *fêtes galantes* for contemporary scenes of social intercourse. By making such associations, he could be seen to be 'legitimizing' his art, giving it the historical backing expected by the Academy. He was doing so, however, on his own terms.

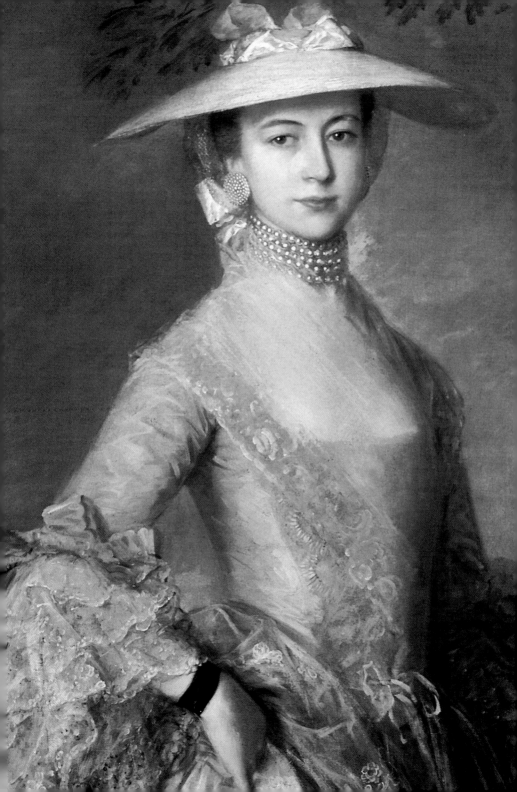

Chapter 11: Grand Portraits

Despite Gainsborough's own preference for landscape, it was portraiture that made his name when he was in Bath. His grander representations were particularly important for this. From the time that he displayed *Ann Ford* in his studio, he made 57 it clear that he had the resources to produce a major painting of a woman. Over the next few years he produced a series of brilliant examples in this mode. His *Countess Howe* reached unprecedented heights with its stunning combination of *hauteur* and sensual delight. Another work of the period, *Lady Alston*, is 90 equally successful in conveying a quieter mood. Coolly attired in a ruched blue dress and flowing silken gown, she wanders through a darkened glade. While the Countess walks with an arm akimbo, boldly looking you in the face, Lady Alston modestly folds her forearms and glances away from you, out of the picture. Both pictures take Van Dyck as a starting point, but only as a starting point. They match the Flemish master in elegance, but show a new type of grand portrait in which temperament and mood are more varied.

Above all, these ladies are more independent and individual than their equivalents at the court of Charles I. They belong to a different society, in which the female voice had greater sway. By our standards opportunities for women in the later eighteenth century were still hugely restricted, but they were greater than they had been, particularly for the wealthy and the aristocratic. The change had been taking place gradually during the eighteenth century, aided by a progressive increase in wealth in Britain and the growing power of domesticity. Such changes had already begun to become visible in conversation portraits earlier in the century, where the domestic sphere is given a distinct, if limited, place. But in the age of George III these changes were expressed with greater style in a new kind of 'grand portrait'. There was a new culture of display in London – greatly augmented by the arrival of exhibition societies. There was also an increasingly rhetorical mood, fuelled by growing conflict. In the forty-six years of the combined reigns of the first two Georges (1714–60) there were nine years of war and in the sixty years of George III's reign (1760–1820) there were thirty-one. Military

88. **Thomas Gainsborough**, *Mary, Countess Howe* (detail), c. 1763–64. A detail of one of Gainsborough's finest portraits, showing the great attention he paid to jewelry and costume. See plate 2 for a full reproduction.

90. Thomas Gainsborough,
Lady Alston, 1761–62.
A fine example of the type of elegant grand female portrait that Gainsborough created in his first years in Bath.

89. Joshua Reynolds,
Captain Orme, 1756.
Reynolds dominated portraiture in London after his return from Italy in 1753. In later years Gainsborough was considered by many to be his rival, and to surpass him in some areas. Reynolds remained unrivalled however in his depiction of men of action, particularly military officers.

heroes were an almost constant presence, and they could be shown largely against a backdrop of success, of a gradual wresting of territories and wealth from the enemy – usually the French. At home, too, with the growth of parliamentary power, a new stage opened up for the warrior politician, the great speech-makers such as William Pitt the Elder, 1st Earl of Chatham who needed to be shown in commanding patrician roles. This was the world of authority – military and civilian, spiritual and intellectual – that Reynolds was so well formed to represent and for which he invented a new pictorial form. Just as Reynolds can be said to have re-invented the male grand portrait in the 1750s, finding a new and more active mode suitable for naval and military gentlemen such as Commodore Keppel and Captain Orme, so Gainsborough can be said to have re-invented the female grand portrait in his early years at Bath.

Gainsborough was less successful, however, in finding an equivalent formula for his male subjects. This was not just because of his notorious weakness for the petticoats. Some of his finest and most perceptive portraits – for example, that of Abel, are of men. But he rarely succeeded with the domineering type. It is not often remembered these days that *Countess Howe* is a pendant picture to that of her husband, *Admiral Earl Howe*. Howe was one of the most successful admirals in British history. Yet in Gainsborough's picture he looks less capable of putting an enemy to flight than his commanding wife. It is painted decently enough, with appropriate nautical attributes, yet it could hardly stand against Reynolds' *Commodore Augustus Keppel*, a celebration of the survival from shipwreck of a much less distinguished naval officer. What Gainsborough had trouble mastering was that sense of public rhetoric which seemed to emanate so naturally from those figures celebrated by Reynolds who had a sense that they were born to rule. He, himself, was deeply suspicious of the grand style as defined by Reynolds. After reading Reynolds' fourth *Discourse* in which the grand style is expounded, he remonstrated in a letter: 'Everyone knows that the grand style must consist in plainness and simplicity, and that silks and satins, Pearls and trifling ornaments would be as hurtfull to simplicity as flourishes in a Psalm Tune; but Fresco would no more do for portraits than an Organ would please Ladies in the hands of Fischer; there must be variety of lively touches and surprising Effects to make the Heart dance, or else they had better be in church – so in Portrait Painting there must be a Lustre and finishing to bring it up to individual life.'

82

It is this 'variety of lively touches and surprising Effects', this 'Lustre and finishing', that enlivens Gainsborough's own version of the grand portrait. He is much better in the world of ambiguities and uncertainties, of desires and the sense of transience. It is typical, too, that he should implicitly mount his attack on Reynolds' grand style in terms of female portraiture. His grand female portraits still retain something of the aesthetic of motion so celebrated by Hogarth, and of that sensuousness that Gainsborough absorbed from the Rococo. It would be fair to say that he probably did not regard such works as 'grand' portraits at all. Many of his female portraits are enlivened by a sexual *frisson*, but intimacy does not have to mean this. It can also be about tenderness. Only one other painter in Britain at the time could match Gainsborough in this area. This was the Scot Allan Ramsay who had been the leading portrait painter in London before Reynolds' return from Italy and who still had considerable sway. The continental-trained Ramsay painted in a finer and more detailed manner than most British artists. His delicate portrait of his wife is one of the finest pictures of the age. It shows a perfect understanding of contemporary French and Italian portraiture, and combines this with the fleeting sensibility more evident amongst British practitioners. Mrs Ramsay is tending some flowers and turns to view us slightly anxiously, as

91. **Allan Ramsay**, *The Artist's Wife (Margaret Lindsay of Evelick)*, c. 1758–60. A generation older than Gainsborough, the Scottish painter Allan Ramsay was the leading portraitist in London prior to the emergence of Reynolds. This exquisite painting of his second wife shows a mastery of the kind of intimate female portrait innovated by Rococo painters in France.

though we have just disturbed her. It was such work that caused Horace Walpole to observe that Ramsay seemed 'formed to paint women', whereas Reynolds rarely succeeded with them. Ramsay's intimate style also appealed to George III, who made him his principal painter when he came to the throne in 1760. The public rhetoric of Reynolds was less appealing to him. Later, when Ramsay had retired, the King was to patronize Gainsborough, who was in many ways Ramsay's successor in the intimate mode. Yet Gainsborough has a softer manner and could perhaps handle more wistful moments. When, for example, he painted the ageing Mary, Duchess of Montagu he did so with a tenderness that showed beauty without denying the effects of age. As so often in female portraits, the Duchess holds some flowers in her hands, but, here, they have slipped into shadow as though to emphasize their role as a symbol of transience.

Yet Gainsborough could not occupy a central place in the portrait practice of his day without facing the problems of the more public kinds of portraiture. A challenge was set to him in 1766 when he received a commission to paint David Garrick, the most celebrated actor of his age, for the Town Council of Stratford-upon-Avon – a gesture in recognition of the role that the great thespian had played in restoring the fortunes of

95

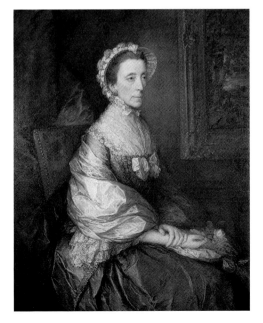

92. **Thomas Gainsborough,**
Mary, Duchess of Montagu,
c. 1768. A moving depiction of an older lady. The Duchess was a friend and supporter of the artist.

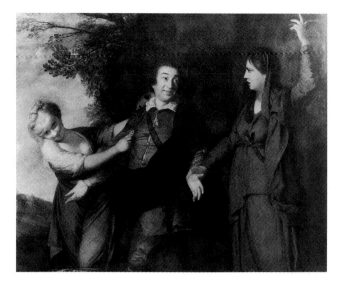

93. (right) **Joshua Reynolds,** *Garrick between Tragedy and Comedy*, 1762. Garrick, the leading actor of the age, had himself depicted by most major portraitists of the day. In this work, Reynolds places him in an allegory, in which he is having to choose between comedy and tragedy. He appears to prefer the former.

95. (opposite) **Thomas Gainsborough,** *Garrick and Shakespeare's Bust*, 1766. Commissioned by the town council of Stratford-upon-Avon, this picture portrays Garrick paying homage to Shakespeare. It shows how Gainsborough was not really comfortable with grandiose and rhetorical themes.

94. Monument to William Shakespeare, designed by William Kent, the figure executed by Peter Scheemakers, 1740. Shakespeare's work was reassessed in the early eighteenth century, leading to the dominance in English literature that he has enjoyed ever since. Scheemakers' memorial was created as a result of the renewed interest in the bard.

Stratford's greatest son, William Shakespeare. Garrick was one of the most depicted individuals of the age. He knew well enough the value of portraits for promoting his reputation. Five years previously he had been transformed by Reynolds into a historical composition in *Garrick between Tragedy and Comedy* in which, in a parody of the classical subject, of the 'choice of Hercules', he is shown choosing the former over the latter – a reference to his own successful career as a writer of comedies. In Gainsborough's work he had a more reverential role to play – looking up in affection and respect to a bust of the immortal bard. Yet it almost seems as though comedy has once again got the upper hand. For Garrick is surely making too free with his hero, as he lounges against the effigy as though they were drinking companions. Shakespeare, it must be confessed, does not look at all amused. It may be that Gainsborough tried to take a leaf out of Reynolds' book by 'ennobling' his image of Garrick through basing it on a sculpture. It has been remarked that there is more than a passing resemblance between the actor's pose and the celebrated statue of Shakespeare by Peter Scheemakers (1691–1781). This might have been a reference that contemporaries could have picked up on. However, the pose is common enough and not much different from that used by him for William Wollaston or Sir Edward Turner. If this was a 'historical' reference it was not well put.

Gainsborough wisely kept away from military heroes, at which he had even less likelihood of success than with civilian

celebrities such as Garrick. However, sometimes it was unavoidable, as when he found himself more or less commandeered by his friend Lord Pitt into doing a pendant pair of his daughter and son-in-law, Lord and Lady Ligonier. Ligonier was a military gentleman and Gainsborough had a brave stab at showing him in uniform about to ride a favourite horse. When exhibited at the Academy in 1771, critics complained with some justice of the overbearing size of the horse. Doubtless some of them would have had in mind the grand way in which Reynolds had solved a similar problem in his fine portrait of the equerry Captain Orme. In this work, Reynolds has the huge steed bend its head down so that Orme towers above it. This both adds dynamism to

89

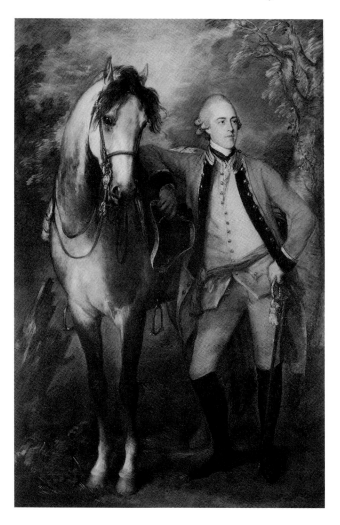

96. **Thomas Gainsborough**, *Lord Ligonier*, 1770. Perhaps because of Reynolds' dominance in this field, Gainsborough tended to avoid military portraits. This one was criticized when exhibited because the horse was thought to be too prominent.

the composition and makes the man look heroic, as he rushes forward with an important message in his hand. In fact, Orme had a highly undistinguished career and was probably no better a man than the avowedly brainless Ligonier. The problem for Gainsborough was that he could not ennoble a dolt with 'character' in the way that Reynolds could. His manner of portraiture was too fatally bound up with observation. Doubtless he could see all too well what soon became evident in a scandal that broke as the pictures were being exhibited – that while His Lordship was besotted with horses, Her Ladyship had a preference for grooms. Lady Ligonier leans against a plinth, wearing one of the abstractly classical gowns that Reynolds had brought into

97. Thomas Gainsborough,
Lady Ligonier, 1770.
Gainsborough has portrayed the Viscountess in a classicizing costume similar to that used by Reynolds in his female portraits. This may have been to make the picture match the grandeur of the companion one of her husband (see plate 96).

fashion, and that Gainsborough had so objected to when painting Lady Dartmouth a couple of years earlier. He has also adopted Reynolds' mode by placing a statuette on the plinth. This is of a dancing satyr and could be a prescient allusion to the Lady's amorous proclivities. Probably it was justified at the time as a reference to her interest, as an amateur artist, in the antique.

Gainsborough succeeded far better with less bellicose males, such as with the Duke of Buccleuch – a man presumably as soft on a dog as he was himself. There is a touching incongruity in the way this man – of the same family as Gainsborough's friend the elderly Duchess of Montagu – has allowed posterity to witness this almost embarrassing display of intimacy while proudly besporting the insignia of a knightly order on his jacket.

The artist could also succeed with men of business – men presumably like his practical cousin John Gainsborough who

98. **Thomas Gainsborough**, *Henry, 3rd Duke of Buccleuch*, 1770. The Duke of Buccleuch was a friend of the artist and appears to have shared his affection for dogs.

99. **Thomas Gainsborough**, *Sir Benjamin Truman*, 1770–74. A magnificent portrait of a no-nonsense self-made industrialist, founder of the celebrated Truman brewery.

had helped his hapless father out when he fell on hard times –
such as Sir Edward Turner (1762), one of his earliest Bath clients,
who had recently come into money, and clearly spent quite a bit
of it on a staggeringly elaborate coat of brocaded French silk.
Despite such attire, the *nouveau riche* gentleman stands in a no-
nonsense way holding the back of a chair in the artist's studio.
Even later, when Gainsborough was wont to obscure the con-
text of the sitting and set his gentlemen out walking in invented
romantic landscapes, he lost none of his acuity in perceiving
personality. In his last years at Bath he portrayed Sir Benjamin
Truman, founder of the famous brewery. No amount of poetic
ambience can disguise the fact that we are being confronted with
a very down-to-earth character. He clasps a stout stick with a fist
that seems all too used to banging the table at business meetings.
His face, unmoved by the glories of nature surrounding it, is
not the sort to be taken in by flattery. Stout, plain-dressed, and
proud of it, he is the epitome of the forthright manufacturers
who were driving the country to a new level of commercial
achievement. Gainsborough has noticed all this and recorded it
with, one suspects, some slight amusement. In the crown of
the hat that Truman holds so firmly in front of him, the artist
has clearly inscribed the name of the maker, as though to mock
his client's literalness and insistence on value for money. For
a fleeting moment he has returned grand portraiture to the
world of Hogarth.

The encounter with the grand portrait had been a necessary
one that led to losses as well as gains. The freshness of
Gainsborough's Suffolk work was gone for ever. However,
despite the more elaborate packaging in this new form of
portraiture, the artist remained as sensitive as ever to observa-
tion – to the perception of character and the liveliness of
individual appearance.

Chapter 12: The English Arcadia

Gainsborough continued to have a problem finding a profitable market for his landscapes in his mid career. However, he did enjoy increasing critical acclaim for them. When he exhibited *The Watering Place* at the Academy in 1777 Horace Walpole, the leading connoisseur of British art, described it as being: 'In the style of Rubens, & by far the finest landscape ever painted in England, & equal to the great masters.' Approval of his landscapes was to grow in the decades after his death, when he came to be seen as the quintessential portrayer of the English countryside. In his important *The Lives of the Most Eminent British Painters* (1829–33), Allan Cunningham wrote: 'A deep human sympathy unites us with his pencil, and this is not lessened because all its works are stamped with the image of old England; his paintings have a national look.'

 On the face of it, there would seem to be a contradiction between Gainsborough's landscapes having a 'national look', while being 'in the style of Rubens'. The discrepancy reflects to some extent the different concerns of two different generations. Yet Walpole, no less than Cunningham, was keen to see a national school of landscape arise and thought Gainsborough one of those who could achieve it. Writing in his own seminal history of British art, *Anecdotes of Painting* (1762), Walpole thought that the current wealth of Britain, combined with the taste for landscape evidenced in the recent vogue for landscape gardening, meant that: 'enough has been done to establish such a landscape school, as cannot be found on the rest of the globe. If we have the seeds of a Claude or Gaspar amongst us, he must come forth.'

 There were patrons, too, who were keen to see this happen. In the late 1760s Lord Shelburne commissioned paintings from Gainsborough, Richard Wilson and George Barret (d. 1784) for his Wiltshire home, Bowood House, with which he 'intended to lay the *foundations of a school of British landscape.*' Gainsborough certainly responded to such calls while he was at Bath. During this period he re-formed his landscape. True to the precepts of Walpole, he sought to present an idealized British scenery ennobled by a study of the Old Masters. As Walpole discerned,

100

123

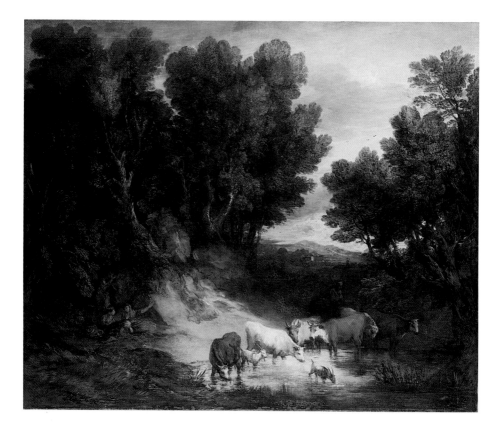

100. **Thomas Gainsborough**, *The Watering Place*, 1777.
This work shows the new form of idyllic landscape
that Gainsborough perfected while in Bath. It combined
the compositional and lighting effects of the Old Masters
with scenery studied by the artist in the hills of Somerset
and Wiltshire.

Gainsborough replaced the detailed realism that he had originally learned from Dutch masters such as Ruisdael and Wijnants with the grandeur and breadth of Flemish and Italianate landscapists. However, it is far from being mere pastiche. We can see this clearly enough if we compare *The Watering Place* with the Rubens which, by common consent, seems to have been his starting point for this picture. Rubens' *Peasants with Cattle by a Stream in a Woody Landscape* (*c.* 1620), 84 also known as *The Watering Place*, is now in the National Gallery, London, but was then in Montagu House in London, where Gainsborough would have seen it. In the place of Rubens' ebullient daytime scene, with peasants bustling about, Gainsborough has evoked a meditative mood. The figures are seated in the shade at sunset. Even the cattle, highlighted in the foreground, have picked up the mood. They do not meander to and fro as in Rubens' work, they dutifully line up at the water's edge to form a tasteful arrangement. Much of this Arcadian tranquillity comes in fact from Italianate rather than Flemish painting, from Claude Lorrain (1600–82) and Gaspard Poussin (1615–75). Gainsborough has shaped these different influences together to form a harmonious whole, and one that both he and his admirers felt to be particularly relevant to English scenery in his own day.

The wistful mood of the work relates to a growing perception in the 1760s that 'old England' was disappearing as rural communities were broken up at the hands of 'improvers'. It was the climate in which the 'nature' poetry of writers such as Thomas Gray and Oliver Goldsmith took on a particular poignancy. The latter's *Deserted Village* (1770) was apparently initiated in protest at the destruction of the Oxfordshire village of Nuneham Courtenay to make a garden for Lord Harcourt in 1761. As well as writing movingly about the ruined site, Goldsmith also invokes an image of the traditional rural worker for whom 'Light labour spread her wholesome store; Just gave what life required but gave no more.' Such a labourer was independent and self-regulating. He did what was sufficient, but no more. He was to be contrasted with the work slave on the modern improved farm, who had lost the right to common land through enclosure and who now had to engage in backbreaking toil as the inadequately paid employee of a landlord.

Despite his notorious aversion to books, Gainsborough was aware of the works of such poets, as is clear from remarks he made in his letters. In the 1760s he began to introduce a view of rural life in his work that evoked the traditional, easeful society

101. **Thomas Hancock,** after Thomas Gainsborough, *The Rural Lovers*, c. 1765–70. Gainsborough's rural scenery was adapted in his lifetime to decorate jugs and other domestic utensils.

102. **Paul Sandby,** *The Gate of Coverham Abbey, Yorkshire*, 1752. Paul Sandby was the leading topographical draughtsman of his day. After he had abandoned such work himself, Gainsborough recommended Sandby to a client on one occasion. The intention may have been ironic.

103. **Richard Wilson,** *The Destruction of Niobe's Children*, 1760. Wilson, who had studied in Rome, was the principal representative of classical landscape in Britain during Gainsborough's lifetime.

that Gray and Goldsmith envisioned. He also became convinced around this time that a too exact rendering of the contemporary scene could not produce the form of landscape he was aiming at. Around 1764 he wrote haughtily to Lord Hardwicke, who had asked him to paint a view, 'with regard to *real views* from nature in this country, he has never seen any Place that affords a Subject equal to the poorest imitations of Gaspar or Claude', adding, 'Mr G. hopes Lord Harwicke will not mistake his meaning, but if his Lordship wishes to have anything tollerable of the name of G. the subject altogether, as well as figures &c must be of his own Brain.' This denial of the topographical is all the more striking in view of Gainsborough's own early exact views of London and Suffolk. Perhaps he was sensitive to the fact that the popular image of him as a landscapist was somewhat rudely rustic. His early pastorals might not have sold well, but some had been propagated as engravings and others had entered popular culture as decorations. He was aware, too, that a new group of specialists – amongst whom he specifically recommended Paul Sandby (1725–1809) to Lord Hardwicke – were taking the portraiture of places to a new level of expertise which he could no longer assimilate into his pastoral mode.

However, if Gainsborough wished to separate his own landscape evocations from more prosaic modes, he was equally clear that he did not wish to emulate the pretensions of historical landscape. His principal rival was Richard Wilson. Like Reynolds, Wilson had been to Italy and had returned with a mastery of the classical forms of Claude and other Italianate masters. In many ways he occupied a similar place in landscape painting to Reynolds' in portraiture. Just as Reynolds historicized portraiture through the introduction of poses and motifs from the Old Masters, so Wilson painted scenery with Classical themes and subjects, or else produced views of British landscape cast in the Claudian mode. In 1767 he was described by the *Public Advertiser* as being of 'the first rank among the landskip painters'. For Gainsborough, however, such classicizing was as much an imposition on natural beauty as the rhetoric of Reynolds was upon portraits. 'Do you really think', he wrote to William Jackson at about this time, 'that a regular composition in the Landskip way should even be fill'd with history, or any figure bus such as fill a space (I won't say stop a gap) or create a little business for the Eye to be drawn from the trees in order to return to them with more glee.'

104. Thomas Gainsborough, *Woodland Pool with Rocks and Plants*, c. 1765–70. An example of the kind of direct study of natural forms that Gainsborough made during his excursions into the countryside surrounding Bath.

105. Thomas Gainsborough, *Going to Market*, c. 1770. In the later part of his career Gainsborough became increasingly interested in creating poetic atmospheric effects in his rural scenes – peasants going to and coming from market was one of his favourite themes.

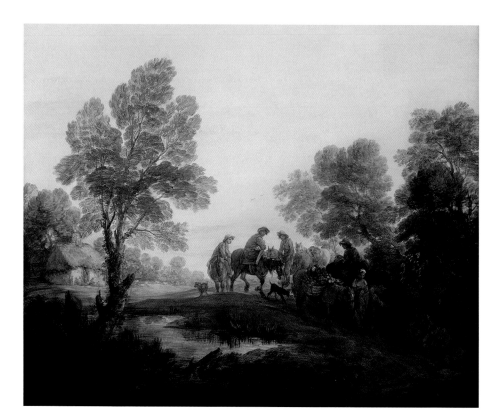

106. **Thomas Gainsborough,**
Man with Claude Glass, c. 1750.
The Claude glass was a convex
tinted mirror which concentrated
the forms and tonalities of scenes
viewed through it. It was named
after the great French classical
landscapist Claude Lorrain as it
was believed to make nature look
like one of his compositions.
Once thought to be a portrait of
Gainsborough himself, this work
is more likely to be a study of an
amateur artist, amongst whom
the use of the Claude glass was
highly popular.

Despite his views on topography, Gainsborough remained as keen as ever to study the details of nature. He wandered the hills and woods around Bath whenever he could. Sometimes he went with fellow artists such as the young Ozias Humphry, or with friends who were amateurs of art – such as Uvedale Price and Philip Thicknesse, and perhaps the man he recorded viewing the landscape 'picturesquely' through a Claude glass. He made vivid drawings of rocks and trees and streams and clumps of grass from which he developed Arcadian visions in his studio. Gainsborough was doing more on his wanderings than keeping in touch with a nature already known. He was discovering a new and more exotic terrain than his native Suffolk. It is worth remembering that the promoters of Bath were not slow to celebrate the hilly scenery as a site of Arcadian bliss. In his *Description of Bath* (1765), John Wood declared that, 'The cliffs and Combs of the Hills that skreen [sic] the quick turning Part of *Nant-Baden* [ancient British name for Bath] are beauties in Nature, so exceeding great [that it had been claimed that they offered] a finer Seat for *Apollo* and the Muses, than they could have had even about *Parnassus* itself.' It was in such beautiful and mysterious scenery, Wood claimed, that the primeval world of an Ancient British Arcadia could still be glimpsed. Gainsborough may not have read Wood's book, but such sayings may well have circulated in the meeting rooms of Bath.

Whatever their source, these images seem to express an increased yearning for refuge. They are closed in, almost womb-like with their enfolding warmth. Herds and flocks are tended, produce brought to market, people return to homes in the woods after a working day. Figures fade in twilights of melting beauty. Uvedale Price, who accompanied Gainsborough frequently on his excursions into the country, recorded how, when he came across 'cottage or village scenes', he remarked 'in his countenance an expression of particular gentleness and complacency.' This idyllic view of country life is also expressed in the artist's letters. When complaining in one of these to Jackson about the demands of his family he exclaimed: 'we must jogg on and be content with the jingling of Bells, only d-mn it I hate a dust, the Kicking up of a dust, and being confined *in Harness* to follow the track, while others ride in the waggon, under cover, stretching their Legs in the straw at Ease, and gazing at Green Trees & Blue skies.'

Such longings appear to animate inventions such as the wash drawing of a boy lolling in the back of an empty cart. He stares at us, dangling and stretching his legs at ease, as though he had not a care in the world. Is he an image of release?

By the end of his time in Bath, Gainsborough was turning such characters into subjects in their own right. They were the 'cottage' and 'fancy' pieces of his later years. Yet as they grew more prominent, they seemed to lose some of their idyllic character and take on troubling ambiguities. It was as though the more he identified with them personally, the more they adopted his worries as well as his wishes. In *The Woodcutter's Return* (1772–73) a familiar person takes centre stage. He is no longer the sanguine fuel gatherer of *Cornard Wood* and other early works. Head bent down, he trudges with his load towards a hovel overflowing with awaiting women and children. Is this Arcadian bliss, or is it 'being confined *in Harness*'? Perhaps the artist himself did not know.

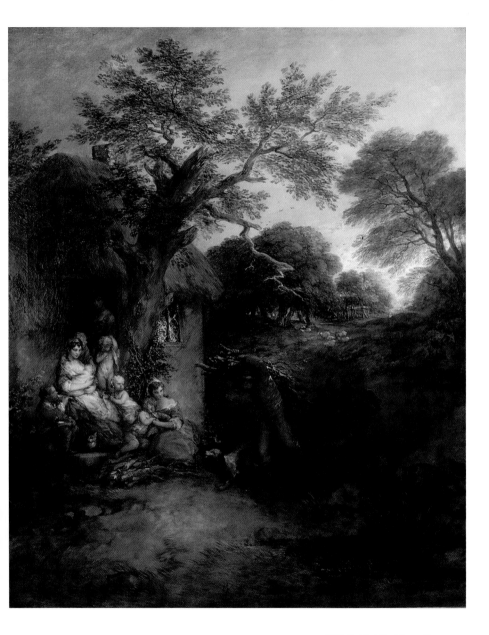

108. **Thomas Gainsborough,**
The Woodcutter's Return, 1772–73.
The theme of the woodcutter recurs
throughout Gainsborough's career.

Chapter 13: The London Practice

109. Schomberg House, Pall Mall, 1856.
This engraving is from a monograph on
Gainsborough by Fulcher. Gainsborough
rented the west wing of Schomberg House
(on the right-hand side of this picture) when
he came to London. He used it as a home,
studio and gallery.

In the summer of 1774 Gainsborough left Bath and settled in London. For the last fourteen years of his life this was to be his home and place of work. As when he arrived in Bath, he knew the importance for his portrait business of establishing himself at a central and fashionable address. He rented the west wing of Schomberg House in Pall Mall. Situated within yards of St James' Palace and other royal residences, it could hardly have been better placed for access to high society. It was noticeably smarter than Reynolds' residence further east in Leicester Square, then the heart of the artistic community.

Yet while a grand address, Pall Mall was essentially a place of business. For a long time during Gainsborough's residence in Schomberg House, the east wing was occupied by the famous auctioneer James Christie, whose persuasive powers of oratory, celebrated in a satire by Robert Dighton, enabled him to establish the auction house that still bears his name. From a commercial point of view, Christie was very much in the same line as Gainsborough, selling art through charm and showman-ship at high prices to the well heeled and well bred. The two felt an affinity for each other and were much in each other's houses. Gainsborough gained a richer knowledge of Old Master paint-ings from viewing the work that went through the auctioneer's sale rooms, and Christie certainly profited from the artist's sharp eye and technical expertise. As he settled in, Gainsborough laid his own residence out more like a place of business. He added both a studio and a gallery in an extension at the back, using the latter in his final years to stage exhibitions of his work.

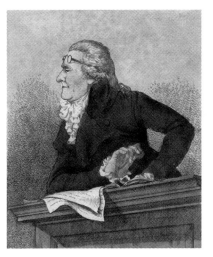

110. **Robert Dighton**, *The Specious Orator (James Christie)*, 1794. A satire of the famous auctioneer, founder of Christie's, at work. Christie was a close friend of Gainsborough and lived in the east wing of Schomberg House.

A more dubious neighbour turned up in Schomberg House in 1781. This was James Graham, a mountebank doctor who claimed to have invented a 'celestial bed' which helped couples to conceive through the application of electrical forces. Dr Graham had originally opened his 'Temple of Health' in 1779 on the Royal Terrace, Adelphi, and retreated to Schomberg House when revenues began to decline. By then the celestial bed seemed to have been attracting custom more as an erotic thrill than as an aid to family planning. Flighty women about town such as Emma Hart (later Lady Hamilton) were known to visit. It was also rumoured that the doctor's attractive female assistants were prepared to assist gentlemen visitors in practical demonstrations of the bed's amazing properties for a consideration.

Given his own weakness for the petticoats, Gainsborough may well have taken more than a passing interest in his new neighbours. They can hardly have been congenial to his family, and Mrs Gainsborough was doubtless relieved when Dr Graham's business collapsed in 1784. It would seem in any case that the move to London brought little happiness to the artist's wife or daughters. They appear to have become increasingly isolated. They were not able to penetrate the social circles that he could by virtue of his artistic standing. On the other hand, they seem to have given themselves airs that alienated them from their humbler acquaintances. Reporting on the cutting short of a visit Mrs and the Misses Gainsborough made to their relatives back in Sudbury, the artist wrote sadly: 'I don't know what's the matter, either people don't pay them honour enough for ladies that *keep a coach*, or else Madam is afraid to trust me alone in this great town.' Probably it was a bit of both.

Gainsborough's move to London might seem to be a logical, almost an inevitable one. Like such musical and theatrical friends as Abel, Sheridan and Mrs Siddons, he could be seen as using success in Bath to launch himself on the larger stage of London. Yet his 'pre-London run' had lasted nearly fifteen years, and there had not been much sign that he wished to leave. Only weeks before he came to the metropolis, he had had an expensive harpsichord delivered from London to his house in Bath – not the kind of thing to do if you are planning a move!

Perhaps Gainsborough sensed that Bath was passing its peak as a fashionable venue. When Joseph Wright attempted to establish a portrait business in the town in the wake of Gainsborough's departure, he was unsuccessful. Wright's sober manner, however, was never likely to have attracted the same

clientele as the seductive style of his predecessor. Gainsborough could also have been drawn to London by a sense of new opportunity. In portraiture, Reynolds was still master of the field, but he was much taken up with Academy matters and also trying to prioritize his historical work. Francis Cotes (1726–70) – the artist who seemed for a time to rival him as a portraitist – had died young in 1770. George Romney (1734–1802), the young turk from the north and future celebrator of the charms of Emma Hart, had left London for Italy in 1773. Although there were many other portrait painters vying for fashionable business, none of them could be said to have been a match for Gainsborough. A final attraction might have been his knowledge that Abel and Bach were setting up a new concert room in Hanover Square. Gainsborough was one of the artists commissioned to provide a transparent painting for this. When the Room opened in February 1775, his comic muse was, as one visitor put it, 'most highly spoken of'.

Despite such auguries, Gainsborough's earliest years in London do not seem to have been very successful. Business was slow, and he did not help matters by refusing to exhibit at the Royal Academy, following a disagreement about the hanging of his works in 1773. It is perhaps a sign of his difficulties that he did not increase his prices for portraits from the levels he had set in his last years in Bath; that is 30 guineas for a head, 60 for a half-length and 100 for a full-length. In fact, it was not until 1787 that he put them up to 40, 80 and 160 gns, respectively.

The tide began to turn in 1777, when he once more showed work at the Academy. He seemed to have learned a lesson, for he returned with three great works, designed to demonstrate his mastery both of grand portraiture and of landscape. *The Hon.* 133 *Mrs Thomas Graham* was the grandest and most formal of all his Van Dyckian portraits. *Karl Friedrich Abel* was equally 78 impressive as a moving and original character study. *The* 100 *Watering Place*, the work hailed by Horace Walpole as the equal of the Old Masters, seemed to move landscape painting in Britain onto a different plane. Gainsborough also included full-length portraits of the Duke and Duchess of Cumberland in 119, 120 this exhibition. This marked the beginning of patronage by the royal family, perhaps the final boost to establishing his position as second only to Reynolds in the London portrait business.

Gainsborough's manner of painting did not undergo any dramatic change when he moved to London. It did, however, gradually increase in allusiveness. The 'magick' scrawls and

dashing fluidity became more marked. This could be seen as a response to the glitter of the metropolis, an ever greater insistence on individuality in a competitive world of effects. Yet it could also be seen as a sign of the times, a response to the growing mood of sensibility that could be seen at one and the same time as meretricious ostentation or incipient mysticism. To some extent inspired by the sensational French landscape and scene painter De Loutherbourg, Gainsborough also turned to 148 experiments with illuminated paintings, using these to evoke a particular kind of contemplative landscape. Yet despite his own religious leanings, he did not follow De Loutherbourg and others into the more occult faiths of the day. Nor did he engage in metaphysical speculations about the transcendent properties of light like Erasmus Darwin and other natural philosophers of the day.

As always, Gainsborough seems to have held the wilder side of himself in check when it came to business. In the 1780s, particularly after his second split with the Royal Academy, he became increasingly independent in his transactions. He held annual exhibitions in his gallery at Schomberg House, which were widely reported in the press. He was particularly fortunate to have found a champion in Henry Bate, proprietor of the *Morning Herald*. Bate was a vicar and later a baronet – his name enlarged to Sir Henry Bate-Dudley. Known as 'the fighting parson' – from the time when he sent some cut-throats who had tried to rob him packing – he was the model campaigning journalist, for ever on the defence for favoured causes. His admiration for Gainsborough must have been enhanced by the full-length of him the artist exhibited at the Academy in 1780. Bate-Dudley stands with an attentive hound in the open countryside. He flexes his cane stick with alert expression. He is ready to take on all comers with cutting slash and epigram. Bate-Dudley was tireless in his praise of Gainsborough's work, often to excess. It was nothing for him to claim that the artist had outdone Watteau or some other Old Master. While such hyperbole may have harmed at times, there is no doubt that Bate-Dudley was important in keeping Gainsborough's name before the public.

Gainsborough was at the height of his fame in the 1780s, yet it was not a happy time. There were professional disappointments, notably his failure to become painter to the King when the post fell vacant in 1784. His quarrel with the Royal Academy may not have harmed his standing, yet it did isolate him to some degree from a leading part of the artistic community. Sensing his

111. **Thomas Gainsborough,** *Sir Henry Bate-Dudley, c.* 1780. Bate-Dudley – both parson and squire – was proprietor of the newspaper the *Morning Herald*. A campaigning journalist, he stoutly promoted Gainsborough's work in the press.

own life was nearing its end, he became increasingly concerned to secure a lasting reputation, working harder to produce fancy pieces in the manner of the Old Masters and was disappointed at the mixed reception some received. On a personal level, he was troubled by the melancholy of his wife and the unsettled behaviour of his daughters. It is perhaps no wonder that he looked more and more to the countryside for release and solace. Yet despite owning a country retreat and making journeys to picturesque areas, he remained a city man. When he knew his final days had come, it was to Schomberg House that he chose to return to die.

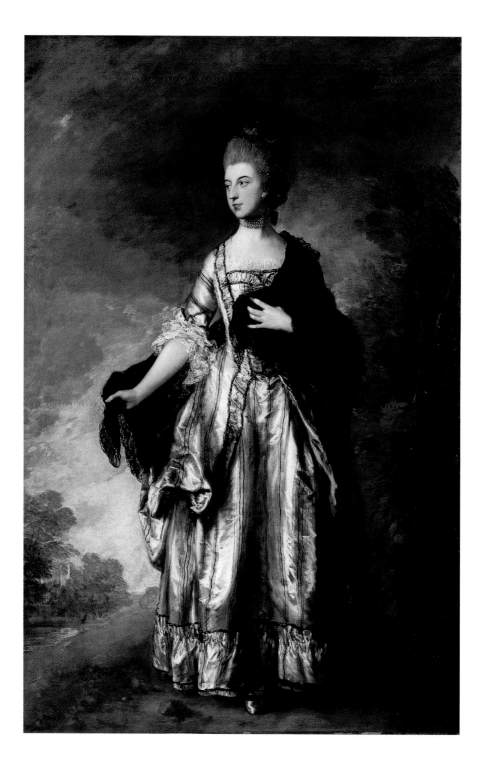

Chapter 14: Academy and Exhibition

In 1768, midway through Gainsborough's career, the Royal Academy of Arts was established in London. It was the most momentous occurrence in the history of British art in the eighteenth century. Finally, artists had a prestigious organization, sanctioned by royal authority, to represent their interests. Forty elected academicians presided over an institution that upheld the highest professional standards. It ran a school for training the young and held an annual exhibition of works by living artists deemed worthy by the academicians of display. The summer exhibition rapidly became a fashionable event and gave a new prominence to the visual arts in London. All this might be seen as a blessing; but there were also problems. The new institution created – or perhaps one should say confirmed – a hierarchy in the arts. The academicians were now the 'aristocrats' of the profession. To many, they represented a threat to a freer form of artistic practice then flourishing.

Gainsborough's relationship to the Academy was a complex one. Living in Bath, he was not closely involved in the negotiations that brought it into existence. He was, however, offered membership at its foundation. This in itself is a sign of how highly regarded he was, since no more than a handful of artists living outside London received such an honour. While accepting, Gainsborough always kept a certain distance from Academy affairs. He was wary of the intellectual claims of the institution, particularly as these were articulated by Reynolds, in the annual *Discourses* on art that he delivered as the Academy's president. 'Sir Joshua either forgets, or does not chuse to see that his Instruction is all adapted to form the History Painter, which he must know there is no call for in this country.' Gainsborough wrote this to a friend who had sent him a copy of Reynolds' fourth *Discourse*, which is dedicated to an exposition of the 'great style'. He was also concerned about the detrimental effects of regular exhibitions, condemning the 'impudent style' of brash, bravura painting that he felt resulted from these. He, himself, felt forced to make concessions. One acquaintance described how Gainsborough strengthened his colours for exhibition,

112. **Thomas Gainsborough,** *Isabella, Viscountess Molyneux (later Countess of Sefton),* c. 1769. Shown at the first exhibition of the Royal Academy, the artist wanted this grand portrait to prove his skills as a fashionable portrait painter.

113. Richard Earlom,
after Charles Brandoin,
*Exhibition of the Royal Academy
in 1771*, 1772.
The annual exhibition of the
Royal Academy in London rapidly
became a fashionable event,
particularly after the Academy
moved to Somerset House in
1780. This engraving shows
the earlier and more crowded
exhibition space in Spring
Gardens.

114. **Johann Zoffany**, *The Academicians of the R.A.*, 1771–72.
A 'conversation', probably painted at the request of George III, which
shows the academicians in their finery. Ostensibly posing a model for
study, they are principally advertising themselves as members of an
exclusive club. The two female members, Angelica Kauffmann and
Mary Moser, are only present as pictures on the wall as it was deemed
improper for them to be shown in the presence of a naked male model.
The other two absentees are Nathaniel Dance and Gainsborough,
who had both quarrelled with the Academy by this time.

saying he, 'often painted higher for the room, and afterwards brought his pictures down'.

Gainsborough may have been critical of exhibition, but he also knew the practice had transformed his fortunes. He had been a regular exhibitor at the Society of Artists – the freer association of artists that had preceded the Academy – since 1761. Like Joseph Wright, the Derby-based artist who had achieved success through showing his 'candlelight' pictures at the Society, he had found that he could establish a national reputation, while remaining active in the provinces by these means. Whatever criticisms he may have had of the Academy, he recognized the power of the new organization and the value to himself of being associated with it. In 1768, when the founding of the Academy was causing a split in the artistic community, Gainsborough had been offered a directorship at the Society of Artists. 'I thank you for the honour', he replied, 'but for a particular reason I beg leave to resign.' The 'particular reason' was that he had already accepted membership of the Academy. He did not remain with the Society of Artists, as Wright and the animal painter George Stubbs (1724–1806) did. He supported the new and more powerful hierarchy.

The Academy exhibition led to increased public rivalry between Gainsborough and Reynolds. Gainsborough made his mark from the start by exhibiting the superb Van Dyckian *Viscountess Molyneux.* A year later he trumped this with *The Blue* 112, 81 *Boy*, a work which seems to have caused Reynolds to abandon Van Dyckian portraits for many years. Reynolds, however, was able to demonstrate how much more successful he was with grand portraits which depended upon learned associations. His most magnificent essay in this mode, the *Three Ladies Decorating a Term of Hymen* (1774), may well have been created to show how far he could out do Gainsborough in grandeur. The composition is based on a skilful combination of poses from Italian seventeenth-century paintings and constitutes an allegory that alludes to the forthcoming marriage of one of the ladies depicted.

By this time, however, Gainsborough was no longer showing his work at the Academy, having withdrawn from the exhibition of 1773, following a dispute about the way his pictures were hung. It would seem that trouble had already been brewing before that. In 1772, Johann Zoffany (1733–1810) exhibited a group portrait of the Academicians at the Academy. Probably commissioned by the King, it shows the leaders of the profession gathered together in a room where a model is being posed for

a life class. On the wall behind are examples of antique sculpture, thus showing how the Academy promoted the study of nature guided by the idealizing principles of classical art. The picture has some notable omissions. The two female members of the academy, Angelica Kauffmann (1741–1807) and Mary Moser (1744–1819) are shown only as portraits on the wall, as women would not have been allowed in the presence of a naked male model. The other omissions are George (1741–1825) and Nathaniel Dance (1736–1811), and Gainsborough. It is often stated that Gainsborough was not represented because he was in Bath. However, another Bath artist, William Hoare, is shown in the picture. There is, moreover, a head of Gainsborough by Zoffany from this period, which might well have been made as a study for the Academy group. Since both Nathaniel Dance and Gainsborough failed to exhibit at the Academy in 1773 because, as Horace Walpole put it, they had 'quarrelled with Sir Joshua', it seems likely they withdrew their presences from the Zoffany group portrait for the same reason.

Gainsborough may have thought that by coming to settle in London he would be able to do without the Academy. However, business in these early London years was slow, and it was probably for this reason that he decided to make amends. He returned to exhibiting in 1777, with a grand series of portraits and landscapes, as has been seen in the previous chapter. As has also been discussed, this was the time when newspaper criticism began to play a part in the promotion of the artist's career. Regular exhibitions brought with them regular art journalism, and Gainsborough was one of the first to profit from the new genre, particularly as it was practised by his friend Bate-Dudley.

Gainsborough's second quarrel with the Academy was also connected with exhibition. In 1783 he sent a set of small ovals of the King and Queen and their thirteen children for show at the Academy. Undoubtedly proud of the evidence that these provided of his favour in court circles, he gave precise stipulations about how he wished these to be hung. He required them to be shown as an integrated unit, with frames touching, and in a certain order. He even submitted a diagram to make this order clear. The tone of the letter that he sent was unmistakably challenging: 'Mr Gainsborough presents his Compliments to the Gentlemen appointed to hang the Pictures at the Royal Academy; and begs leave to *hint* to Them, that if the Royal Family … are hung above the line along with full lengths he never more, whilst he breaths, will send another Picture to the

115. **Johann Zoffany**, *Portrait of Thomas Gainsborough*, c. 1772. Zoffany made this study of Gainsborough at about the same time as he painted the group portrait of the academicians (see plate 114).

116. Thomas Gainsborough, Fifteen portraits of George III and family, 1783. This group of portraits of the King and Queen and thirteen of their children was a high point of Gainsborough's patronage by the royal family. Not unnaturally, the artist wished to boast of his achievement by showing the group at the Academy. He gave strict instructions on how they should be exhibited.

117. Thomas Gainsborough, letter to the Royal Academy explaining the hanging of the royal portraits, 1783. Gainsborough was always very particular about how his pictures should be exhibited. In this letter to the Academy, he stipulated that the pictures should be hung in the order illustrated, with frames abutted. He also stipulated that they should be hung low enough for them to be studied closely in detail.

exhibition – This he swears by God.' His concern about the pictures not being hung along with full-lengths was due to the wish that his pictures could be studied both near to and far off. The Academy had a rule that all full-length portraits should be hung above a line of approximately three metres (nine feet) which was the height of a doorway – the argument being that pictures of that size could take such height and be viewed effectively, while smaller pictures could be hung below, where they could be inspected near to.

Since Gainsborough's group of portraits were individually small works, the committee was able to accommodate his wish. It was a different matter in the following year, when the artist submitted his group portrait of the three eldest daughters of George III. Once again, Gainsborough asked to have the picture hung low so that it could be studied near to. The hangers declined to do this. He therefore withdrew all his works, with the following letter: 'Mr Gainsborough's Compts to the Gentn of the Committee, & begs pardon for giving them somuch trouble; but as he has painted this Picture of the Princesses in so tender a light, that notwithstanding he approves very much of the established Line for Strong Effects, he cannot possibly consent to have it placed higher than five feet & a half, because the likenesses & Work of the Picture will not be seen any higher; therefore at a Word, he will not trouble the Gentlemen against their inclination, but will beg the rest of his Pictures back again.'

In this letter Gainsborough is trying to pull rank, to suggest that he is sufficiently important to have his special conditions met. But he is also stressing an aesthetic point. This is that his pictures are painted in 'so tender a light' and do not thrive in the brash competitive atmosphere of the exhibition hall. By the time of this second withdrawal from the Academy, Gainsborough was sufficiently well established to thrive without the exhibition. In the last years of his life he staged his own exhibition in the gallery at his house in Pall Mall, where he was able to control the conditions of exhibition as he liked.

While Gainsborough withdrew from the Academy exhibition, he never withdrew from the Academy. He remained an academician, and gradually began to rebuild personal relations. In 1788 he attended the Academy's annual dinner. Had he not died later that year, he might well have returned to exhibiting. Gainsborough was no revolutionary, and while he might claim a licence for his individualism, he still wished to remain on the right side of the authorities.

118. Gainsborough Dupont, after Thomas Gainsborough, *Three Eldest Princesses*, 1793. A print by Gainsborough's nephew and studio assistant after the large-scale portrait of the three eldest princesses that Gainsborough sent to the Academy exhibition. The original picture was cut down to the central section in the nineteenth century. When the Academy refused to exhibit this picture as Gainsborough stipulated he withdrew it and all his other works from the show. He never exhibited at the Academy again.

Ironically, in the years that he had cast himself off from the Academy exhibitions, he came nearer than ever to carrying out the Academy's principles. Not only did he base his work increasingly on a study of the Old Masters – albeit largely the Flemish and the Spanish, but he also made essays into history painting. Perhaps the popular successes of the modern history paintings of the Americans Benjamin West (1738–1820) and John Singleton Copley (1738–1815), together with the commissions that were being handed out to artists by the print publisher John Boydell for scenes from Shakespeare for his *Shakespeare Gallery*, were beginning to make him think again about his earlier remark that there was no call for history painting in Britain. Negotiations between Gainsborough and Boydell for a Shakespearean subject failed. He entered the genre carefully, choosing themes that fitted naturally with his penchant for woodland scenery such as the biblical *Hagar and Ishmael* (*c.* 1788) and the mythological *Diana and Actaeon*. 1

The Academy also remained keen to claim him. The eulogy that Reynolds delivered about him as the fourteenth of his *Discourses* was more than a personal tribute. It was an assertion that, at base, Gainsborough and the Academy had the same goals in art – that however much personal rivalry may have existed between himself and Gainsborough as portrait painters, they still shared the same deep reverence for their art and knew the values of study, of attentive and judicious selection from the works of the masters. Most importantly, Gainsborough was contrasted to that other great adversary of Reynolds, then long dead – William Hogarth. Hogarth – who had been bitterly opposed to the idea of the establishment of a Royal Academy, preferring instead the free association of artists that he had himself previously promoted – had, in Reynolds' opinion, made the mistake of trying to succeed in history painting, for which he had no talent. At least Gainsborough had had the sense to leave well alone and only work at what he was good at. There could have been little that Reynolds had to fear in recommending Gainsborough in this last phase of his life to the attention of the Academy students.

Chapter 15: Royal Patronage

Gainsborough's career in London was greatly enhanced by the patronage he received from the royal family. Although never an official court painter, he was well favoured by the King and his relatives, becoming known at one time as the 'Apollo of the Palace'. His most celebrated achievement was the full-length portrait of Queen Charlotte, exhibited in triumph at the Royal Academy in 1780. A possible initial point of contact with the royal family could have been provided by Gainsborough's old friend Joshua Kirby, who had taught George III drawing and perspective when the latter was Prince of Wales. But Kirby died in 1774, the year that Gainsborough came to London, so probably there was little opportunity for an introduction to be effected. In fact, it was not until he had been in London for three years that any member of the royal family gave him a commission.

123

Gainsborough seems to have had some feeling that he should receive royal patronage while he was still in Bath. To judge from a remark by Thicknesse published in his *Sketches and Characters of the most eminent and most singular Persons now living* (1770), it was believed that absence of Scottish blood was the reason for his lack of preferment, 'though we should have been glad to have seen some mark of R—l favour shewn to this gentleman [Gainsborough], yet we are spiteful enough to confess, we are glad he was born on this side of the Tweede'. It should be remembered that Ramsay, from well beyond the Tweed, was at that time principal painter to the King.

The first royal commissions came not from the King, but from his brother and sister-in-law, the Duke and Duchess of Cumberland. Exhibited at the Royal Academy in 1777, their portraits are both works of exceptional quality. Yet they are also nuanced with wit. The Duke of Cumberland steps forward somewhat shiftily, glancing at us out of the corners of his eyes and nervously fingering his regalia. Reputed to be 'pert, insolent and senseless', he led a dissolute life. He had kept many mistresses and been cited in divorce proceedings before marrying Anne Horton, an aristocratic Irish widow, in 1771. She was described as 'very well made with the most amorous eyes in the world and

119, 120

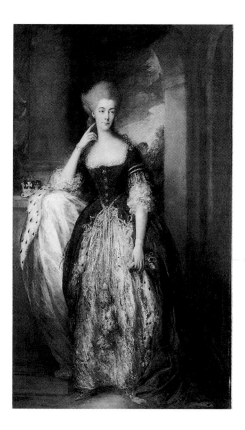

119. **Thomas Gainsborough,**
Anne, Duchess of Cumberland, 1777.
Gainsborough's first royal commission was from
the King's younger brother, the Duke of Cumberland,
for a pair of portraits of himself (see plate 120) and
his wife. Both were somewhat flighty and dissolute
in their life style and Gainsborough has managed to
hint at this, despite the grandeur of the settings.

120. **Thomas Gainsborough,**
Henry, Duke of Cumberland, 1777.

eyelashes a yard long'. Gainsborough has certainly shown her in a seductively unsteady pose, almost as though she is mocking the officialdom to which she now belonged. Such subtle subversions would hardly have recommended the artist to the King. George, a model of sobriety, was barely on speaking terms, in any case, with his disreputable younger brother. He despised his ways as much as he did those of his own heir, the Prince of Wales, in later years.

Yet around 1780 the King began to take an interest in Gainsborough. Possibly this was because he was short on choices. His favoured painter, Ramsay, had effectively given up his practice by then, following a fall that had damaged his painting arm. In the 1770s he had favoured the Queen's compatriot, Zoffany. Yet Zoffany had aroused displeasure by taking liberties with the commission that the Queen had given him to paint the *Tribuna* in Florence. In any case, Zoffany was principally a painter of small conversations, and was never really at home with full-lengths. The obvious choice for grand portraits was Reynolds. The King, however, could not stand the President of the Royal Academy. This might have been a personal dislike – though Reynolds took such great care to ingratiate himself to the wealthy and famous that it is striking that he failed here. It may have been because he was too closely associated with the hated Whig opposition who were beginning to gain the upper hand in politics and he may also have been put off by Reynolds' artistic pretensions. Though a conscientious patron of the arts, the King was at heart a bluff character, given to making down-to-earth observations followed by 'what! what!' He disconcerted the novelist and lady-in-waiting Fanny Burney once by exclaiming, 'Lot of stuff in Shakespeare, what! what!' He appreciated the fact that both Ramsay and Zoffany were good, straightforward painters with no 'stuff' in them. Gainsborough may have had a somewhat flightier manner, but he, too, avoided confusing portraiture with allegory and the historical manner. He did an excellent likeness, moreover, and knew that was what portraiture was really about (what! what!).

Matters seem to have come to a head when Reynolds produced a singularly uninspired pair of portraits of the royal couple in regal robes on behalf of the Royal Academy in 1779. Both King and Queen look ill at ease in these 'official' representations. Almost immediately afterwards they seem to have sat for Gainsborough who produced full-length portraits of them for the Academy show of 1781. Nothing could be greater than the

121. **Joshua Reynolds,** *Queen Charlotte*, 1780. One of a pair of portraits of the royal couple commissioned by the Royal Academy. Reynolds' failure to make an inspiring image of either may have spurred the King to commission Gainsborough to paint him and Queen Charlotte (see plates 122 and 123).

contrast between these portraits and Reynolds' work. Reynolds' king had sat awkwardly on his throne, swathed in yards of ermine. Gainsborough has him standing imposingly in a landscape, loosely reminiscent of Windsor Great Park. Instead of coronation robes, he wears his preferred costume, the 'Windsor uniform', probably designed by himself, that had been introduced in 1778. There is, it is true, a little stiffness in the figure – as Horace Walpole observed. But how could you make an accurate portrayal of the King without this? The portrait of Queen Charlotte is a real triumph, one of the finest of all official royal portraits. Now middle aged, Queen Charlotte had never been a beauty, but Gainsborough has given her allure and painted her with sympathy. First we are bowled over by the sheer deliciousness of her dress – those 'petticoats' that Gainsborough was so fond of. One night Gainsborough and his assistant Gainsborough Dupont stayed up, painting by candlelight, in order to get this part of the picture finished in time for the Academy exhibition. But what is even more striking is the expression of the Queen. Gainsborough has shown her looking off to the left, as though in conversation with someone there. Her mouth is beginning to move, there is a glow of pleasure on her face. He animates her countenance with a beautiful expression, thus obviating the question of whether she was, in fact, a beauty.

122. **Thomas Gainsborough**, *George III*, 1780. A somewhat stilted yet sympathetic picture of the King. He is shown in a 'Windsor uniform', the court dress that he had recently introduced to the royal household, rather than in full royal regalia.

123. **Thomas Gainsborough**, *Queen Charlotte*, c. 1780. This portrait of the Queen – a pendant to that of her husband (see plate 122) – is one of Gainsborough's most masterful creations. He shows the Queen in truly regal splendour, with a magnificently painted dress, while communicating a sense of her character and warmth.

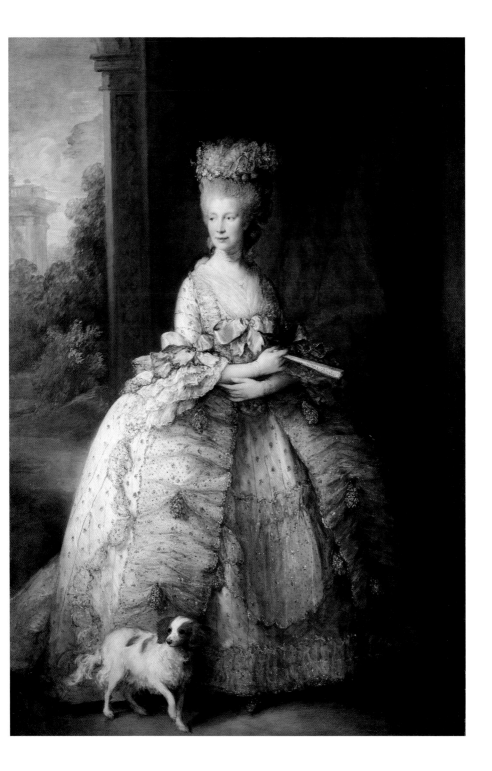

It is a sign of the success of these portraits that they were regularly copied, becoming, in effect, the definitive representations of the King and Queen, replacing the official ones made by Ramsay in 1761. The personal touches that Gainsborough has achieved in these works suggest an intimacy. Apparently both the King and Queen liked Gainsborough, enjoying his playfulness and wit. He amused them. Gainsborough once said he 'talked bawdy to the king & morality to the Prince of Wales'. This was a risky business, but perhaps it worked. For although the king was almost tediously moral, he was also very well intentioned and enjoyed good fun. He did not like his courtiers to be too grand, and Gainsborough might well have hit the right note.

Queen Charlotte seems to have taken an interest in the more intimate side of Gainsborough's work, owning twenty-two of his drawings. She commissioned him to paint Richard Hurd, Bishop of Winchester and an old friend of the royal couple. In 1782 Gainsborough painted the royal couple and all their children (with the exception of the Duke of York, who was away in Hanover) in a series of ovals. These were all shown at the Academy together according – as discussed in the previous chapter – to the special arrangement that Gainsborough insisted on. One gets the feeling that he was rubbing Reynolds' nose in the fact that he was enjoying royal favour in a way that the President did not. In 1784 Gainsborough followed this with an imposing full-length of the three eldest princesses, commissioned by their brother, the Prince of Wales. This work was subsequently cut down to the central portion, but an engraving by Gainsborough Dupont shows how grand it was in conception. Always susceptible to female beauty, the artist declared himself to be 'all but raving mad with ecstacy in beholding such a constellation of youthful beauty'. The young princesses were then in their first bloom. The artist's susceptibility to the lively and kittenish Princess Elizabeth, in particular, can also be seen in his oval half-length of her. Yet, while suggesting the allure of the young princesses, he still recognized royal protocol enough to give them an appropriate degree of decorum.

Gainsborough was so incensed with the Academy's refusal to hang this work as he requested that he withdrew all his pictures from the exhibition and never showed there again. The *Three Eldest Princesses* were put on show in the artist's own studio, where they were widely praised by the press. This withdrawal may have been something of a pyrrhic victory. For later in the year, on 10 August, Ramsay died. He was replaced as principal

painter to George III not by Gainsborough, but by Reynolds. Reynolds' appointment has been described as an inevitability, in view of his towering position in the art world in general and his presidency of the Royal Academy in particular. That may be, but Gainsborough certainly believed that he had had a chance, and that he had only been excluded by a faction. In a letter to Lord Sandwich dated 29 November 1784, he describes himself as 'G – who was very nearly being King's Painter only Reynolds Friends stood in the way.' There may well have been more to it than that. Gainsborough's petulant behaviour over the showing of his works at the Academy may have alarmed a King who liked decency and order in all things. Perhaps Gainsborough's 'talking bawdy' to him had not gone down as well as the artist thought. Perhaps the first signs of his own oncoming madness may have scared him off this erratic companion. There were no

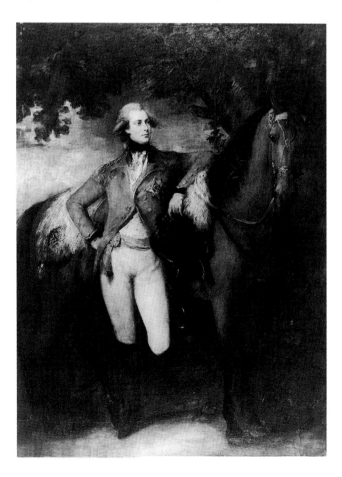

124. Thomas Gainsborough, *George IV, as Prince of Wales*, 1782. The Prince of Wales is shown here as an officer on active service, despite being forbidden by his father to take part in any military exploits. By the time this was painted the Prince's dissolute lifestyle had already led to a breakdown of relations with his father. Deeply in debt, he never paid Gainsborough for this picture.

125. **Thomas Gainsborough,**
Princess Elizabeth, c. 1782.
Always susceptible to female
allure, Gainsborough declared
himself to be 'all but raving mad
with ecstasy' when painting the
princesses in their 'youthful
beauty'. He appears to have been
particularly struck by Princess
Elizabeth, then in her early teens.

definite commissions for work from the King after this date. He
might have ordered a *Richmond Water Walk*, for which some stud-
ies exist, but this is not clear. In his last year, Gainsborough tried
unsuccessfully to persuade King George to buy his *Woodman*. 162

The only definite royal commissions Gainsborough received
after 1784 were from those louche members of the family with
whom the King was no longer in communication. He continued
to work for the Prince of Wales, by now an arch enemy of the
palace. In 1782 he had portrayed him leaning against his horse in 124
a grand and supercilious manner. At the same time, the Prince
commissioned a similar equestrian portrait of his boon compan-
ion Colonel St Leger. The Prince's continued interest was a
mixed blessing. Quite apart from the difficulty of being favoured
by one whom the King disliked so much, it was not financially
rewarding. Heavily in debt all round, the Prince owed the artist
the huge sum of £1,228 10s at the time of the latter's death.

Gainsborough's continued relationship with that other royal
renegade, the Duke of Cumberland, led to one of his finest late
works. In this painting the Duke and his wife are strolling in

126. **Thomas Gainsborough**, *Henry, Duke of Cumberland, The Duchess of Cumberland and Lady Elizabeth Luttrell*, 1783–85. The last, and one of the finest, works painted by Gainsborough for a member of the royal family. The Duke and Duchess of Cumberland stroll in a park, observed at a distance by the Duchess' sister.

grounds, possibly those of Cumberland Lodge in Windsor Great Park. The work seems to have begun as a Zoffany-like conversation, according to an early drawing, but developed more towards the romantic format. Once more there is some comedy – the Duchess' sister Lady Elizabeth Luttrell appears to be sketching them in the distance. She was a woman of noted low morals and one might ask what she is doing loitering in the undergrowth. The Rococo feel to the whole is augmented by the oval shape of the frame. However, this work seems to have been no more financially rewarding to Gainsborough than the work he did for the Prince of Wales. The picture remained unclaimed in his studio at the time of his death.

Gainsborough's relationship with the royal family may have been unsatisfactory after 1784. Yet the very fact of having once been 'Apollo of the Palace' certainly helped him to achieve many other grand commissions in the last years of his life. It also brought him wider fame, both through the copies that were made of George III and Queen Charlotte for distribution throughout the kingdom, and through the sale of mezzotints after key works. The latter also spread his reputation abroad. The mezzotint of the Prince of Wales was copied by no less a personage than the French neo-classical master Jacques-Louis David (1748–1825) in Paris.

Chapter 16: Family Problems

There is a tradition that Gainsborough painted a portrait of his wife every year on her birthday. If he did, most of these must now be lost. There remain several pictures, however, that chart her course through life. None is more moving than the one now in the Courtauld Institute Gallery in London, probably painted a few years after the couple had settled in London. Margaret Gainsborough is shown in half-length. She looks at us in a direct, almost searching manner. There is melancholy and tenderness in her expression. Her hands are delicately touching a black veil cast loosely over her head. We would almost think she was in mourning, were it not for the lighter costume underneath. We do not know when this picture was painted, although the care that Gainsborough has taken with it might suggest that it was made for some special occasion. Perhaps, as John Hayes has suggested, it was for Mrs Gainsborough's fiftieth birthday. 127

It is an intimate, affectionate image, yet it is also a troubled one. The couple would have been married over thirty years when the picture was painted. Their relationship had changed much as Gainsborough's career had developed. Margaret had brought an annuity of £200 a year to the marriage. This must have been a bedrock for their finances when the artist was young and struggling, earning only a few pounds for each picture. Now, however, he could nearly match his wife's annual income by painting a single full-length. When they were married, they lived in humble lodgings in a tradesman's area; now they were in the heart of the West End. There is not much sign that Mrs Gainsborough was comfortable with their grand abode. Nor is there any indication that she had much to do with the *beau monde* with which her husband mingled.

Gainsborough felt her to be wayward and difficult. 'If I tell you my wife is weak but good, and never much formed to humour my Happiness, what can you do to alter her?' he wrote in 1775 to his sister in Bath. Yet he was fond of her, and appreciated her devotion to him. He also felt guilty. In 1763 he suffered a 'most terrible fever' that brought him close to death following a trip to London. This illness was brought on, he felt convinced, by a 'foolish act' that he had committed on his journey. He may indeed

127. **Thomas Gainsborough**,
Mrs Thomas Gainsborough, *c.* 1778.
A sympathetic study of the artist's
wife, possibly in celebration of her
birthday. It has been noted recently
by David Solkin that the pose
resembles that of the antique statue
of 'pudicity' in the Vatican in Rome.

have contracted a venereal disease then which permanently weakened his constitution. His anguish at his folly was heightened by the devotion with which his wife nursed him. In October 1763 he wrote to a friend, James Unwin: 'My Dear Good Wife has set up every night ti'l within a few and has given me all the Comfort that was in her power. I shall never be a quarter good enough for her if I mend a hundred degrees.' Gainsborough recovered, but he did not mend by any degree.

They had differences about finances, too. Gainsborough was liberal with money, lived extravagantly and gave freely to those in need. Margaret was tight fisted and tried to keep a hold on the family finances. It may have been her doing that they made several shrewd property investments, which stood her and their children in good stead after the artist's death. There also seems to have been a playful element to their relationship, acted out to some extent by their pet dogs, Fox and Tristram. There are early stories of how they would use the dogs to pass messages to each other when making up after a quarrel. They can hardly have been the first English couple to have used their pets to communicate emotions.

128. **Thomas Gainsborough,**
Tristram and Fox, 1775–85.
The pet dogs of Gainsborough and his wife. They reputedly used them to pass messages to each other when making up after a quarrel.

Throughout his life, Gainsborough felt a need for the support of his devout and hard-working sisters, and for that of his virtuous brother Humphrey, the Henley minister. It was a great sadness to him when Humphrey died in 1776, and he exerted himself greatly to try to gain proper recognition for his brother's contribution to the development of the steam engine and other inventions. With Humphrey gone, their eldest brother 'scheming Jack' increasingly became a problem. This eccentric inventor and rogue still lived in Sudbury, with his wife and family, in very straightened circumstances. Gainsborough made provision for him, though not in his usual spirit of generosity. He used his sister Mrs Dupont who was still living in Sudbury as an intermediary. 'I promised John', he wrote to her in 1783, 'when he did me the honour of a visit in Town, to allow him half a crown a week, which with what his good cousin Gainsboro' allows him, and sister Gibbon, I hope will (if applied properly *to his own use*) render the remainder of his old age tolerably comfortable, for villainously old he is indeed grown. I have herewith sent you three guineas, with which I beg the favour of you to supply him for half a year with 2s. 6d. per week.... And that he may not know but what you advance the money out of your own pocket, I have enclosed a letter that you may show him, which may give you a better power to manage him if troublesome to you.'

Gainsborough's lack of sympathy may have been because Jack's eccentricity revealed a family strain of mental instability now all too evident in his own household. The first signs came in 1771 when Mary, his elder daughter, was unwell. Their doctor, Moysey, when called to assist, declared the illness 'was a family complaint and he did not suppose she would ever recover her senses again.' But on that occasion she did, with the help of other more sympathetic medical practitioners. By this time his daughters were young women. They were no longer 'Molly and the Captain', the delightful children he had captured in so many pictures, chasing a butterfly, posing with a cat, and acting out all kinds of pastoral fancies. They had moved on, too, from that time as early adolescents when Gainsborough had hoped to train them up in his own profession. This was when he portrayed them in a double portrait with drawing materials before a statue of Flora. X-rays of the picture show the statue to have been an afterthought. Originally the elder daughter had been facing the younger. Now they were moved together to gain instruction from the Goddess of the flowers. They are displayed with the cool Van Dyckian elegance that their father was then employing

129. **Thomas Gainsborough,**
Mary and Margaret Gainsborough, c. 1763–64.
In contrast to earlier pictures of his daughters at
play (see plates 51 and 52), here they are shown
near the end of childhood, developing artistic
and intellectual pursuits.

in his grand portraits. At that time they were attending a school for young ladies, Blacklands in Chelsea. They were learning the social graces there, but the artist intended them to acquire practical skills as well. On 1 March 1764 he wrote to James Unwin: 'You must know I'm upon a scheme of learning them both to paint Landscape and that Somewhat above the common Fan mount stile. I think them capable of it, if taken in time, and with proper pains bestow'd ... that they may do something for their bread.' As the daughters later told Joseph Farington, Gainsborough sent them many letters of practical instruction in drawing when they were at Blacklands, which they now regretted they had lost.

Gainsborough's concern to give his daughters the means of gaining a livelihood accorded with the activities of his own sisters, all of whom worked while at the same time marrying and bringing up families. This was the kind of industrious, trading background from which he came. Mrs Gainsborough, however, had other plans. Mindful of her own elevated lineage, she intended her daughters to marry and lead the lives of ladies. This was an ambition that the daughters shared.

Gainsborough's last double portrait of them shows them at this stage. Now in their early twenties, they stand in their elegant gowns in a romantic countryside, attended by a faithful dog. They have lost both the exuberance of their childhood and all signs of any professional activity. Although Mary was by then a talented draughtsman and Margaret an accomplished musician (always 'jangling at the harpsichord' as her father somewhat unkindly put it), they did not wish to be thought of as women who had to perform for a living. Once when requested to play for Queen Charlotte, Margaret angrily refused. While not as unstable as Mary, she also displayed disturbing signs of wilfulness.

Gainsborough was himself doubtful whether his wife and daughters would succeed in their strategies. 'But these fine ladies', he complained to Jackson, 'and their tea drinkings, Dancings, *husband huntings* and such will fob me out of the last ten years, & I fear miss getting husbands too.' Perhaps because of their evident eccentricity – or because as daughters of an artist (however successful) they could hardly be counted as ladies, and had no dowries to speak of either – husband hunting met with little success. Bath was full of adventurers in search of class and cash, but these peculiar young women could offer neither. The situation became worse when they moved to London, where their social isolation increased. It was at this point that a last desperate attempt was made; one that ended in tragedy.

130. **Thomas Gainsborough,** *The Artist's Daughters,* c. 1770–74. The last portrait of the artist's daughters painted as a pair. They are now grown up and represented as elegant and eligible ladies. By this time they were already revealing signs of mental instability.

Amongst Gainsborough's acquaintances was the German musician Johann Christian Fischer. The leading oboist of the day, he was much prized by royalty and a member of the Queen's band. Some time in the mid-1770s Gainsborough painted a full-length of him, a work later exhibited at the Royal Academy in 1780. Like the portrait of Abel, it shows the musician as a composer, rather than as a mere performer. He leans against a harpsichord, his celebrated oboe discarded in favour of a quill, looking upwards as if for celestial inspiration. It is a splendid composition in which the figure's cocky pose conveys something of the good opinion that the musician was said to have had of himself. It may have been the occasion of this portrait that brought Fischer into intimacy with Gainsborough's daughters. In 1775 he wrote to his sister complaining of Fischer's attentions: 'I have never suffered that worthy Gentleman ever to be in their Company since I came to London; and behold while I had my eye upon Peggy, the other Slyboots, I suppose, has all along been the object. Oh, d—n him, he must take care how he trips me off the foot of all happiness.'

Gainsborough seems to have feared that this self-centred and difficult man would be a disastrous match for either of his temperamental daughters. Despite all his efforts, Mary, the 'other slyboots', eloped with Fischer, getting married on 21 February 1780. Two days later the artist wrote to his sister, 'as to his oddities and temper, she must learn to like as she likes his person, for nothing can be altered now. I pray God she may be happy with him and have her health.' This prayer was not to be granted. Mary, whose own mental health was so fragile, was quite unable to cope with the 'oddities and temper' of her husband. The marriage was over in six months. Mary returned home, and gradually lapsed into irredeemable madness.

There was little to alleviate this sad state of affairs in Gainsborough's last years. Even the presence of his nephew, Gainsborough Dupont, as assistant and member of the household hardly helped. For while harmless enough, this effete young man was not exceptional either in skill or character. As the artist grew weaker with illness, he must have realized that there would be no continuation either for his family or his practice in the years to come.

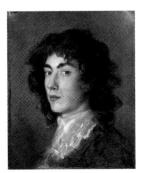

131. **Thomas Gainsborough,**
Johann Christian Fischer,
c. 1780. Fischer, the leading oboist of the day, is shown here as a composer rather than as a performer. At the time that this picture was exhibited at the Academy, Fischer was in the middle of a short-lived and disastrous marriage to the artist's daughter, Mary.

132. **Thomas Gainsborough,**
Gainsborough Dupont, 1770–75. Gainsborough's nephew and studio assistant. After Gainsborough's death he attempted to continue his own career without much success, dying young in 1797.

Chapter 17: Romantic Women and Painted Ladies

From the time that he first achieved success in Bath, Gainsborough's principal reputation was as a painter of fashionable women. He showed them with incomparable elegance, in flowing robes as luxurious as those of Van Dyck, wandering soulfully in wild landscapes, pausing by fantastic buildings or seated in interiors beneath gorgeous swags and hangings. He painted the *beau monde*, that is clear. But who exactly were these women of fashion? Some of his sitters were of the highest reputation, such as the Honourable Mrs Graham. Some were well-born ladies of doubtful reputation, such as Mrs Graham's close friend, Georgiana, Duchess of Devonshire. Some were adventurers with virtually no reputation at all, such as Mrs Robinson. Yet from their portraits you would hardly be able to tell them apart. In Gainsborough's pictures they all come together in a communal dream.

134

139

Gainsborough was not, of course, the only portrait painter to depict this world. Courtesans and countesses mingled in the studios of Reynolds, Romney and all the other artists who depicted the rich and famous. No doubt such promiscuity has always been a feature of high society. It was a tradition in portraiture, too, to expect women to be shown in fanciful and 'theatrical' roles that suggested vanity more than character. As Pope observed in his jaundiced epistle *On the Character of Women* in 1735: 'Whether the charmer sinner it or saint it, If folly grow romantic, I must paint it.'

In the middle years of George III's reign, however, loose behaviour gained a particular prominence. The growing independence of action already noted in the 1760s increased under the impact of libertarian ideals in the years leading up to the French Revolution in 1789. Though aimed at society as a whole, it was in fact wealthy aristocrats who had most opportunity of putting such notions into practice. This can certainly be seen in the actions of the Duchess of Devonshire. A leading member of the Whig oligarchy, she simultaneously dominated fashion and political affairs. Her prominent role in the election of 1784 when she campaigned vigorously for the recall of the radical Whig

133. **Thomas Gainsborough,** *The Hon. Mrs Thomas Graham,* 1775–77. One of the principal works exhibited by Gainsborough at the Academy in 1777, this grand portrait of a noble woman is closely based on the paintings of Van Dyck. Its stormy landscape and romantic mood, however, express a sensibility rapidly becoming fashionable in society at the time.

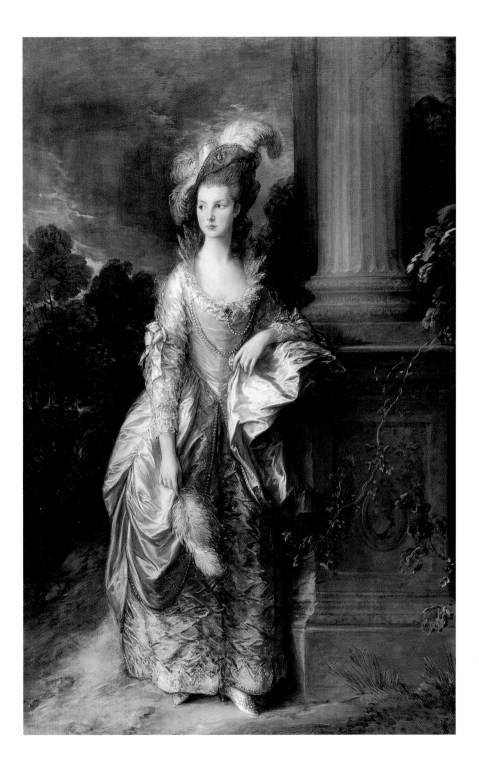

Charles James Fox, taking her advocacy to the point of trading kisses for votes, caused much consternation about the ways in which women were now assuming 'masculine' roles – to the point of being sexually pro-active.

The growth in the number of public places of entertainment further increased the possibility for the respectable and disreputable to become confused. In her best-selling novel *Evelina, or the History of a Young Lady's Entrance into the World* (1778), Fanny Burney played upon these ambiguities. Although the heroine eventually achieves a most respectable and satisfactory marriage, she encounters all kinds of dangerous situations when, as a young *ingénue*, she comes up from the country to live with relatives in London. Not only is she approached by all kinds of unsuitable suitors in such public places as assembly rooms, but also she even, when losing her way in some poorly regulated pleasure gardens, finds herself in the company of ladies of the night. This is the world that is hinted at by Gainsborough in his painting *The Mall* (1783). The Mall was a place for the elegant to stroll, close to the royal residences. Yet it also led through St James' Park, where common prostitutes would ply their trade. It was here that the young James Boswell had found sexual gratification in the 1760s, as his *London Journal* attests.

136

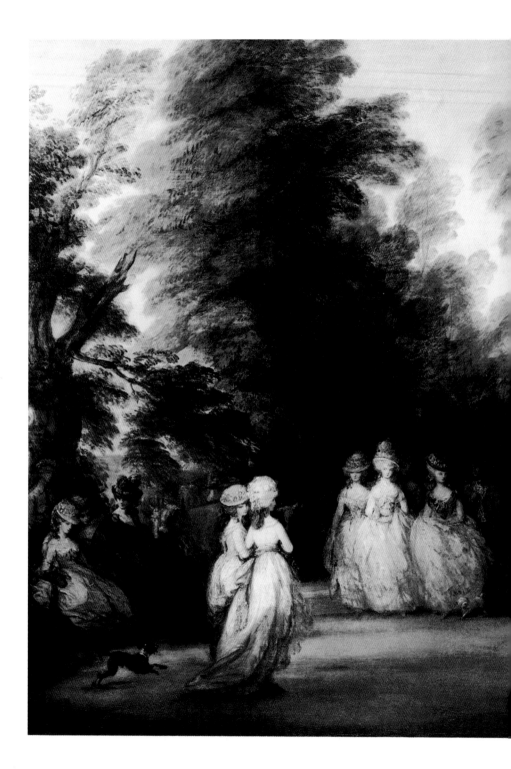

136. **Thomas Gainsborough,**
The Mall, 1783. This large canvas
represents the Mall – the walkway
along the side of St James Park in
London – as an idealized parkland
scene. It was favourably compared
by contemporaries with the work of
Watteau, and was certainly inspired
by Watteau's parkland scenes of
gallantry (see plate 3). It alludes only
obliquely to the Mall's more common
reputation as a place of assignments
and prostitution. This earthier side
of the Mall can be found in other
depictions, such as that by Joseph
Nickolls (see plate 137).

137. **Attributed to Joseph Nickolls**, *St James' Park and Mall*, c. 1745. An unvarnished view of the Mall that contrasts with the idealized representation by Gainsborough (see plate 136).

138. **Thomas Gainsborough**, *Study of a Lady*, c. 1785. One of the many studies of women walking that Gainsborough made at this time. The origins of this one are not known, though a similar one has an inscription on the back recording how the artist spotted the lady out walking and recorded her because of his attraction to her 'fascinating leer'.

Earlier representations of the park, such as that by Joseph Nickolls (fl. 1726–55), had made clear the nature of the rumbustious goings on beneath the trees. Gainsborough knew the area well. His own painting room at the back of his house looked out onto it. Yet when he depicted it, he gave it an air of elegance and mystery. Basing his work ostensibly on that of his hero the French Rococo master Watteau, he turned the scene into a *fête galante*, the fashionable women drifting through in their flowing gowns like ethereal spirits, and only the slightest hint of dubious assignments deep in the shadows.

It was Gainsborough's intention to follow up *The Mall* with a similar representation of the Richmond water walk for the King. This was never completed, but a series of studies of figures remain. One particularly fine one is, according to the inscription on the back, a portrait of a woman Gainsborough saw strolling in the park. He was much taken by what he called her 'fascinating leer'. She, seeing him sketching, walked to and fro several times 'to allow him to make a likeness'. He never knew her name.

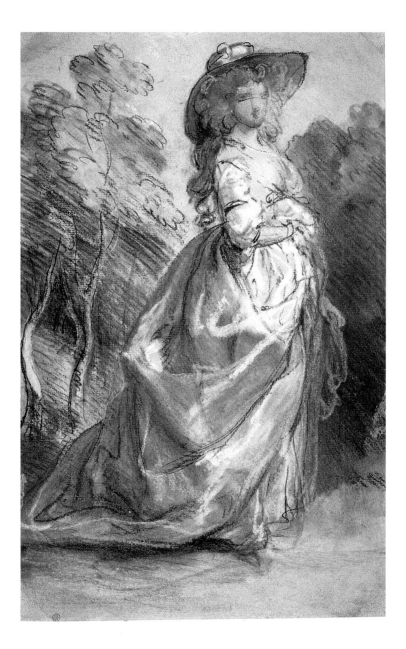

Like gardens and assembly rooms, the portrait painter's studio was one of those sites where ambiguous interchanges could take place. They were not regulated, like the salons of great houses. They could be entered by anyone who wished. It was up to the ingenuity of the individual artist to manage this situation to his best advantage. Few did this more successfully than Gainsborough. Witty, entertaining, with an incomparable sense of style, he knew how to flatter women of every kind, and was rewarded with their allegiance. More importantly, he was able to present them with a romantic ideal of themselves, while still preserving, miraculously, a likeness. It certainly helped that Gainsborough had a keen eye for fashion, one that had been sharpened under the tutelage of his milliner sisters. During the 1780s he warmed to the taste for 'freer' flowing robes and large-brimmed hats with ostrich feathers pioneered by the Duchess of Devonshire.

Curiously, Gainsborough seems to have succeeded least with his depiction of the Duchess of Devonshire herself. Since the full-size portrait he painted of her was cut down to a half-length in the nineteenth century it is hard to judge its original effect, though it does not appear to be one of his most inspired canvases. He is reputed to have laid down his brush, claiming her likeness had defeated him. It is hard to credit such unlikely behaviour, though it is just possible that there was an awkwardness caused by political difficulties. The Duchess was a liberal-minded Whig, Gainsborough (despite voting for Fox in 1784) was essentially conservative in his politics. Like other members of the Spencer family, Georgiana was close to Reynolds, who shared their progressive political sympathies.

134

Perhaps Gainsborough was at his best when portraying those women who were caught, as he was, in the ambiguities of this world of shifting values. He was much attracted to performers and painted a fine likeness of Mrs Robinson, popularly known as 'Perdita' on account of her exceptional performance of that role from Shakespeare's *The Winter's Tale*. There is no hint of her acting profession in the picture. She sits like a grand lady in the landscape. In her hand she holds, as a grand lady would, a miniature of her husband. In this case it is of her lover – The Prince of Wales. It was he who had commissioned the portrait, though by the time it was finished he had abandoned her. It was perhaps for this reason that the work was not exhibited at the Academy in 1782, as originally intended.

139. **Thomas Gainsborough,** *Mrs Mary Robinson, 'Perdita',* 1781. A celebrated actress, Mrs Robinson was known as Perdita because she played that part in Shakespeare's *The Winter's Tale*. At the time this portrait was painted she was mistress to the Prince of Wales, but he abandoned her soon after. She died in poverty, having suffered from paralysis for many years.

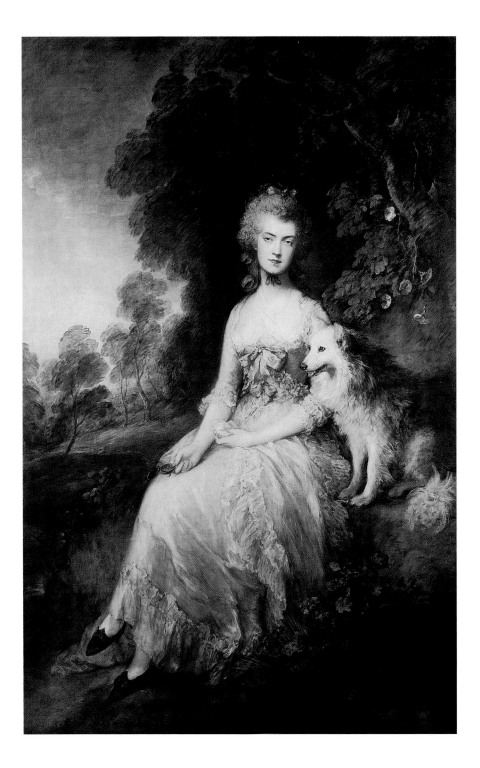

140. J. Thornthwaite, after
James Roberts, *Signora Baccelli*
in the Ballet called Les Amants
surpris, 1781. Giovanna Baccelli
was an Italian dancer. She is
shown here performing the dance
that had brought her success in
the ballet *Les Amants surpris*.
When Gainsborough painted his
portrait of her for her lover, the
Duke of Dorset, he also alluded to
this role. Her pose marks out her
status as a 'mere' performer – no
lady would have had themselves
represented in such a manner.

141. Thomas Gainsborough,
Giovanna Baccelli, 1782.

Gainsborough did show another portrait of a theatrical celebrity on that occasion. This was the Italian dancer Giovanna Baccelli. Baccelli had had a recent success in the ballet *Les Amants surpris*, and appears to be performing this in the picture. It was most unusual for women to be shown *en rôle* in this manner and one journalist could not resist a jibe at the fact that her face seems to be thickened with theatrical make-up, 'the face of this admirable dancer is evidently *paint-painted*'. Doubtless the reviewer wished to allude to the fact that Baccelli was a 'painted lady' in another sense. For she was known to be the mistress of the 3rd Duke of Dorset. Gainsborough's portrait of the Duke was withdrawn from the same exhibition, it would seem, for reason of decorum.

With the portraits of Mrs Robinson and Baccelli Gainsborough was perhaps sailing rather close to the wind. He seems to have avoided the public display of such dangerous sitters subsequently. He certainly regained the high ground with his portrait of the celebrated Mrs Siddons in 1785. No hint of scandal surrounded the leading tragic actress of the age. Gainsborough was well aware that Reynolds had portrayed her in high historical mode as the 'tragic muse' a year before. It had been commissioned by Sheridan as an advertisement for his Drury Lane theatre. It shows the actress adopting a pose reminiscent of the prophets of Michelangelo's ceiling in the Sistine Chapel in Rome. As though to provide an exact contrary, Gainsborough shows her in the height of contemporary fashion. As one contemporary observed, 'Mrs Siddons' dress is particularly *novelle*, and the fur around her cloak and foxskin muff are most happy imitations of nature.' As though to add insult to injury, Gainsborough has also painted her in a blue dress, thus refuting Reynolds' tenet that a central mass could not be depicted successfully using that cold colour, as he had already done in *The Blue Boy*.

142. **Joshua Reynolds,**
Mrs Siddons as the Tragic Muse,
1784. Reynolds' famous picture of Mrs Siddons, the greatest actress of her day, as the personification of tragedy. The pose is based on that of a prophet from Michelangelo's Sistine Chapel Ceiling in the Vatican in Rome. It seems the picture may have been commissioned by Sheridan as an advertisement for the Drury Lane theatre he managed and at which Mrs Siddons performed.

143. **Thomas Gainsborough,**
Mrs Siddons, 1783–85. Gainsborough's portrait of Mrs Siddons could be seen as a riposte to Reynolds'. She is shown not as an allegorical figure but as a lady in the height of contemporary fashion. Typically, he also took care to individualize her features, though perhaps he was over assiduous in this matter. When painting her face, he is reputed to have exclaimed, 'Confound the nose, there's no end to it'.

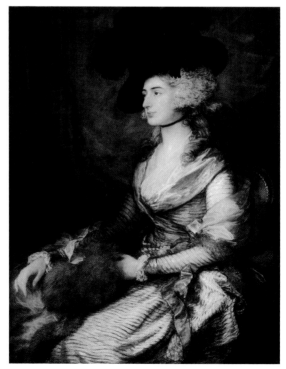

144. Thomas Gainsborough,
The Morning Walk, 1785.
A classic Gainsborough image of an elegant and fashionable newly wed couple taking a stroll in idyllic parkland scenery. Gainsborough has used Mrs Hallett's costume to show off all his skills at handling feathery and diaphanous materials. The couple's life was not to remain this harmonious for long. Mr Hallett's gambling habit soon put paid to both their fortunes.

145. Thomas Gainsborough,
Pomeranian Bitch and Puppy,
c. 1777. Pomeranian dogs were introduced into Britain from Germany by Queen Charlotte. They were highly popular in the 1780s, when their fluffy appearance made them the perfect accessory to the flowing robes and feathers then in vogue. The mother and pup depicted here may have belonged to Gainsborough's friend, the musician Karl Friedrich Abel.

Equally respectable was Gainsborough's double portrait of Mr and Mrs Hallett, also painted in 1785, in which the fashionable couple stroll as though in the open countryside. The two were married in that year and may be in their wedding garments. Mrs Hallett's dress of fine ivory silk, with gauzy muslin accessories, enables the artist to blend her form with the foliage behind, as though she was part of nature. The strolling motion of the pair, aided by the lively pose of the Pomeranian dog, is unusual in a portrait, though it may have been influenced by the artist's current designs for the *Richmond Water Walk*. It provides a perfect image of a couple setting out in life together and led to the picture receiving the popular name of *The Morning Walk* in the late nineteenth century. Despite this, it would seem that life was not so harmonious for the Halletts. Already addicted to the turf, Mr Hallett was to lose both their fortunes through betting.

Appearances may be deceptive in this blissful portrayal of marriage. Gainsborough seems nearer the truth in what might seem to be, at first, a deliberately romantic construction. His portrait of Mrs Sheridan, completed in 1786, shows the wife of the playwright seated in fetching disarray on a bank in wild nature. Sheridan was by that time an ambitious politician as well as a theatre manager. His wife, formerly Elizabeth Linley, had sacrificed her career as a singer when she married him. He had hardly repaid the complement, being continuously unfaithful to her and driving them deeper and deeper into debt with his gambling and loose living. If she is shown as abandoned here, it can hardly have been more than she felt. She was to die a few years

146

later, in 1792, in her mid-thirties – largely, one suspects, of neglect. The artist, who had known Elizabeth since she was six, was all too well aware of the sad circumstances of her life. Sheridan may have commissioned a portrait the year before of Mrs Siddons in the character of 'tragedy'. Gainsborough now gave the impresario a picture of his own wife that could equally well bear that title. Perhaps the artist's own frequently expressed wishes to 'escape' to nature have also affected the mood of this work. There is a rare level of feeling in this picture, which became a model for the fashionable 'romantic' portraits that Thomas Lawrence, in many ways Gainsborough's successor, was to promote so successfully in the decades to come. Unlike those later works, however, the melancholy expressed here is of a deep and personal kind.

146. **Thomas Gainsborough**, *Mrs Richard Brinsley Sheridan*, 1785–86. Gainsborough had known Mrs Sheridan since his early days in Bath when she had been the celebrated soprano Elizabeth Linley (see plate 76). The fashionably romantic melancholy of this picture – with unkempt dress and isolated setting – conveyed an all too real suffering. Mrs Sheridan died prematurely in 1792 after years of neglect and mistreatment by her husband.

147. **Thomas Gainsborough,**
Rocky Coast Scene with Fishermen, c. 1781–82.
Gainsborough first exhibited a coastal scene in
1781, possibly as a response to the growing
taste for wild and 'sublime' scenery.
The drama of such work was certainly appreciated
by contemporaries. As Horace Walpole said of
one of the exhibits of 1781, 'one steps back
for fear of being splashed.'

Chapter 18: Nature and Fancy

'His grace was not academical, or antique, but selected by himself from the great school of nature.' Reynolds' pronouncement, in his posthumous eulogy on Gainsborough, echoes a commonly held sentiment of the time. Gainsborough was the great painter of nature, the artist who had taken the alternative route to that of the Academy and based his art not on the precedents of the past, but on direct observation. However untrue (or at least partial) we now feel this judgment to be, there is no doubt that it formed the basis of the artist's reputation in the last years of his life – and indeed for generations to come.

Gainsborough had already established himself during his years at Bath as the painter of a particularly English Arcadia. In his early years in London he secured this with scenes such as *The Watering Place*. In the climate of mounting nationalism during the 1780s, this reputation grew, and was augmented by a wilder and more varied range of landscape that the artist now produced. It is a sign of this variety that he should have turned in the early 1780s to the depiction of seascapes, in which rocky and dangerous scenes are shown. When viewing one exhibited at the Royal Academy in 1781, Horace Walpole commented, 'one steps back for fear of being splashed'. This tribute to naturalism was probably not just generated by the relatively muted effects of such works, but rather a recognition that stormy seascapes were now one of the 'sublime' genres of landscape that had become fashionable. The new view of the sublime that had been pioneered by Edmund Burke in his famous essay on the *Sublime and Beautiful* of 1757 had led to the production of all kinds of images of fear and sensation that found a growing audience. It had been this genre that had enabled the Swiss painter Henry Fuseli (1741–1825) to establish himself with such panache with his *Nightmare*, exhibited at the Academy in 1781. In this case, Gainsborough was probably responding to the wild seascapes of the French painter who had made such subjects his own, Claude-Joseph Vernet (1714–89). A more immediate challenge was provided by Vernet's pupil De Loutherbourg, who had been settled in London since 1771, and included seascapes in his repertoire of sublime illusionistic scenes of danger.

100

148

148. Philippe Jacques de Loutherbourg, *The Smugglers' Return*, 1801. The French painter De Loutherbourg was already a specialist in dramatic landscapes when he settled in London in 1771. He introduced new and more sensational scene painting in the theatre and specialized in disaster subjects. He and Gainsborough were close in the 1770s, but later fell out.

149. E. F. Burney, *Eidophusikon*, *c.* 1780. One of De Loutherbourg's most celebrated innovations was the Eidophusikon. This was a miniature theatre with cut-out figures, dramatic scenes and sounds. Extracts from epic poems such as Milton's *Paradise Lost* were performed.

By this time, Gainsborough's former adversary, Richard Wilson, had all but ceased to paint. He was to die in 1782. As with his earlier rival, Gainsborough made clear that his view of nature was strikingly different from that of his opponent.

De Loutherbourg had first made his reputation as a scene painter, working in Drury Lane and had subsequently drawn the crowds in 1781 with an illusionist theatrical presentation of landscape and dramatic scenes, the *Eidophusikon*. It is reputed to have been the sight of this that caused Gainsborough to develop a light box of his own for which he designed transparencies.

150. Thomas Gainsborough's light box, *c.* 1781–82. Gainsborough seems to have developed his light box for displaying transparencies in emulation of De Loutherbourg's Eidophusikon. However, while the Frenchman's invention impressed through action and drama, Gainsborough's illuminated image invited contemplation.

151. Thomas Gainsborough, *Cottage Scene by Night*, *c.* 1781–82. One of the transparencies painted on glass by Gainsborough for display in his light box. These were broadly painted and focused on providing generalized effects of poetic illumination.

While emulating De Loutherbourg, Gainsborough was also stressing difference. De Loutherbourg's scenes are public and sensationalist. They are designed to be marvelled at by a crowd. Gainsborough's scenes are intended for individual contemplation by means of a light box set up like a peepshow. Their effects are less illusionistic – the brushwork can clearly be seen – and the emphasis seems to be more on reflection, encouraging poetic thoughts about the transformative effects of light. Such introspection is typical of the approach he was increasingly developing to the contemplation of nature in his last years.

It seems certain that Gainsborough was stimulated by De Loutherbourg to attempt wilder and more affecting forms of scenery. Probably he felt a rivalry, particularly after De Loutherbourg was elected an academician in 1780. Later the two fell out, and Gainsborough became convinced that De Loutherbourg was one of those who had worked against him in the Academy. It is striking that the press, particularly Gainsborough's friend Bate-Dudley, frequently defended the artist's landscapes against those of De Loutherbourg in strongly nationalistic terms. De Loutherbourg was characterized as a showy Frenchman, Gainsborough, a 'natural' Englishman.

Both Gainsborough's light box and coastal scenes show a less illusionist and more painterly approach to their subject which could fit in with this English naturalness. The same could be said for his scenes of wilder parts of Britain. De Loutherbourg, in tune with the new taste for picturesque travel, had begun to discover the beauties of the mountainous parts of Britain during the 1780s, making a particular feature of the scenery of Derbyshire and the Lake District. Gainsborough, too, began to travel to such places. He visited the Lake District in 1783 and subsequently worked scenes he studied there into compositions. True to his principles, he turned the specific into the general, making a view of *Langdale Pikes* into a *Mountain Landscape with Shepherd*. Later he created even more abstract and evocative scenes from the experience, such as *Rocky Landscape*. It seems an important point of Gainsborough's claim that he should avoid the specific and the sensational. It was also part of his argument against public exhibition – that it encouraged the kind of showiness with which De Loutherbourg drew the crowds. His own art, he claimed, was more poetic and contemplative.

152. **Thomas Gainsborough**, *Study of Langdale Pikes*, c. 1783. Following the vogue for wilder scenery, Gainsborough made a visit to the Lake District in 1783. This study, which may have been made on the spot, is of Langdale Pikes. He used it as the basis for an imaginative composition (see plate 153).

153. **Thomas Gainsborough**, *Mountain Landscape with Shepherd*, c. 1783. This composition is loosely based on a study of Langdale Pikes in the Lake District. However, the design has been turned into a 'composition', with clearly defined coulisses, simplified forms and a stronger system of tonal contrasts. Despite drawing inspiration from nature, Gainsborough firmly set himself against making topographical records.

154. **Thomas Gainsborough**, *Rocky Landscape*, *c.* 1783. In his oil paintings of mountain scenery Gainsborough took the process developed in his drawn compositions a step further, suppressing detail in favour of the broad evocation of mood. In contrast to De Loutherbourg, the mood is usually quiet and contemplative.

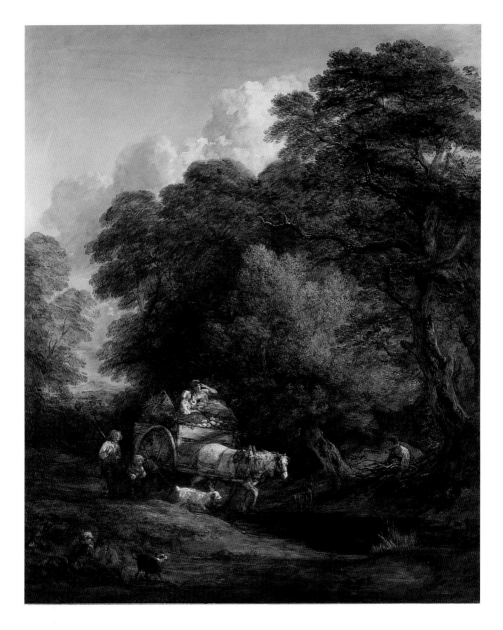

155. **Thomas Gainsborough**, *The Market Cart*, 1786. The finest and most fully developed version of a theme that had occupied Gainsborough since the 1760s. A cart returns from market, richly illuminated by the setting sun as it passes majestic trees. Gainsborough evokes here the image of a departed idyllic world. The theme is given greater dignity by the melancholic tones of darkness that are encroaching. A highly individual note is provided by the figure of the woodcutter emerging from beneath the trees in front of the richly laden cart. This could be taken as an image of Gainsborough himself, encountering his own fantasy.

It was in this mood that he returned, in 1786, to the final and grandest of his Arcadian visions, *The Market Cart*. This work seemed to be a summation of his images of peasants travelling through the countryside. Here, the cart moves towards us and there is a sense of coming home. There is an enveloping closeness in the way that it lurches towards the lane, which is all the more compelling because it is combined with a truly monumental sense of the trees – they are sublime in the awe-inspiring, rather than the frightening, sense. This truly seems to be a foreshadowing of the celebration of local scenery that Constable later achieved. Like Constable's, too, it was only made when he was living in the city and was looking back nostalgically at his view of the country. These are wish-fulfilment pictures, far removed from any kind of factual representation of rural life. But they are none the less powerful for that.

The quiet, contemplative power achieved in this work suggests both how Gainsborough worked through the challenge of De Loutherbourg's sensationalism, but also how, in the last decade of his life, he was increasingly concerned with making his own kind of treaty with the Old Masters. Undoubtedly, he felt the need to match the growing interest in historical art, as can be seen in Chapter 14 which discusses his relations with the Academy. It is for this reason, too, that he concentrated increasingly on his own kind of subject painting, the 'fancy pictures', for which he became so celebrated.

The 'fancy picture' was not an invention of Gainsborough's, it was a commonly understood term at the time for a poetic figurative design, usually of children or youths in a rural setting. Loosely inspired by the paintings of urchins by Bartolomé Esteban Murillo (1618–82), they represented, like landscape painting, a rural fantasy, a dream-like evocation of the simple life to soothe the minds of city dwellers. Gainsborough's concentration on this type of work in the 1780s can be seen as a product both of his new and more extensive view of nature and as a means of entering the area of figurative composition. He received much encouragement, including that of his adversary Reynolds, who bought his *Girl with Pigs* from the Academy exhibition in 1782. Reynolds did himself attempt some fancy pictures, such as his *Cupid as Link Boy*, though characteristically he made such works full of arch associations. He did appreciate in Gainsborough, however, what he saw as a pure and unaffected representation of rural characters: 'In his fancy pictures, when he had fixed on his object of imitation, whether it was the mean and vulgar form of

157

156. J. Dean, after Joshua Reynolds, *Cupid as Link Boy*, 1777. Like Gainsborough, Reynolds painted 'fancy pieces' of small children either as city urchins or in pastoral settings. This picture has, like many such works, erotic overtones. Link boys carried torches to light people on their way at night. They were often used to lead people to clandestine assignments – hence the association with Cupid, the God of Love.

157. **Thomas Gainsborough**, *Girl with Pigs*, 1782.
Gainsborough's 'fancy pieces' of poor children in
rural settings were greatly admired in his lifetime,
although they are probably now the aspect of his
art that we find most unsettling. *Girl with Pigs* so
impressed the artist's rival Reynolds that he bought
it when it was exhibited at the Academy in 1782.

a woodcutter, or a child of an interesting character, as he did not attempt to raise the one, so neither did he lose any of the natural grace and elegance of the other.'

Yet in fact such works are far from simple imitations. They are, rather, poetic evocations, in which the desires of the ageing artist seem all too clear. He certainly used real models. The girl who posed for the scene with pigs was employed, a few years later, for one of his most celebrated scenes, *Cottage Girl with Dog and Pitcher* (1785). Now verging on adolescence, it is hard not to see some erotic overtones in this scene of melancholy yearning or to believe that the artist would have been unaware of the traditional symbolism of a broken pitcher. He would at least have known the sentimental works by his contemporary the French genre painter Jean-Baptiste Greuze (1725–1805) which dwelt on such themes. There is a strongly voyeuristic element in many of these works.

158. **Thomas Gainsborough**, *Cottage Girl with Dog and Pitcher*, 1785. Inspired by Murillo (see plate 87), this is a beautifully painted, but highly artificial, image. It merits Hazlitt's description of such work as 'nature sitting for its portrait'.

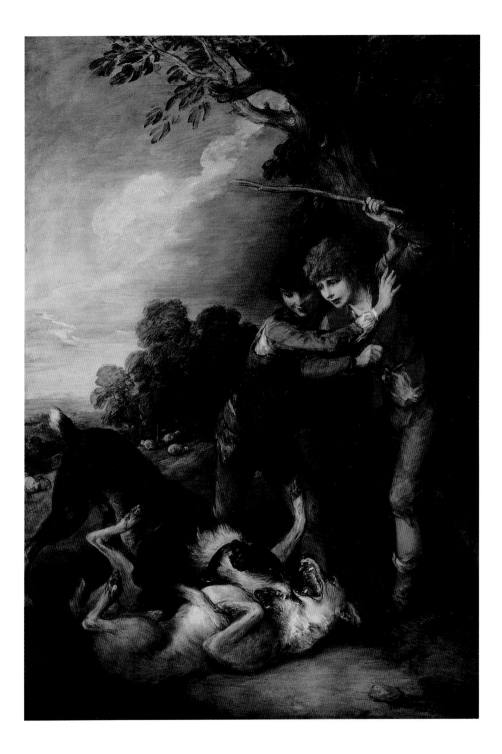

We may have problems with such works today, particularly with the idea of them as unvarnished transcripts of nature. As William Hazlitt later said, this is not so much nature as 'nature sitting for its portrait'. Yet we can at least recognize the technical brilliance of the best of them, particularly the way in which he has mastered the methods of the Flemish and Spanish schools. On other occasions he looked, unusually for him, towards the Italians. His more vigorous work of *Two Shepherd Boys with Dogs Fighting* bears an unmistakable reference to the most famous of landscape paintings, Titian's *St Peter Martyr* (*c.* 1530), the work that Reynolds had singled out for praise because of the way in which it combined history and landscape in his eleventh *Discourse*, delivered in December 1782, the year before Gainsborough exhibited this work at the Academy. Such work also prepared the ground for his essays in historical painting, notably the mythological *Diana and Actaeon* and *Hagar and Ishmael. Two Shepherd Boys with Dogs Fighting* is one of the most vigorous of such fancy pictures, in which he attempts an unusual degree of movement. Perhaps he was not altogether comfortable with the result, for he returned after this to quieter scenes.

All these later works are marked both by a growing sense of the grammar of painting – the rhetoric of the Old Masters. Gainsborough also seems to show an awareness of the effect of the spectator on the scene. They might have been seen as natural by his contemporaries, but it was really an inner nature he was describing, the fancies of the perceiving mind.

159. **Thomas Gainsborough**, *Two Shepherd Boys with Dogs Fighting*, 1783. This image is unusual for Gainsborough in the violence it portrays. Visually it seems to be a response to Titian's *St Peter Martyr* in which an assassination takes place. Here the principal conflict appears to be between the boys about whether or not to intervene in the fight. Might this be a struggle between good and evil – or between innocence and experience?

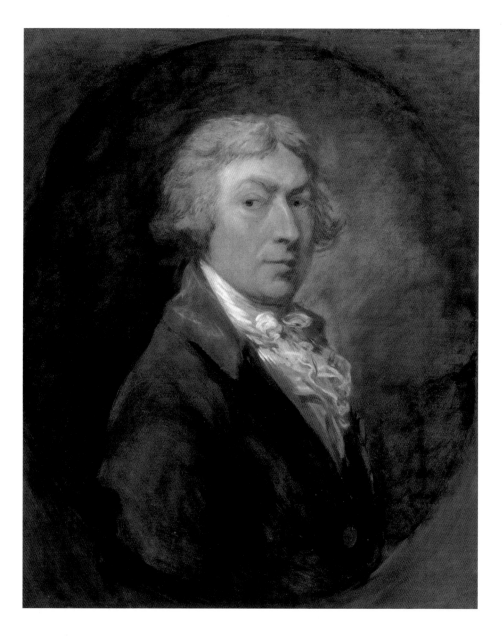

160. **Thomas Gainsborough**, *Self-Portrait*, *c.* 1787.
Painted in the last years of his life, this self-portrait
may originally have been intended for Abel, who
died in 1787. On his death bed Gainsborough
indicated that this was the portrait he wished to
be remembered by.

Chapter 19: Death and the Woodman

Some time in 1785 Gainsborough first became aware of a swelling in his neck. 'It has been 3 years coming on', he wrote in a letter in April 1788, 'and having no pain til lately, I paid little regard to it; now it is painful enough indeed.' Despite the assurances of two eminent doctors that it was not harmful, the swelling grew and the artist sickened. On 2 August 1788 he died of cancer. Although the growth had not caused him pain earlier, Gainsborough had been fearful that something was amiss. According to his daughters, he referred to it as his 'Lieutenant Colonel', as though it were in some way regimenting his life. Ever since his serious bout of illness in 1763 he had had an acute sense of mortality. Around 1780 he had produced a soft ground etching of an old man looking at a tombstone in a country churchyard, which was later published with the opening lines of Gray's *Elegy*. In the late 1780s he often spoke as though he was sure death was near. When his close friend Abel died in June 1787 he wrote, 'I shall never cease looking up to heaven – the little while I have to stay behind – in hopes of getting one more glance of the man I loved from the moment I heard him touch the string.'

161. **Thomas Gainsborough,**
Wooded Landscape with Peasant Reading Tombstone, 1780.
A meditation on mortality, this was published posthumously with the opening lines of Gray's *Elegy Written in a Country Churchyard*. Gainsborough himself brooded on death after his severe illness in the early 1760s.

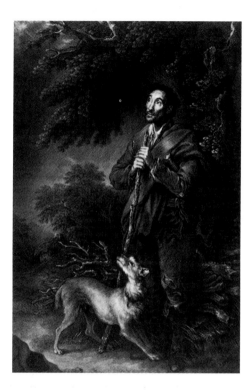

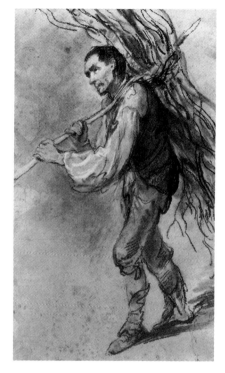

162. **Peter Simon, after Gainsborough,**
The Woodman, 1791. This picture, showing an aged
woodman sheltering from a storm, was the one that
Gainsborough regarded as his most important work.
This view was not shared by his contemporaries.
The picture was destroyed by fire in 1812 and is
only known now from engraved copies.

163. **Thomas Gainsborough,**
Study of a Woodman Carrying Faggots, c. 1787.
A study for *The Woodman* (see plate 162).
The model was 'a poor smith worn out by labour'
who attracted Gainsborough's attention in the
summer of 1787.

Yet during this period Gainsborough also believed his powers as an artist to be growing, and seemed determined to work to the best of his ability to achieve what he could before it was too late. Reynolds said that it was his impression that Gainsborough's regret at losing life 'was principally the regret of leaving his art; and more especially as he now began, he said, to see what his deficiencies were; which, he said, he flattered himself in his last works were in some measure supplied.'

It was in the last three years of his life that he did indeed make efforts to produce works on a grander and more complex scale than ever before. Perhaps the greatest achievement of these years was his *Market Cart*. Yet the work that he himself set most 155 store by was of a rather different kind. This was *The Woodman*. Completed in 1787, it was destroyed by fire in the early nineteenth century and is now only known through an engraving. To judge by this, it was somewhat unsettlingly full of pathos. It depicted an old and decrepit woodman caught in a storm. He looks upwards with an anguished expression, his apprehension echoed in the dog, turning in alarm, by his feet. In the distance is a cottage, a darkened and perhaps unreachable shelter. Gainsborough had apparently been inspired to do this work by the model. According to the engraver John Thomas Smith (1766–1833), this was 'a poor smith worn out by labour... Mr Gainsborough was struck by his careworn aspect and took him home; he enabled the needy wanderer by his generosity to live – and made him immortal in his art.' There are many studies that Gainsborough made of this man in the summer of 1787, showing him carrying faggots and in other poses connected with the theme of the woodman. The woodman had been a figure in Gainsborough's landscapes from his earliest days. He appears in the foreground of *Cornard Wood*, busily gathering his bundle. He 38 had turned up time and again in cottage scenes, bearing his heavy load home. He is virtually the only figure seen at work in such pictures, and often appears to function as an alter ego for the painter. Like the woodman, he went to nature, gathered what he found and brought it home, sometimes literally, as when he collected the twigs and rocks he used for painting his landscapes in the studio.

Gainsborough would doubtlessly have been aware, too, of the careworn woodman's encounter with death in the famous fable of Aesop. According to this, an old man was carrying the faggots he had gathered to sell in the city one day. Wearied by his long journey, he sat down by the wayside, and throwing down his

164. **Joseph Wright,**
The Old Man and Death, c. 1773.
Wright's depiction of Aesop's fable
of the old man and death was
exhibited at the Society of Artists
in 1774, where it might well have
been seen by Gainsborough.

load, besought 'Death' to come. 'Death' immediately appeared in answer to his summons and asked for what reason he had called him. The old man hurriedly replied, 'That, lifting up the load, you may place it again upon my shoulders.' Gainsborough would also have known the visualization of this scene exhibited by Joseph Wright at the Society of Artists in 1774. In some ways his own picture could be said to be a sentiment-laden, naturized revision of the theme. Death is not a skeleton now, but a threatening storm. Gainsborough's woodman does not seem inclined to have his load placed back on his shoulders, either. And yet, like the woodman, Gainsborough still believed he had work to do.

Even before *The Woodman*, Gainsborough had seemed to be concerned with death in the landscape, though in a way that would seem to introduce the theme of punishment. Sometime around 1785 Gainsborough conceived the large canvas of *Diana* 165 *and Actaeon*. The only time that he attempted a scene of classical mythology, it tells the story of the huntsman Actaeon who spied the Goddess Diana and her nymphs bathing. Diana punished him by splashing his face with water and at this point he turned into a stag and was torn to pieces by his own hounds. Once again, one wonders about the biographical significance of this scene. It could be seen as a warning about being too prurient in 'peeping on nature'. Yet it also contains, at some level, both his guilt about his weakness for the petticoats and conveys the subjective voyeuristic mood evident in so many of his later fancy subjects. Formally, it can be seen as a continuation of his interest in Italian

art – and in particular Titian – that had been initiated by his *Two Shepherd Boys with Dogs Fighting*. But here he has entered into a world he had always forbidden himself – that of the naked figure. In the end he did not finish the work, which remained unknown to contemporaries until after his death. In recent times it has been hailed as one of the artist's masterpieces, but in his own eyes it was probably an experiment that he did not quite know how to complete – or a secret he could not bring himself to confess. In many ways it raised huge questions about the nature of historical art and indeed of painting that would seem truly bold if he had allowed them to surface. Gainsborough was worried about these issues professionally at the time, particularly after he had received the challenge of producing a work for Boydell's *Shakespeare Gallery*. Whatever his feelings about his *Diana and Actaeon*, Gainsborough was in no doubt that *The Woodman* was his masterpiece and did all he could to promote it. He had it sent to the palace for George III to inspect. Yet while making complimentary remarks, the monarch declined to buy it. He offered it to his assistant, Gainsborough Dupont, as a reward for work he had done. But Dupont, much to the artist's dismay, elected instead to take the erotically charged *Haymaker and Sleeping Girl*. When he wrote as a dying man to ask Reynolds to visit him and see his works, he says explicitly, 'my woodman you never saw.' Despite this, Reynolds did not single out the work in his eulogy. Perhaps in the end, *The Woodman* was too personal in its meaning to have significance for any but Gainsborough himself. Yet its presence seems to have provided him with solace in his last months, as though it had at least given some indication of what he could achieve.

It often happens, on the point of death, that people have a beatific vision. Gainsborough's final utterance appears to indicate this. Faithful to his artistic mission to the end, he is supposed to have said: 'We are all going to heaven, and Van Dyck is of our company.' This seems, in fact, to be an embellishment of something less poetic, more enigmatic. According to Farington, who had it from one who was present, Gainsborough's actual words were: 'Van Dyck was right'. Who knows? Perhaps he was.

165. Thomas Gainsborough,
Diana and Actaeon, c. 1785.
Gainsborough rarely painted historical
or mythological subjects. This unfinished
work appears to have been his most
ambitious attempt. It is also one of the
very few painting in which he depicted
the nude figure. Despite the evident
eroticism of the subject – Diana and her
nymphs being spied on bathing, it also
involves retribution and death. Actaeon,
who has intruded on the Goddess,
is being punished by being turned into
a stag, after which he is pursued by
his own hounds and torn to pieces.

Epilogue: The Name of Gainsborough

'If ever this nation should produce genius sufficient to acquire to us the honourable distinction of an English School the name of Gainsborough will be transmitted to posterity, in the history of the Art, among the very first of that rising name.'

Reynolds' pronouncement, shortly after the artist's death, has been justified by time. There is an English School, and Gainsborough is one of its brightest stars. At the time that he spoke, Reynolds was being as much a politician as a prophet. He was not just paying a pious tribute, he was setting out to draw from Gainsborough's 'excellences and defects, matters of instruction to the Students in our academy.' He was ensuring that his old rival fitted into the grand plan for English art that he had mapped out. Gainsborough would probably not have been averse to this. Although he had quarrelled with the Academy, he was deeply concerned, in his last years, with the issues raised by that institution and its president. Like them, he wished to promote an art that connected with the mainstream of the Old Masters. He wanted to see the rise of an English School that could hold its own in the international community, rather than just subsist as an eccentric backwater. He differed from Reynolds in seeing a future in such a school for painterly effect and the celebration of nature. Yet in the end, Reynolds had to concede that such practices did have their place, provided they knew their limitations and did not interfere with the emergence of the most important type of art, history painting.

The problem was that history painting, as envisaged by Reynolds, never did emerge. Despite the encouragement he gave, the efforts of promoters such as Boydell, the innovation of modern history painting by West and Copley, and the gothic inventions of Fuseli, British historical artists cut a sorry figure in the international scene. By contrast, British portraiture was readily attracting admiration abroad in the 1780s. As has already been mentioned, the French neo-classical painter David took an interest in Gainsborough's grand yet informal portrait manner and copied the design of his *Prince of Wales*. During the 1790s the fashion for court portraits in the British style spread. As painter to the Spanish court, Francisco José de Goya (1746–1828) took a professional interest in such work and Gainsborough's impact

has been traced in his free-standing full-lengths of aristocrats. Later this reputation helped Thomas Lawrence, in many ways Gainsborough's successor, to become the most celebrated portrait painter in Europe.

For the generation after Reynolds and Gainsborough it was nature – the landscape painting of Turner and Constable, the low-life rural scenes of George Morland (1763–1804) and David Wilkie (1785–1841), that marked the true direction of the new British school. Reynolds had himself expressed a preference for Gainsborough's fancy pictures as the most original part of his art. But for the younger artists, it was the 'purer' nature of the landscapes that appealed. This direction was confirmed in the great retrospective exhibition held at the British Institution, London, in 1814 as part of a patriotic revaluation of the founders of what was then confidently being claimed as a great national school. On this occasion the reviewer in the *New Monthly Register* wrote of Gainsborough: 'His portraits prove him to have been a respectable portrait-painter; but he must rest his fame on the most incontrovertible of all bases, his landscapes. True and faithful to nature, he refines all he represents.' For the naturalists – now the rising force in British art – Gainsborough's faithfulness to nature was a talisman. He was particularly important for his fellow East Anglian Constable, who invoked Gainsborough's name when making his own studies of their local terrain, commenting once, 'I see Gainsborough in every hedge and hollow tree.' Although Constable felt that Gainsborough had been too 'general' in his treatment of individual forms, he still looked to his work as a precedent for celebrating local scenery on a monumental scale. His *Haywain*, the picture that gained him international fame and that has subsequently become a stereotype for Englishness, is in many ways a more detailed and specific reworking of his forerunner's *Market Cart.*

166

155

By this time, the celebration of the naturalism of British art had become a national issue. It was seen as the expression of both the Protestant spirit and the enquiring, empirical mind of the Anglo-Saxon. Gainsborough was characterized in such terms in the most important assessment of British art of the early nineteenth century, Allan Cunningham's *The Lives of the Most Eminent British Painters* (1829–33). 'His paintings have a national look' that author declared.

Yet the greater naturalistic advances of subsequent generations – Constable, Turner, the pre-Raphaelites, the French Realists and Impressionists – caused this reputation to fade. The

166. John Constable, *The Haywain*, 1821. Constable always saw Gainsborough as his forerunner in painting 'natural' English landscapes. He felt the tie all the more closely because they were both from the same part of Suffolk.

167. James Abbott McNeill Whistler, *Harmony in Grey and Green: Miss Cicely Alexander*, 1872–74. The American painter Whistler greatly admired the elegance of Gainsborough's portraits, which he saw as part of a European tradition that reached back through Spanish and Flemish art to the Italian Renaissance. He copied many of Gainsborough's studio practices, including the use of extremely liquid paint and exceptionally long brushes to achieve subtle and well-balanced tonal effects in large pictures.

generality that Constable had deplored in Gainsborough now made his landscapes seem artificial in comparison with what had followed. The fact that little of his earlier Dutch-inspired work was known at this time encouraged the view of him as a somewhat sentimental interpreter of the countryside.

At the same time, however, Gainsborough's reputation as a portraitist revived. A new vogue for the eighteenth century as the 'age of taste' emerged with the aesthetic movement in the 1870s. Gainsborough's portraits seemed to epitomize the elegance and stylishness of that bygone time. Whistler – the great American aesthete who found naturalism so painfully vulgar – thrilled to the painterly brilliance of Gainsborough. He saw the artist as the best British representative of a tradition of grand portraiture leading back to Van Dyck, Velázquez and Titian. He made a special study of Gainsborough's methods and even went so far as to paint a 'Blue Girl' (a portrait of Eleanor Leyland in 1879, now destroyed) to work through similar problems. He emulated the delicious textual effects achieved in such works as *Miss Cicely Alexander*. He even adopted Gainsborough's practice of using brushes several feet long to achieve broad tonal effects in his pictures.

168. **Augustus John,** *Madame Suggia*, 1920–23. Gainsborough remained an inspiration for society portraitists in the twentieth century. Augustus John's magnificent painting of the cellist Madame Suggia appears to owe a debt to *Ann Ford* (see plate 57).

Gainsborough's portraits certainly played their part in the revival of a grand British portrait practice in the early twentieth century. Often the masters of that age made direct references to their predecessor's work. Augustus John (1878–1961), for example, gave his striking portrait of the great cellist *Madame Suggia* (1920–23) something of the panache and defiance to be found in *Ann Ford*. 57

Since those days, Gainsborough has remained an admired figure, though less of a generative one for contemporary art. Modernist aesthetics, however, have brought about a further revaluation, leading to an emphasis on the more spontaneous and intuitive side of his art. In the 1920s Gainsborough's early work was reassessed and he gained his place once more amongst the heroes of naturalism. No work played a stronger part in this than *Mr and Mrs Andrews*, discovered and shown at the 44 Gainsborough bicentenary show in Ipswich in 1927. He was hailed, in particular, by the great Bloomsbury critic and promoter of Post-Impressionism, Roger Fry. No admirer of British art, which he felt to be sullied by vulgarity and a non-pictorial

interest in narrative, Fry singled out Gainsborough along with Constable as one of the few examples of true painting in the national school. It was this Gainsborough, one who could share with Constable the honour of being a precursor of the Impressionists, that was admired by the advocates of modernism.

In the popular mind, however, Gainsborough remains the elegant portraitist. It is no accident that he is one of a handful of British painters to have achieved the accolade of popular culture and be widely reproduced in the tat and trivia of kitsch. *The Blue Boy* has appeared on countless biscuit tins and chocolate boxes. There are also special lines in Gainsborough dolls and Gainsborough porcelain figurines – such as those produced by the Royal Worcester factory, in which the *Countess Howe* appears as a firm favourite. He also shares with Lawrence the honour – or indignity – of being the only British artists to form part of the Walt Disney Gallery of Old Masters – where tribute is paid to him in the form of *The Blue Duck*. In the face of such trivialization, it is tempting to follow the line of most academic historians and critics and say that the preference for his portraits is purely a matter of popular taste. In recent years there has been an increasing tendency to promote the grander landscapes and

169. Countess Howe figurine from Royal Doulton China. The popularity of Gainsborough's portraits has led to them being reproduced in all forms of media. Several have been used by the Royal Doulton China company as the basis for figurines. This one, modelled by Peter Gee, is from a highly prized limited edition.

170. **Walt Disney**, *The Blue Duck*, 1941–45. Gainsborough is one of only two British artists to make Walt Disney's Gallery of Old Masters. Almost inevitably, the portrait chosen to be guyed was *The Blue Boy*.

fancy pieces, with all their learned references and technical expertise. There have also been attempts to belabour his images – in the teeth of his own opposition to such matters – with all the complex historical and literary referentiality so beloved by post-modernists. But I do not think this is an accurate perception of the situation. For what is at the heart of Gainsborough is his skill in observation. From this point of view, perhaps the historian nearest to the mark recently has been Bettina Gockel, who has seen a continuity between Gainsborough's making of likeness with his 'scratches and markings' to the far more extreme testing of representation against painted mark in the portraits of Francis Bacon (1909–92). Such a pairing, however strange it might seem at first, does at least stress the tradition of exploratory representation that has been alive in Britain since the days of Hogarth.

It is, in any case, Gainsborough's powers of observation that keep his portraits alive. It is not the grandeur that matters, it is the sense of a real person sympathetically and intelligently apprehended. This perceptiveness is at the heart of the best of his landscapes and subject pictures too. Gainsborough was not principally an inventor. He had little of the narrative skill of Hogarth or the compositional brilliance of Reynolds. But he seized the occasion perfectly. In this he is essentially a Hogarthian, believing the essence of beauty to be liveliness and transience. He was always looking and discovering.

It is appropriate, therefore, to end by returning to his drawings. They reveal him at work, thinking and looking with every stroke. This is particularly evident in his studies, such as those of a cat, observed stretching, cleaning, sleeping. Each pose is quickly noted, one after another; unpremeditated, yet somehow falling onto the page in a delightful circular pattern. But it can also be found in his invented compositions, such as the blocked out design for an uncompleted picture of a maid with a broom at an open door. Here, there is the same rapid, incisive calligraphy discovering delightful movements and gestures. It is economic, almost schematic, yet still contains a breathtaking sense of life and form. This is the art of perception, of pictorial intelligence at its height. It is the heart of Gainsborough the artist.

171. **Thomas Gainsborough,** *Figure Study for The Housemaid,* *c.* 1785–88. An elegantly understated study, perhaps a preliminary design for a painting.

172. (overleaf) **Thomas Gainsborough,** *Studies of a Cat,* mid-1760s. A round of sketches of a cat sleeping, stretching and grooming. Gainsborough reputedly made these drawings while staying in a country house, and presented them as a gift to his hostess.

172

T Gainsborough.

Chronology

1727
Born in Sudbury, Suffolk, the youngest of ten children; baptized on 14 May. His father, John, was a clothier and wool handler. After going bankrupt in 1733, he became the local postmaster.

c. 1740
Went to London, where he was taught by Hubert François Gravelot. He also studied at the St Martin's Lane Academy, where he met Francis Hayman, for whom he worked.

1744
Set up his own studio.

1745
Earliest dated painting, *Bumper*.

1746
Lived in Hatton Gardens. Married Margaret Burr, illegitimate daughter of the Duke of Beaufort, on 15 July at Dr Keith's Mayfair Chapel, London.

1748
Death of first born, Mary. Painted view of Charterhouse for the Foundling Hospital. His father died on 29 October.

1749
Returned to Sudbury early in the year and set up a practice there.

1750
Birth of daughter, Mary.

1752
Birth of daughter, Margaret. Moved to Ipswich.

1759
Moved to Bath.

1761
First exhibited at the Society of Artists in London.

1763
Experienced severe illness; moved out of the centre of Bath to Landsdown.

1766
Moved to Royal Circus in Bath.

1768
Founder member of the Royal Academy of Arts, London.

1769
First exhibited at the Royal Academy of Arts, London.

1772
Took on his nephew, Gainsborough Dupont, as an apprentice.

1773
Quarrelled with the Royal Academy and ceased to exhibit there.

1774
Moved to London, living for the rest of his life in Schomberg House, Pall Mall.

1777
Resumed exhibiting at the Royal Academy; received first royal commissions.

1780
Painted King George III and Queen Charlotte, becoming for a time court painter in all but name.

1784
Final quarrel with the Royal Academy. Ceased to exhibit there and subsequently held his own annual exhibition at Schomberg House. On the death of Allan Ramsay, the post of principal painter to the King became vacant, but it went to Reynolds rather than Gainsborough.

1788
Died on 2 August; buried in Kew churchyard.

Bibliography

1. General

W. T. Whitley, *Thomas Gainsborough*, London, 1915, remains the most thorough biography of the artist.

There are many general introductions to the artist's work, including:

Malcolm Cormack, *The Paintings of Thomas Gainsborough*, Cambridge and New York, 1991
Adrienne Corri, *The Search for Gainsborough*, London, 1984. A stimulating exploration, but claims should be checked against more recent literature.
John Hayes, *Gainsborough: Paintings and Drawings*, London, 1975
John Hayes, *Gainsborough* (exh. cat.), London, 1980
Nicola Kalinsky, *Gainsborough*, London, 1995
Jack Lindsay, *Thomas Gainsborough: His Life and Art*, London and New York, 1983
E. K. Waterhouse, *Gainsborough*, London, 1958 (2nd edn 1966). Contains the most comprehensive catalogue of the artist's oeuvre to date.

Recently, three important scholarly studies have been published:

Amal Asfour and Paul Williamson, *Gainsborough's Vision*, Liverpool, 1999
Bettina Gockel, *Kunst und Politik der Farbe: Gainsboroughs Portraitmalerei*, Berlin, 1999
Michael Rosenthal, *The Art of Thomas Gainsborough: 'a little business for the eye'*, London and New Haven, 1999

The most useful place for keeping up with work on the artist in recent years has been *Gainsborough's House Review* (ed. Hugh Belsey), first published in 1989 – Gainsborough's house also has an informative website: www.gainsborough.org.

The catalogue of the 'Gainsborough' exhibition that will take place at Tate Britain, London, in autumn 2002 will undoubtedly be a major contribution to scholarship on the artist.

2. Catalogues of Works and Collections of Letters

The most complete listing is found in E. K.Waterhouse (*op. cit.*), although there have been some significant additions and changes since it was published. Particular areas of Gainsborough's work are covered in the following:

John Hayes, *The Drawings of Thomas Gainsborough*, 2 vols, London and New Haven, 1970
An addenda was published by John Hayes, 'Gainsborough's Drawings: A Supplement to the Catalogue Raisonné', in *Master Drawings*, XXI no. 4, 1983, pp. 367–91
John Hayes, *Gainsborough as Printmaker*, London and New Haven, 1971
John Hayes, *The Landscape Paintings of Thomas Gainsborough: A Critical Text and Catalogue Raisonné*, 2 vols, London, 1982

Important entries on Gainsborough's works can be found in:
Judy Egerton, *The British School, National Gallery Catalogues*, London and New Haven, 1998

A catalogue raisonné of Gainsborough portraits is being prepared by Hugh Belsey, curator of Gainsborough's House Museum.

Gainsborough was a brilliant letter writer. For many years the standard publication was Mary Woodall (ed.), *The Letters of Thomas Gainsborough*, London, 1961. This has recently been replaced by John Hayes (ed.), *The Letters of Thomas Gainsborough*, London and New Haven, 2000

3. Background

This is not the place for a general bibliography on eighteenth-century English culture. However, the following are recommended to those wishing to start exploring the social and artistic context of Gainsborough's career:

Ann Bermingham, *Landscape and Ideology: The English Rustic Tradition*, London and Berkeley, 1987
John Brewer, *The Pleasures of the Imagination: English Culture in the Eighteenth Century*, London and New York, 1997

Richard Leppert, *Music and Image: Domesticity, Ideology and Socio-Cultural Formation in 18th-Century England*, Cambridge and New York, 1988
Marcia Pointon, *Hanging the Head: Portraiture and Social Formation in Eighteenth-Century England*, London and New Haven, 1993
Aileen Ribeiro, *The Art of Dress: Fashion in England and France, 1750–1820*, London and New Haven, 1995. Contains much important information on costume in Gainsborough's portraits.
Desmond Shawe-Taylor, *The Georgians: Eighteenth-Century Portraiture and Society*, London, 1990
David Solkin, *Painting for Money: The Visual Arts and the Public Sphere in Eighteenth-Century England*, London and New Haven, 1993
William Vaughan, *British Painting: The Golden Age from Hogarth to Turner*, London and New York, 1999

4. Special Studies

Part One: Suffolk
Brian Allen, 'Watteau and his Imitators in Mid-Eighteenth-Century England', in *Antoine Watteau* (F. Moureau and M. M. Grasselli, eds), Paris, 1987, pp. 265–66
Hugh Belsey, *Gainsborough's Family* (exh. cat.), Gainsborough's House, Sudbury, 1988
Susan Foister, Rica Jones and Olivier Meslay, *Young Gainsborough* (exh. cat.), London, 1997
'Holywells Park', in *NACF Review*, 1992, pp. 122–23
Susan Legouix Sloman, 'Mrs Margaret Gainsborough: 'A Prince's Daughter', in *Gainsborough's House Review*, 1995–96, pp. 47–58
Michael Levey, *The Painter's Daughters Chasing a Butterfly*, London, 1975
David Tyler, 'Thomas Gainsborough's Daughters', in *Gainsborough's House Society Annual Report, 1991–92*, Sudbury, 1992, pp. 50–66
David Tyler, 'Thomas Gainsborough's Days in Hatton Garden' and 'The Gainsborough Family: Births, Marriages and Deaths Re-examined'; both in *Gainsborough's House Review*, 1992–93, pp. 27–32, 38–54

Part Two: Bath
D. Cherry and J. Harris, 'Eighteenth-Century Portraiture and the Seventeenth-Century Past: Gainsborough and Van Dyck', in *Art History*, 5 (1982), pp. 287–309

Anne French (ed.), with contributions by Aileen Ribeiro and Viola Pemberton-Pigott, *The Earl and Countess Howe by Gainsborough: A Bicentenary Exhibition*, Ruislip, 1988
Gainsborough in Bath: A Bicentenary Exhibition, 1 July–14 August 1988, Bath, 1988
Susan Legouix Sloman, 'Artists' Picture Rooms in Eighteenth-Century Bath', in *Bath History*, VI (1996), pp. 132–54
Paul Spencer-Longhurst and Janet M. Brooke, *Thomas Gainsborough: The Harvest Wagon* (exh. cat.), Birmingham and Toronto, 1995

Part Three: London
Gainsborough and Reynolds: Contrasts in Royal Patronage (exh. cat.), London, 1994
Martin Postle, *Angels and Urchins. The Fancy Picture in Eighteenth-Century British Art* (exh. cat.), Nottingham, 1998
Michael Rosenthal, 'Gainsborough's *Diana and Actaeon*', in *Painting and the Politics of Culture: New Essays on British Art, 1700–1850* (John Barrell, ed.), Oxford and New York, 1992, pp. 167–94
David Solkin, 'Gainsborough's Classically Virtuous Wife', in *The British Art Journal*, vol. 2, no. 2, winter 2000/01, pp. 75–77

Principal Collections

The finest selection of Gainsborough paintings is in the National Gallery in London. The paintings there – which include some of his greatest works (*Mr and Mrs Andrews*; *Cornard Wood*; *The Painter's Daughters Chasing a Butterfly*; *The Morning Walk*) – provide a representative coverage of his career. The largest public collection of Gainsboroughs is in Tate Britain in London, which holds *The Watering Place*, and many other fine works. Other important London collections are the Wallace Collection, which includes *Mrs Mary Robinson*, Kenwood, which houses *Mary, Countess Howe*, and Dulwich College, which includes *The Linley Sisters*. The best and most extensive collection of his drawings and prints is also in London, in the British Museum.

The largest and most important collection in the UK, outside London, is that in Gainsborough's House in Sudbury. It contains more paintings from the artist's early rather than later career, but is perhaps most distinguished for its fine range of drawings. Other important works can be found at The Barber Institute of Fine Arts, Birmingham (*The Harvest Wagon*); The National Gallery of Scotland, Edinburgh (*The Hon. Mrs Thomas Graham*); Ipswich Borough Council Museums and Galleries (*Portrait of William Wollaston*; *Holywells Park, Ipswich*); and The Fitzwilliam Museum, Cambridge (*Heneage Lloyd and his Sister, Lucy*). A substantial number of major Gainsboroughs are still in private collections in the UK. The most important of these (and in fact the most extensive of all Gainsborough collections) is that belonging to Her Majesty Queen Elizabeth II (*Queen Charlotte*; *Diana and Actaeon*).

Outside the UK, the most important European collection is in the National Gallery of Ireland, Dublin (*James Quin*). In Paris, the Louvre has some fine works, notably *Lady Alston*.

In the USA, there are substantial collections in the Huntington Gallery, San Marino, California (*The Blue Boy*); The National Gallery of Art, Washington, D.C. (*Mrs Richard Brinsley Sheridan*); and the Yale Center for British Art, New Haven. There are also good collections at Cincinnati Art Museum (*Ann Ford*); and The Frick Collection, New York (*The Mall*).

List of Illustrations

31 *Tom Peartree, c.* 1752. Oil on panel, approximately 60 x 90 (23⅝ x 35⅜). Ipswich Borough Council Museums and Galleries

32 T. Major, after Gainsborough, *Landguard Fort,* 1754. Engraving. © Copyright The British Museum, London

33 *Joshua Kirby, c.* 1757–58. Oil on canvas, 41.9 x 29.2 (16½ x 11½). V&A Picture Library

34 William Hogarth, *False Perspective,* frontispiece to Joshua Kirby's *Dr Brook Taylor's Method of Perspective made easy,* 1754. Gainsborough's House, Sudbury, Suffolk

35 *Landscape with Peasant Resting Beside a Winding Track,* 1747. Oil on canvas, 101.9 x 147.3 (40⅛ x 58). Philadelphia Museum of Art

36 After Ruisdael, *La Forêt (The Forest),* late 1740s. Black and white chalks on buff paper, 40.8 x 42.2 (16 x 16½). Whitworth Art Gallery, University of Manchester

37 Jacob Ruisdael, *A Pool Surrounded by Trees, and Two Sportsmen Coursing a Hare, c.* 1665. Oil on canvas, 107.5 x 143 (42⅜ x 56¼). The National Gallery, London

38 *Cornard Wood, near Sudbury, Suffolk,* 1748. Oil on canvas, 122 x 155 (48 x 61). The National Gallery, London

39 *Holywells Park, Ipswich,* 1748–50. Oil on canvas, 50.8 x 66 (20 x 26). Ipswich Borough Council Museums and Galleries

40 *St Mary's Church, Hadleigh, c.* 1748–50. Oil on canvas, 91.4 x 190.5 (36 x 75). Private Collection

41 *Landscape with a Woodcutter and Milkmaid,* 1755. Oil on canvas, 106.7 x 128.2 (42 x 50½). By kind permission of the Marquess of Tavistock and Trustees of the Bedford Estate

42 Francis Hayman, *The Jacob Family, c.* 1745. Oil on canvas, 96.5 x 108 (38 x 42½). Private Collection

43 *John and Ann Gravenor, with their Daughters, c.* 1752–54. Oil on canvas, 90.2 x 90.2 (35½ x 35½). Yale Center for British Art, Paul Mellon Collection, New Haven, Connecticut

44 *Mr and Mrs Andrews, c.* 1750. Oil on canvas, 69.8 x 119.4 (27 ½ x 47). The National Gallery, London

45 *Heneage Lloyd and his Sister, Lucy, c.* 1750–52. Oil on canvas, 64.1 x 81 (25¼ x 31½). The Fitzwilliam Museum, University of Cambridge

46 *The Rev. John Chafy,* 1750–52. Oil on canvas, 76.2 x 63.5 (30 x 25). © Tate, London 2002

47 *John Plampin, c.* 1750. Oil on canvas, 50.2 x 60.3 (19¾ x 23¾). The National Gallery, London

48 François-Bernard Lépicié, after Antoine Watteau, *Antoine de la Roque,* 1734, engraving

49 *Major John Dade, of Tannington, Suffolk, c.* 1755. Oil on canvas, 76.2 x 64.8 (30 x 25½). Yale Center for British Art, Paul Mellon Collection, New Haven, Connecticut

50 *Edward Vernon, c.* 1753. Oil on canvas, 126.4 x 103.8 (49¾ x 40⅞). By courtesy of the National Portrait Gallery, London

51 *The Painter's Daughters Chasing a Butterfly, c.* 1756. Oil on canvas, 113.5 x 105 (44⅜ x 41⅜). The National Gallery, London

52 *The Painter's Daughters with a Cat, c.* 1760. Oil on canvas, 75.6 x 62.9 (29¾ x 24¾). The National Gallery, London

53 'Of the Boy and the Butterfly', illustration 22 from *Divine Emblems: or, Temporal Things Spiritualized* by John Bunyan. John Marshall, London, 1724. By permission of the British Library. Shelfmark 4404.c.58

54 William Hogarth, *The MacKinnon Children, c.* 1742. Oil on canvas, 180.3 x 143.5 (71 x 56½). National Gallery of Ireland, Dublin

55 *Portrait of William Wollaston,* 1758–59. Oil on canvas, 124.5 x 99 (49 x 39). Ipswich Borough Council Museums and Galleries

56 *Lady Innes, c.* 1758–59. Oil on canvas, 100.9 x 71.1 (39¾ x 28). The Frick Collection, New York

57 *Ann Ford (Mrs Philip Thicknesse),* 1760. Oil on canvas, 196.9 x 134.6 (77½ x 53). Cincinnati Art Museum, bequest of Mary M. Emery

58 Plate from 'A Letter from Miss F—d' second ed., 1761

59 William Hoare, *Henry, 9th Earl of Pembroke, c.* 1760–70. Pastel on paper. Collection of the Earl of Pembroke, Wilton House, Wilts, UK/Bridgeman Art Library

60 *Caroline Russell,* late 1760s. Pastel on grey paper, 31.9 x 24.3 (12½ x 9⅝). Private Collection

61 *Uvedale Tomkyns Price,* 1760. Oil on canvas, 124.4 x 99.1 (49 x 39). Neue Pinakothek, Munich. Photo Artothek

62 John Robert Cozens, *The Royal Circus, Bath.* Watercolour. Published 1773. Bath and North East Somerset Council

63 *Ignatius Sancho,* 1768. Oil on canvas, 73.7 x 62.2 (29 x 24). National Gallery of Canada, Ottawa. Purchased 1907

64 William Dickinson, after Henry Bunbury, *A Family Piece,* 1781. Stipple, 24.7 x 36.6 (9¾ x 14⅜). © Copyright The British Museum, London

65 *Queen Charlotte, c.* 1780 (detail). Oil on canvas, 238.8 x 158.7 (94 x 62½). The Royal Collection © 2001, Her Majesty Queen Elizabeth II

66 *Queen Charlotte, c.* 1780 (detail). Oil on canvas, 238.8 x 158.7 (94 x 62½). The Royal Collection © 2001, Her Majesty Queen Elizabeth II

67 *James Quin,* 1763. Oil on canvas, 233.7 x 152.4 (92 x 60). National Gallery of Ireland, Dublin

68 *James Quin,* 1763. Oil on canvas, 64.8 x 50.8 (25½ x 20). The Royal Collection © 2001, Her Majesty Queen Elizabeth II

69 *Portrait of Catherine, Countess of Dartmouth, c.* 1771. Oil on canvas, 76.2 x 63.5 (30 x 25). Private Collection

70 Joseph Wright, *Three Persons Viewing the Gladiator by Candlelight,* 1765. Oil on canvas, 101.6 x 121.9 (40 x 48). Private Collection

71 *Old Horse,* 1770s. Plaster, height 24.8 (9¾). Private Collection, on loan to Gainsborough's House, Sudbury, Suffolk

72 *A Wooded Landscape with Figures and Cattle in a Stream, c.* 1760–65. Black chalk and stump with white chalk on buff paper, 271 x 381 (106⅞ x 150). Private Collection

73 *A Woman with a Rose, c.* 1763–65. Black chalk and stump, heightened with white on greenish buff paper, 46.6 x 34 (18⅜ x 13). © Copyright The British Museum, London

74 *Study of a Music Party,* early 1770s. Red chalk and stump, 24.1 x 32.4 (9½ x 12¾). © Copyright The British Museum, London

75 *Study for Portrait of Ann Ford, c.* 1760. Pencil and watercolour, 33.5 x 25.7 (13¼ x 10⅛). © Copyright The British Museum, London

76 *The Linley Sisters,* 1772. Oil on canvas, 200.4 x 153 (78⅞ x 60⅜). Dulwich Picture Gallery, London

77 *Johann Christian Bach, c.* 1776. Oil on canvas, 76.5 x 63.8 (30⅛ x 25⅛). By courtesy of the National Portrait Gallery, London.

78 *Karl Friedrich Abel,* 1777. Oil on canvas, 223.5 x 147.3 (88 x 58). Courtesy of the Huntington Library, Art Collections, and Botanical Gardens, San Marino, California

79 John Nixon, *Karl Friedrich Abel,* 1787. Pen, ink and wash, 17.8 x 13.8 (7 x 5⅜). By courtesy of the National Portrait Gallery, London

80 Anthony van Dyck, *George Villiers, 2nd Duke of Buckingham and his Brother Lord Francis Villiers,* 1635. Oil on canvas, 137.2 x 127.7 (54 x 50⅜). The Royal Collection © 2001, Her Majesty Queen Elizabeth II

81 *The Blue Boy, ?* 1770. Oil on canvas, 177.8 x 121.9 (70 x 48). Courtesy of the Huntington Library, Art Collections, and Botanical Gardens, San Marino, California

82 Joshua Reynolds, *Commodore Augustus Keppel*, 1753. Oil on canvas, 238.8 x 147 (92 x 57). National Maritime Museum, London
83 After Van Dyck, *Lords John and Bernard Stuart*, early to mid-1760s. Oil on canvas, 235 x 146 (92¾ x 57¼). The Saint Louis Art Museum. Gift of Mrs Jackson Johnson in memory of Mr Jackson Johnson
84 Peter Paul Rubens, *Peasants with Cattle by a Stream in a Woody Landscape: 'The Watering Place'*, c. 1620. Oil on oak panel, 99.4 x 135 (39¼ x 53¼). The National Gallery, London
85 After Rubens, *The Descent from the Cross*, early to mid-1760s, 121.9 x 97.8 (48 x 38½). Gainsborough's House, Sudbury, Suffolk
86 *The Harvest Wagon*, 1767. Oil on canvas, 114.8 x 119.4 (45¼ x 47). Barber Institute of Fine Arts, University of Birmingham
87 After Bartolomé Esteban Murillo, *The Good Shepherd*, c. 1778. Oil on canvas, 175.9 x 182.6 (69 x 72). Private Collection
88 *Mary, Countess Howe*, c. 1763–64 (detail). Oil on canvas, 244 x 152.4 (96¼ x 60). The Iveagh Bequest, Kenwood House. © English Heritage Photo Library
89 Joshua Reynolds, *Captain Orme*, 1756. Oil on canvas, 240 x 147.3 (94½ x 58). The National Gallery, London
90 *Lady Alston*, 1761–62. Oil on canvas, 226.1 x 165.1 (89 x 65). Louvre, Paris. © Photo RMN
91 Allan Ramsay, *The Artist's Wife (Margaret Lindsay of Evelick, c. 1726–82)*, c. 1758–60. Oil on canvas 74.3 x 61.9 (29¼ x 24¼). The National Gallery of Scotland, Edinburgh
92 *Mary, Duchess of Montagu*, c. 1768. Oil on canvas, 125.7 x 100.3 (49¼ x 39½). In the collection of The Duke of Buccleuch and Queensbury, KT
93 Joshua Reynolds, *Garrick between Tragedy and Comedy*, 1762. Oil on canvas, 148 x 183 (58¼ x 72). Somerset Maugham Theatre Collection, London
94 *Monument to William Shakespeare*, designed by William Kent, the figure executed by Peter Scheemakers. Erected in 1740. Marble, life-size. Westminster Abbey, London
95 *Garrick and Shakespeare's Bust*, 1766. Destroyed by fire, 1946.
96 *Lord Ligonier*, 1770. Oil on canvas, 237.5 x 156.2 (93¾ x 61½). Courtesy of the Huntington Library, Art Collections, and Botanical Gardens, San Marino, California

97 *Lady Ligonier*, 1770. Oil on canvas, 236.2 x 154.9 (93 x 61). Courtesy of the Huntington Library, Art Collections, and Botanical Gardens, San Marino, California
98 *Henry, 3rd Duke of Buccleuch*, 1770. Oil on canvas, 123.2 x 96.5 (48½ x 38). In the collection of The Duke of Buccleuch and Queensbury, KT
99 *Sir Benjamin Truman*, 1770–74. Oil on canvas, 237.8 x 151.4 (93¾ x 59¾). © Tate, London 2002
100 *The Watering Place*, 1777. Oil on canvas, 147.3 x 180.3 (58 x 71). The National Gallery, London
101 Thomas Hancock, after Thomas Gainsborough, *The Rural Lovers* on large cabbage leaf jug, c. 1765–70. Etching transfer print on Worcester porcelain. Gainsborough's House, Sudbury, Suffolk
102 Paul Sandby, *The Gate of Coverham Abbey, Yorkshire*, 1752. Watercolour and body colour, 26.5 x 38.4 (10¾ x 15¼). © Copyright The British Museum, London
103 Richard Wilson, *The Destruction of Niobe's Children*, 1760. Oil on canvas, 147.3 x 188 (58 x 74). Yale Center for British Art, Paul Mellon Collection, New Haven, Connecticut
104 *Woodland Pool with Rocks and Plants*, c. 1765–70. Watercolour and black chalk stippled with oil paint on paper, 22.9 x 28.3 (9 x 11¼). Yale Center for British Art, Paul Mellon Collection, USA/Photo: Bridgeman Art Library
105 *Going to Market*, c. 1770. Oil on canvas, 122 x 147.4 (48 x 58). The Iveagh Bequest, Kenwood House © English Heritage Photo Library
106 *Man with Claude Glass*, c. 1750. Drawing. © Copyright The British Museum, London
107 *A Boy Reclining in a Cart*, c. 1767–70. Pen and brown ink with grey and brown washes, 17.6 x 22.1 (6¾ x 8¾). © Copyright The British Museum, London
108 *The Woodcutter's Return*, 1772–73. Oil on canvas, 147.3 x 123.2 (58 x 48½). Reproduced by kind permission of His Grace, the Duke of Rutland from his collection at Belvoir Castle, Leicestershire, UK
109 Schomberg House, engraving from monograph of Gainsborough by Fulcher, 1856
110 Robert Dighton, *The Specious Orator (James Christie)*, published 1794. Coloured etching, 19.8 x 14.8 (7¾ x 5¾). By courtesy of the National Portrait Gallery, London.

111 *Sir Henry Bate-Dudley*, c. 1780. Oil on canvas, 223.5 x 149.9 (88 x 59). © Tate, London 2002
112 *Isabella, Viscountess Molyneux (later Countess of Sefton)*, c. 1769. Oil on canvas, 236 x 155 (93 x 61). Board of Trustees of the National Museums and Galleries on Merseyside (Walker Art Gallery, Liverpool)
113 Richard Earlom, after Charles Brandoin, *Exhibition of the Royal Academy in 1771*, 1772. Mezzotint © Copyright The British Museum, London
114 Johann Zoffany, *The Academicians of the R.A.*, 1771–72. Oil on canvas, 100.7 x 147.3 (39¾ x 58). The Royal Collection © 2001, Her Majesty Queen Elizabeth II
115 Johann Zoffany, *Portrait of Thomas Gainsborough*, c. 1772. Oil on canvas, 19.7 x 17.1 (7¾ x 6¾). © Tate, London 2002
116 Fifteen portraits of George III and family, 1783. Oil on canvas, each oval c. 59 x 44 (23¼ x 17¼). The Royal Collection © 2001, Her Majesty Queen Elizabeth II
117 Letter from the artist to the Hanging Committee of the Royal Academy illustrating the arrangement of the royal portraits. Royal Academy of Arts, London, 1783
118 Gainsborough Dupont, after Thomas Gainsborough, *Three Eldest Princesses*, 1793. Mezzotint, 66 x 45.5 (26 x 17¾). Gainsborough's House, Sudbury, Suffolk
119 *Anne, Duchess of Cumberland*, 1777. Oil on canvas, 172.6 x 101.9 (68 x 40¼). The Royal Collection © 2001, Her Majesty Queen Elizabeth II
120 *Henry, Duke of Cumberland*, 1777. Oil on canvas, 238.1 x 142.2 (93¾ x 56). The Royal Collection © 2001, Her Majesty Queen Elizabeth II
121 Joshua Reynolds, *Queen Charlotte*, 1780. Oil on canvas, 236 x 146 (92¾ x 57½). Royal Academy of Arts, London
122 *George III*, 1780. Oil on canvas, 238.8 x 158.7 (94 x 62½). The Royal Collection © 2001, Her Majesty Queen Elizabeth II
123 *Queen Charlotte*, c. 1780. Oil on canvas, 238.8 x 158.7 (94 x 62½). The Royal Collection © 2001, Her Majesty Queen Elizabeth II
124 *George IV, as Prince of Wales*, 1782. Oil on canvas, 186.7 x 250.2 (73¾ x 98½). The National Trust, Waddesdon. Photo Photographic Survey, Courtauld Institute of Art
125 *Princess Elizabeth*, c. 1782. Oil on canvas, oval 59 x 44 (23¾ x 17¾). The Royal Collection © 2001, Her Majesty Queen Elizabeth II

126 *Henry, Duke of Cumberland, The Duchess of Cumberland and Lady Elizabeth Luttrell*, 1783–85. Oil on canvas, 163.8 x 124.5 (64½ x 49). The Royal Collection © 2001, Her Majesty Queen Elizabeth II
127 *Mrs Thomas Gainsborough, c.* 1778. Oil on canvas, 76.6 x 63.8 (30¼ x 25¼). The Courtauld Institute Gallery, Somerset House, London
128 *Tristram and Fox*, 1775–85. Oil on canvas, 61 x 50.8 (24 x 20). © Tate, London 2002
129 *Mary and Margaret Gainsborough, c.* 1763–64. Oil on canvas, 127.2 x 101.7 (49¼ x 39½). Worcester Art Museum, Worcester, Massachusetts
130 *The Artist's Daughters, c.* 1770–74. Oil on canvas, 231 x 150 (91 x 59). Private Collection
131 *Johann Christian Fischer, c.* 1780. Oil on canvas, 228.6 x 150.5 (90 x 59½). The Royal Collection © 2001, Her Majesty Queen Elizabeth II
132 *Gainsborough Dupont*, 1770–75. Oil on canvas, 44.5 x 36.2 (17½ x 14¼). © Tate, London 2002
133 *The Hon. Mrs Thomas Graham (1757–92)*, 1775–77. Exhibited in 1777. Oil on canvas, 237 x 154 (93¼ x 60½). The National Gallery of Scotland, Edinburgh
134 *Georgiana, Duchess of Devonshire, c.* 1785. Oil on canvas, 127 x 101.6 (50 x 40). Devonshire Collection, Chatsworth. By permission of the Duke of Devonshire and the Chatsworth Settlement Trustees.
135 Anonymous engraving of 'A Certain Duchess…', April 1784. © Copyright The British Museum, London
136 *The Mall*, 1783. Oil on canvas, 120.6 x 147 (47½ x 57½). The Frick Collection, New York
137 Attributed to Joseph Nickolls, *St James' Park and Mall, c.* 1745. Oil on canvas, 104.1 x 138.4 (41 x 54½). The Royal Collection © 2001, Her Majesty Queen Elizabeth II
138 *Study of a Lady*, probably for the 'Richmond Water-walk', *c.* 1785. Black chalk and stump on buff paper, heightened with white, 48.4 x 31.1 (19 x 12¼). © Copyright The British Museum, London
139 *Mrs Mary Robinson, 'Perdita'*, 1781. Oil on canvas, 228.6 x 153 (90 x 60½). The Wallace Collection, London
140 J. Thornthwaite, after James Roberts, *Signora Baccelli in the Ballet called 'Les Amants surpris'*, 1781
141 *Giovanna Baccelli*, 1782. Oil on canvas, 226.7 x 148.6 (89¼ x 58½). © Tate, London 2002

142 Joshua Reynolds, *Mrs Siddons as the Tragic Muse*, 1784. Oil on canvas, 236 x 146 (97½ x 57½). Courtesy of the Huntington Library, Art Collections, and Botanical Gardens, San Marino, California
143 *Mrs Siddons*, 1783–85. Oil on canvas, 126.4 x 99.7 (49¾ x 39¼). The National Gallery, London
144 *Mr and Mrs William Hallett, 'The Morning Walk'*, 1785. Oil on canvas, 236.2 x 179.1 (93 x 70½). The National Gallery, London
145 *Pomeranian Bitch and Puppy, c.* 1777. Oil on canvas, 83.2 x 111.8 (32¾ x 44). © Tate, London 2002
146 *Mrs Richard Brinsley Sheridan*, 1785–86. Oil on canvas, 219.7 x 153.7 (86½ x 60½). National Gallery of Art, Washington, D.C.
147 *Rocky Coast Scene with Fishermen, c.* 1781–82. Oil on canvas, 101.9 x 127.6 (40¼ x 50¼). National Gallery of Art, Washington, D.C.
148 Philippe Jacques de Loutherbourg, *The Smugglers' Return*, 1801. Oil on canvas, 74.3 x 106.7 (29¼ x 42). Joslyn Art Museum, Omaha, Nebraska. Gift of Mr and Mrs Arthur Wiesenberger
149 E. F. Burney, watercolour demonstrating the Eidophusikon, *c.* 1780
150 Gainsborough's 'show box' for use with twelve painted transparencies of landscapes, c. 1781–82. Wood and glass, 69.9 x 61 x 40.6 (27½ x 24 x 16). Given by the National Art Collections Fund, from the bequest of Ernest E. Cook. V&A Picture Library
151 *Cottage Scene by Night, c.* 1781–82. Transparency on glass, 27.9 x 33.7 (11 x 13¼). V&A Picture Library
152 *Study of Langdale Pikes, c.* 1783. Pencil and grey wash, 26.4 x 41.3 (10½ x 16¼). Private Collection
153 *Mountain Landscape with Shepherd, c.* 1783. Black chalk and stump and white chalk on buff paper, 23.3 x 36.3 (9¼ x 14¼). Museum of Art (Luis A. Ferré Foundation), Ponce, Puerto Rico
154 *Rocky Landscape, c.* 1783. Oil on canvas, 119.4 x 147.3 (47 x 58). The National Gallery of Scotland, Edinburgh
155 *The Market Cart*, 1786. Oil on canvas, 184.2 x 153 (72½ x 60½). The National Gallery, London
156 J. Dean, after Sir Joshua Reynolds, *Cupid as Link Boy*, 1777. Mezzotint. © Copyright The British Museum, London
157 *Girl with Pigs*, 1782. Oil on canvas, 125.6 x 148.6 (49½ x 58½). Castle Howard Collection, North Yorkshire

158 *Cottage Girl with Dog and Pitcher*, 1785. Oil on canvas, 174 x 124.5 (68½ x 49). National Gallery of Ireland, Dublin
159 *Two Shepherd Boys with Dogs Fighting*, 1783. Oil on canvas, 223.5 x 157.5 (88 x 62). The Iveagh Bequest, Kenwood House. © English Heritage Photo Library
160 *Self-Portrait, c.* 1787. Oil on canvas, 74.9 x 61 (29½ x 24). Royal Academy of Arts, London
161 *Wooded Landscape with Peasant Reading Tombstone*, 1780. Soft ground etching with some aquatint, 29.6 x 39.3 (11⅝ x 15½). Gainsborough's House, Sudbury, Suffolk
162 Peter Simon, after Gainsborough, *The Woodman*, 1791. Stipple engraving. © Copyright The British Museum, London
163 *Study of a Woodman Carrying Faggots, c.* 1787. Black chalk and stump on buff paper, heightened with white, 51.4 x 30.6 (20¼ x 12). Private Collection
164 Joseph Wright, *The Old Man and Death, c.* 1773. Oil on canvas, 101.6 x 127 (40 x 50). Wadsworth Atheneum Museum of Art, Hartford
165 *Diana and Actaeon, c.* 1785. Oil on canvas, 158.1 x 188 (62½ x 74). The Royal Collection © 2001, Her Majesty Queen Elizabeth II
166 John Constable, *The Haywain*, 1821. Oil on canvas, 130.2 x 185.4 (51¼ x 73). The National Gallery, London
167 James Abbott McNeill Whistler, *Harmony in Grey and Green: Miss Cicely Alexander*, 1872–74. Oil on canvas, 190.2 x 97.8 (74¾ x 38½). © Tate, London 2002
168 Augustus John, *Madame Suggia*, 1920–23. Oil on canvas, 186.7 x 165.1 (73½ x 65). © Tate, London 2002
169 Countess Howe figurine modelled by Peter Gee for Royal Doulton. China, height 23.5 (9¼). Photo Royal Doulton plc
170 Walt Disney, *The Blue Duck*, 1941–45. Coloured pencil drawing. © Disney Enterprises, Inc.
171 *Figure Study for The Housemaid, c.* 1785–88. Drawing on paper, 34.6 x 24.8 (13⅝ x 9¾). © Tate, London 2002
172 *Studies of a Cat*, mid-1760s. Black chalk and stump, white chalk on buff paper, 33.2 x 45.9 (13⅛ x 18¼). Rijksmuseum, Amsterdam

Index